Art in Action

Guy Hubbard
Indiana University

Contributing Educators:

D. Sydney Brown
Lee C. Hanson
Barbara Herberholz
Talli Richardson Larrick

CORONADO PUBLISHERS

San Diego Orlando Dallas Chicago

Printed in the United States of America ISBN 015-770049-6(3)

4 5 025 9 8 7 6

Table of Contents

This art is from page viii of the student book.

Introduction

About the Series

Art in Action is a comprehensive series designed to expand and improve the role of art education in all classrooms. Levels One through Six of the series are particularly useful for self-contained classrooms in which teachers must teach all subjects and therefore often have expertise in areas other than art. These six books provide teachers with the means for successfully bringing art into the classroom. The books also simplify the instruction of art for those art teachers who must move from classroom to classroom. By clearly stating what each lesson involves, teaches, and requires, the books greatly reduce the amount of preparation necessary.

Of equal importance for the self-contained classroom is *Art in Action's* cross-curricular approach. It is perfectly adapted for the teacher who desires smooth transitions from one subject to another. Art projects in the series include those based on language arts, science, mathematics, social studies, and more. Not surprisingly, art learning also improves the students' performance in other subject areas. In short, art is vital to the learning experience, and *Art in Action* makes the teaching of art viable and adaptable to many purposes.

Art in Action is also a cumulative program. Material introduced in Level One is reintroduced in succeeding years. At the same time, new material is added. In this way, students move naturally through art learning. Upon completion of Level Six, the students, having received a strong foundation in art, can begin work with a specially trained art teacher.

The first six levels of *Art in Action* are built around the four essential parts of art learning: aesthetic perception, creative expression, art heritage, and aesthetic valuing. This organization allows for a spiraling effect in the presentation of the elements and principles of art and in the use of different media. Reinforcement is natural in this type of organization. Students receive a solid base and are asked to repeatedly refer to this base as new levels of complexity are added.

Using the Books

State departments of education across the nation tend to recommend about 100 minutes of art education per week. *Art in Action* meets this requirement. Each Level, One through Six, contains sixty lessons, divided into four units. Lessons vary in amount of time needed for completion, but twice-weekly sessions of 50 minutes will allow the teacher to complete most of the lessons satisfactorily during the course of the year.

Lesson Format

The lessons in *Art in Action* (Levels Three through Six) are all organized in the same pattern. The text is written at grade level, with art terms appearing in boldface type. The left page of each lesson centers on bringing art to the children's realm of experience. Titled *Observing and Thinking* (or *Looking and Thinking* in Levels One through Three), this portion of the lesson discusses the elements and principles of art, the visuals, artists and art techniques, relevant art history, experiences common to most students, or other pertinent facts. In Levels One and Two, both pages of some lessons are devoted to *Looking and Thinking*; art activities for these lessons appear in the Teacher's Manual.

The right page of each lesson tells, and often shows, how to complete an artwork. This section is titled *Creating Art* (or *Making Art* in Levels One through Three). Short, precise instructions are given in the form of steps, and creativity is not impaired by directions leading to "cookie-cutter" art products. Exploration and imagination, rather than stiff, mechanical creation of a product, are encouraged. The emphasis is always on the *process*.

Included in the lesson is a list of needed art materials (Levels Three through Six). A safety symbol alerts both students and teachers to the need for caution. The safety symbol appears consistently whenever scissors, other sharp objects, glue, or any other hazardous art materials are used in the lesson.

A list of questions referred to as Learning Outcomes (Levels Four through Six) is also provided. Learning Outcomes fall into three categories: understanding art, creating art, and appreciating art. The purpose of these brief questions is to get students to focus on the objectives of the lesson they have just finished. Outcomes for understanding art ask the students to center on the vocabulary, artistic techniques, historical information, or images presented in the lesson. Outcomes for creating art ask the students to recall the learning that occurred during the actual production of an artwork. Finally, Outcomes for appreciating art center on the students' aesthetic values. These Outcomes provide immediate reinforcement of learning. For the lower levels, where too many words on a page can result in a threatening format, the

Outcomes appear in the Teacher's Manual. It is recommended that students complete these Outcomes either orally or in writing as soon as each lesson is completed.

Apart from written text, the series contains vitally important visuals. Not only are reproductions of fine art and photography included, but student examples and pictures showing how to complete art projects are also used. All of these visuals are essential to the art program. Students need to be exposed to the recognized great artists of the world. They also need to see art in the everyday environment—in nature, in cities, in household objects. Finally, the students need to see themselves as artists; this is facilitated when the works of peers are shown as valid art forms.

You will find that the written and visual texts of *Art in Action* work as one. They are related and inseparable. When used together in the teaching process, the words and pictures make a complete statement.

Other Elements of the Books

Unit openers and closers frame the lessons into appropriate units. A two-page format is used for unit openers. They are visually dynamic and verbally exploratory. A general overview of the unit is given each time, but the purpose is not simply to inform. Rather, a fourfold purpose is evident. The unit openers work to encourage aesthetic perception, to develop critical thinking skills, to anticipate learning to come, and to involve students in active learning through exploratory questions.

At the close of each unit, an Exploring Art activity and a Unit Review appear. Each uses a single page. The Exploring Art activity involves exactly what its title implies. Each is an extension and exploration of one important aspect of art, such as an art career or a special group project. The Unit Review similarly fits its title. It serves to test the students on what has been learned in the unit. Questions are asked about a visual—questions which are designed to reflect the unit's emphases.

The remainder of the pupil's book consists of a Glossary (Levels Three through Six only) and an Index (Levels Three through Six only; Indexes for Levels One and Two are located in the corresponding Teacher's Manuals). Both are thorough and will prove to be useful tools for the students' use.

The Teacher's Manual

The format of the *Art in Action* Teacher's Manuals is straightforward. These manuals present everything that even the most inexperienced teacher needs to know in order to teach the lessons. Each lesson is thoroughly outlined, and a broad description for each unit is also included.

Each lesson's outline begins with clearly stated objectives in categories corresponding to those of the Learning Outcomes. Then art vocabulary words used in the lesson are listed. These are followed by a section containing information on lesson preparations. Included are detailed lists of necessary art materials and basic teaching supplies, ideas for things to be done in advance, general helpful hints, and safety precautions.

The Guided Teaching portion of each lesson's guide is based on Bloom's Taxonomy and the theory of clinical teaching. This section includes an anticipatory set and suggestions for focus areas from each portion of the lesson. Included are discussion questions, background information, step-by-step guidelines for the completion of activities, and cleanup suggestions. Regardless of variations in art background, teachers can take the information in the Guided Teaching portion of the manual and successfully teach the lesson.

Evaluating Procedures is also a very important part of the lesson outline. Suggested procedures include the three essential areas of artistic development: recall of information, achievement of stated goals during the creation of an artwork, and aesthetic perception and valuing. Included in these suggested procedures are strategies for oral and written communication which involve teacher and peer evaluation. The last important form of evaluation, self-evaluation, is inherent in the students' proper use of the Learning Outcomes.

Each lesson outline in the Teacher's Manual ends with a section entitled Learning Enrichment. In this section you will find suggested lesson variations and adaptations for different students' needs; cross-curricular extensions; and a wealth of activities centered on art careers, critical thinking skills, group activities, and other specific applications.

Other general material found in the Teacher's Manuals include an extensive How-to-Do-It section and a Bookbinding section. Refer to these early in your art curriculum so you will be at ease instructing your students in the use of different media and the completion of different projects. A list of useful supplementary resources, a materials chart, and Scope and Sequence charts are other valuable tools that *Art in Action* provides for you, the teacher, as you guide students to successful completion of the art curriculum.

Learning Outcomes
Correlated to Critical Thinking Skills

This discussion and the following correlation of Critical Thinking Skills to Learning Outcomes are based on the classifications in *A Taxonomy of Educational Objectives in the Cognitive Domain*, by Benjamin Bloom, et. al. The six levels are briefly defined in the correlation charts.

The lessons in the *Art in Action* student texts and in the Teacher's Manual are designed to promote critical thinking skills in the study of art. The general outline of the critical thinking skills involved in each lesson is:

Lesson Focus—Students recall what they already know about the main point of the lesson, give examples from experience and their immediate surroundings, and (as possible) apply the information in a new situation.

Observing and Thinking—Students begin by giving accurate observations and descriptions of the visuals. Both the student texts and Teacher's Manuals provide basic art theory and background information for immediate use in student comprehension and application. Discussion questions cover the entire span of critical thinking skills.

Creating Art—The primary emphasis in the art activities is on synthesis through application. Through an attempt to use the art element or principle emphasized in the lesson, the student more deeply comprehends it; this comprehension is the basis for critical thinking at the higher levels.

Learning Outcomes—These questions elicit critical thinking at all levels. A detailed breakdown occurs in the following correlation.

Specific uses of the various critical thinking skills are also catalogued in the Scope and Sequence in Part VIII, Aesthetic Valuing Using Critical Thinking Skills.

KNOWLEDGE
Recall information learned in a similar form

Behavioral Terms Indicating Knowledge:

list	observe	recite
define	show	label
state	repeat	identify
name	quote	memorize
select	spell	match
locate		

Sample Learning Outcomes (Student Edition):
Name four ways that lines can vary.
(Lesson 2; page 5)

What is memorabilia? Name two American artists who painted memorabilia. (Lesson 24; page 53)

What are some of the main types of puppets used all over the world? (Lesson 52; page 117)

Learning Outcomes Requiring Use of Knowledge:*
2.1, 3.1, 4.1, 5.1, 7.1, 8.1, 10.1, 11.1, 12.1, 13.1, 14.1, 16.1, 17.1, 20.1, 21.1, 22.1, 23.1, 24.1, 25.1, 28.1, 30.1, 31.1, 32.1, 33.1, 35.1, 36.1, 37.1, 38.1, 39.1, 40.1, 42.1, 43.1, 44.1, 46.1, 48.1, 50.1, 52.1, 53.1, 54.1, 56.1, 57.1, 59.1

COMPREHENSION
Understand and interpret information learned in a different form

Behavioral Terms Indicating Comprehension:

describe	explain	translate
reword	specify	infer
render	generalize	outline
convert	paraphrase	project
tell	summarize	calculate
expand		

Sample Learning Outcomes (Student Edition):
Why must artists carefully study objects in their environment before they can successfully draw or paint them? (Lesson 1; page 3)
What are some of the effects an artist can achieve with analogous and complementary colors? (Lesson 19; page 43)
How are lines, shapes, and colors used in the American flag to create pattern and a sense of rhythm? (Lesson 47; page 107)

Learning Outcomes Requiring Use of Comprehension:*
1.1, 4.3, 6.1, 7.1, 7.3, 8.1, 8.3, 9.1, 11.3, 12.1, 13.1, 13.2, 15.1, 16.1, 16.3, 17.3, 18.1, 19.1, 20.1, 25.3, 26.1, 26.3, 27.1, 28.1, 29.1, 30.1, 31.1, 34.1, 34.3, 35.3, 40.3, 41.1, 42.3, 43.3, 44.3, 45.1, 45.3, 46.3, 47.1, 49.1, 51.1, 52.3, 55.1, 55.3, 56.1, 57.1, 58.1, 60.1, 60.3

*The first number of *Learning Outcomes* represents the lesson number, the second refers to a specific question.

APPLICATION
Use information learned to relate or apply ideas to new or unusual situations

Behavioral Terms Indicating Application:

apply	dramatize	exercise
utilize	demonstrate	develop
change	transfer	mobilize
sketch	employ	solve
produce	manipulate	relate
show		

Sample Learning Outcomes (Teacher's Edition):

Did your group arrange your cards correctly by value? (Lesson 12; page 16)

Does your artwork contain symbols or just a design? (Lesson 35; page 47)

Did you overlap tissue paper in your collage to create an interesting effect? (Lesson 47; page 66)

Learning Outcomes Requiring Use of Application:*
1.2, 3.2, 9.2, 11.1, 12.2, 13.2, 14.2, 16.1, 18.2, 19.2, 20.1, 26.2, 27.3, 28.1, 29.1, 34.2, 35.2, 38.2, 39.2, 40.3, 43.2, 44.1, 45.2, 47.2, 52.2, 54.2, 55.2, 57.2, 58.2

SYNTHESIS
Communicate, generate, or develop something new and original from what is learned

Behavioral Terms Indicating Synthesis:

unify	reorganize	produce
combine	construct	generate
compose	develop	arrange
create	design	invent
form	originate	imagine
assemble		

Sample Learning Outcomes (Teacher's Edition):

Did you create a collage that shows unity? (Lesson 6; page 9)

What does your artwork tell about yourself? Does your background tell what you will do in America? (Lesson 42; page 57)

Did you achieve interesting effects with your spatter painting? (Lesson 56; page 76)

Learning Outcomes Requiring Use of Synthesis:*
2.2, 6.2, 8.2, 10.2, 13.3, 15.2, 16.2, 17.2, 20.2, 21.2, 22.2, 23.2, 29.2, 31.2, 33.3, 35.3, 36.2, 37.2, 38.3, 42.2, 42.3, 43.2, 44.2, 50.2, 55.3, 56.2, 58.2, 59.2

ANALYSIS
Examine and break information down into its component parts and identify its unique characteristics

Behavioral Terms Indicating Analysis:

examine	diagram	scrutinize
analyze	dissect	survey
categorize	separate	search
classify	select	experiment
simplify	inspect	illustrate
compare		

Sample Learning Outcomes (Teacher's Edition):

Does your artwork have unity? Why or why not? (Lesson 7; page 10)

Does your background create a certain mood or feeling? (Lesson 16; page 23)

Did you miss any details in your life-sized portrait? (Lesson 40; page 54)

Learning Outcomes Requiring Use of Analysis:*
1.3, 2.3, 7.2, 8.1, 12.3, 14.1, 15.2, 16.3, 17.1, 18.3, 19.1, 23.1, 24.2, 25.2, 26.2, 27.2, 28.2, 30.1, 30.2, 32.2, 33.2, 39.1, 39.2, 40.2, 41.2, 42.2, 46.1, 46.2, 48.2, 49.2, 51.1, 53.2, 57.1

EVALUATION
Make judgments and evaluate something based on either external or internal conditions or criteria

Behavioral Terms Indicating Evaluation:

evaluate	appraise	assess
judge	rank	criticize
value	estimate	justify
decide	measure	grade
determine	recommend	discriminate
rate		

Sample Learning Outcomes (Teacher's Edition):

Which is the best print that you made? (Lesson 9; page 12)

Will this television show keep the interest of the viewer? Why? (Lesson 45; page 60)

Do you like working with a group to create an artwork? Why or why not? (Lesson 50; page 69)

Learning Outcomes Requiring Use of Evaluation:*
3.3, 4.3, 5.2, 6.3, 7.3, 8.3, 9.3, 11.2, 11.3, 14.3, 15.3, 17.3, 21.3, 23.3, 24.3, 25.3, 26.3, 28.3, 29.3, 30.3, 31.3, 34.3, 36.3, 37.3, 39.3, 41.3, 44.3, 45.3, 48.3, 49.3, 50.2, 50.3, 51.2, 52.3, 53.3, 54.1, 54.3, 58.3, 59.3, 60.3

*The first number of *Learning Outcomes* represents the lesson number, the second refers to a specific question.

Art In Action: Scope and Sequence (Level 3)

I. Elements of Art

Line	ST: 3, 4, 5, 6, 7, 8, 9, 14, 15, 31, 39, 47, 48, 50, 51, 52, 53, 57, 71, 75, 79, 81, 85, 86, 87, 89, 95, 99, 113, 117, 129 TM: 2, 3, 4, 5, 6, 9, 16, 20, 23, 27, 30, 31, 40, 42, 43, 47, 48, 49, 51, 52, 59, 62, 74, 77, 81
Shape	ST: 3, 4, 5, 12, 14, 15, 16, 17, 21, 23, 31, 41, 49, 51, 57, 65, 73, 74, 77, 78, 79, 81, 82, 83, 85, 86, 87, 88, 91, 93, 99, 120, 121, 129 TM: 1, 2, 4, 8, 9, 10, 18, 19, 20, 24, 25, 27, 29, 30, 32, 43, 44, 47, 48, 49, 50, 51, 52, 53, 55, 56, 59, 64, 65, 73, 74, 77, 78, 79, 81
Form	ST: 16, 17, 50, 51, 61, 74, 75, 78, 82, 90, 91, 95, 109 TM: 10, 11, 20, 29, 30, 36, 47, 54, 57, 58
Space	ST: 5, 7, 9, 14, 15, 16, 41, 43, 50, 97, 99, 109 TM: 4, 5, 22, 23, 29, 30, 43, 60, 65, 73, 81
Texture	ST: 8, 9, 10, 11, 12, 13, 51, 65, 129 TM: 1, 5, 6, 7, 8, 9, 20, 29, 39, 40, 43, 44, 64, 74, 77, 78, 81
Color	ST: 3, 4, 7, 12, 13, 14, 15, 17, 20, 21, 22, 23, 24, 25, 27, 28, 29, 31, 37, 38, 39, 40, 41, 42, 43, 44, 45, 47, 49, 53, 55, 57, 64, 65, 70, 72, 73, 76, 77, 83, 84, 85, 86, 87, 91, 93, 96, 97, 99, 107, 113, 115, 119, 122, 123, 125, 127, 128, 129, 133 TM: 1, 2, 4, 5, 8, 10, 11, 13, 14, 15, 16, 17, 18, 19, 20, 22, 23, 24, 25, 26, 27, 28, 29, 30, 34, 35, 39,
Color (Cont'd)	40, 41, 42, 43, 44, 46, 47, 49, 52, 53, 55, 56, 58, 59, 64, 65, 66, 68, 69, 70, 72, 73, 74, 75, 76, 77, 78, 79, 81
Value	ST: 24, 25, 26, 27, 37, 41, 43, 57 TM: 15, 16, 17, 20, 22, 23, 26, 34, 40, 65, 69, 81

II. Principles of Art

Balance	ST: 50, 51, 52, 53, 73 TM: 21, 30, 31, 32, 40, 43, 47, 51
Variety	ST: 5, 9, 12, 23, 54, 55, 71, 104, 105 TM: 3, 8, 21, 31, 32, 33, 42, 44, 49, 50, 68, 70, 77, 78
Rhythm	ST: 12, 13, 55, 121, 123, 127 TM: 8, 9, 21, 33
Repetition and Pattern	ST: 5, 12, 13, 14, 15, 55, 64, 65, 72, 73, 76, 77, 79, 122, 123, 127, 128 TM: 8, 9, 11, 12, 39, 47, 52, 65, 74, 77
Movement	ST: 29, 48, 49, 65, 116, 117, 129 TM: 59, 60, 70, 71
Emphasis	ST: 18, 24, 36, 38, 39, 42, 43, 56, 57, 58, 59, 104, 105 TM: 20, 21, 34, 35, 40, 59, 60, 64, 65
Proportion	ST: 30, 31, 59, 93, 95 TM: 18, 19, 20, 27, 32, 34, 53, 64, 67, 79
Unity	ST: 12, 13, 15, 72, 73, 89 TM: 2, 3, 8, 9, 10, 14, 21, 24, 33, 43, 52, 65, 70

III. Creative Expression Using Various Media and Materials

Drawing: pencil	ST: 5, 7, 29, 31, 41, 45, 51, 53, 57, 75, 77, 79, 95, 111, 113, 115, 119, 131 TM: 3, 7, 11, 19, 25, 27, 29, 32, 57, 68, 69, 70, 71, 72, 79
charcoal	ST: 71 TM: 7, 57

VI. Art Careers (Cont'd)

fashion designer	ST: 64, 65
	TM: 20, 39, 51
film maker	ST: 98, 99
	TM: 58, 59, 60
floral arranger	TM: 20
furniture designer	TM: 20
graphic artist	ST: 118, 119
	TM: 71, 72
illustrator	ST: 111
	TM: 67, 68, 81
industrial/ commercial designer	ST: 54
	TM: 5, 13, 20
interior designer	TM: 20
landscape designer	TM: 20
make-up artist	TM: 20
museum-related	ST: 132, 133
	TM: 79, 80
painter	ST: 24, 26, 38, 42, 124
	TM: 15, 18, 56, 67
photographer	ST: 26, 42, 111
	TM: 1, 16, 53
portrait artist	TM: 20
printmaker	ST: 18
puppeteer	ST: 62, 63
	TM: 37, 40
quilter	ST: 93
sculptor	ST: 50
set designer	ST: 62
	TM: 37, 40
technical illustrator	TM: 20, 70
wallpaper designer	TM: 20

VII. Related Subject Areas

Language Arts	ST: 5, 11, 23, 43, 45, 49, 71, 81, 95, 97, 98, 99, 110, 111, 114, 116, 117, 131
	TM: 2, 6, 7, 8, 10, 11, 13, 16, 17, 23, 24, 25, 27, 35, 37, 38, 39, 42, 43, 44, 46, 48, 49, 50, 53, 54, 57, 58, 59, 60, 61, 65, 66, 67, 68, 69, 70, 78, 79, 81
Social Studies	ST: 28, 40, 56, 60, 61, 64, 70, 74, 76, 77, 78, 79, 80, 82, 84, 86, 87, 90, 91, 92, 93, 114, 126, 130
	TM: 4, 11, 18, 24, 28, 33, 36, 38, 39, 41, 42, 44, 45, 46, 47, 48, 49, 50, 51, 52, 53, 54, 55, 56, 57, 67, 69, 70, 75, 77
Mathematics	ST: 14, 15, 16, 17, 112
Mathematics (Cont'd)	TM: 5, 9, 10, 29, 30, 32, 49
Science	ST: 4, 10, 24, 48, 52, 53, 81, 84, 112, 113, 114, 115
	TM: 3, 14, 24, 32, 46, 66, 70, 79
Industrial Arts	ST: 16, 17, 94, 95, 126
	TM: 10, 11, 57, 58
Creative Arts	ST: 62, 63, 98, 99, 128, 129, 132, 133
	TM: 19, 28, 31, 36, 38, 50, 52, 71, 72, 78, 79
Music	TM: 3, 4, 15, 17, 18, 26, 61
Health/Nutrition	TM: 7, 10, 15, 44, 73, 74

VIII. Aesthetic Valuing Using Critical Thinking Skills

Knowledge	ST: 2, 4, 7, 8, 10, 12, 14, 16, 18, 20, 22, 24, 26, 28, 30, 36, 38, 40, 42, 44, 46, 48, 49, 50, 52, 54, 56, 58, 60, 61, 62, 64, 70, 72, 73, 74, 76, 78, 79, 80, 82, 83, 84, 86, 87, 88, 89, 90, 94, 96, 98, 104, 106, 108, 112, 113, 114, 115, 116, 118, 119, 120, 122, 124, 126, 128, 130, 132, 133
Comprehension	ST: 3, 4, 5, 8, 10, 13, 14, 16, 18, 21, 22, 24, 27, 28, 36, 38, 39, 40, 42, 43, 44, 46, 48, 49, 52, 56, 58, 64, 70, 72, 73, 74, 77, 78, 79, 80, 81, 83, 84, 86, 88, 89, 93, 104, 106, 112, 113, 115, 122, 124, 128, 129
Application	ST: 3, 5, 7, 9, 11, 12, 13, 15, 23, 25, 27, 29, 31, 37, 41, 43, 45, 47, 49, 51, 55, 57, 65, 71, 75, 77, 79, 85, 87, 89, 91, 93, 95, 97, 105, 106, 109, 113, 115, 117, 119, 121, 123, 125, 127, 129, 133
Analysis	ST: 5, 6, 7, 10, 11, 12, 13, 16, 22, 24, 26, 30, 36, 37, 39, 44, 50, 51, 55, 57, 58, 59, 62, 64, 65, 72,

Unit 1 Before You Begin

WHAT IS ART?

This unit is an exploratory unit. The students will learn and use the elements of art while also becoming familiar with different media. They will be exposed to many kinds of art, including fine art, photographs, and student examples. Always the emphasis is on relating art to the real environment.

The unit opener is an appropriate prelude to the first unit, since it asks the students to begin thinking critically about the world. The visuals are all photographs, not pieces of fine art with which the students may not be familiar. The students are asked to describe what they see. They are instructed to really examine the photographs on the pages. The students are also given something to look forward to: soon they will be responding to the world as artists.

Help your students fully explore the photographs in the unit opener. Point out that the left-hand visual on the left page appeals to the senses of touch, taste, and smell, as well as to the sense of sight. Discuss the colors and textures in the pho-tograph. Lead the students to identify the small parts of the buildings pictured on the right side of the left page. Discuss how each building as a whole echoes its small parts. Discuss the Van Ginkel photograph of a cafe by asking exploratory questions. Can the students find circles? Can the students find smooth and rough surfaces? What do the students like about the scene? Use this photograph throughout the unit. As the students discover each element of art, they will enjoy displaying their knowledge in reference to this picture.

As a teacher, your role during this unit should be to lead the students to discover art. Try not to simply tell them about art. Rather, let them discover. The students must feel comfortable as individual artists. Later they can learn some methods and artistic laws. As beginning artists, however, they should be allowed to experiment. They should apply what they learn, discover what works and does not work, and individually reach conclusions about art.

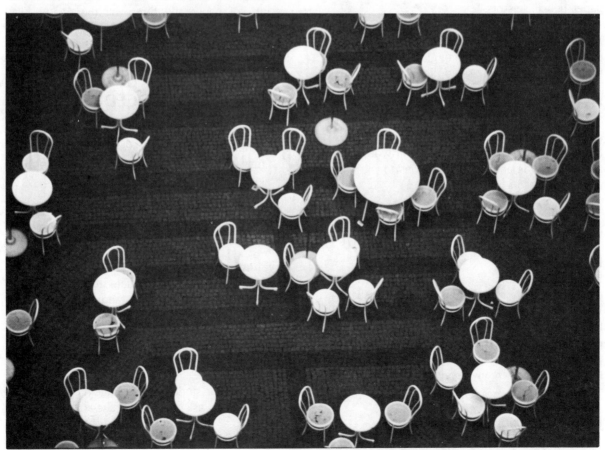

This photograph is from page 1 of the student book.

1

Lesson 1

Seeing Like an Artist pages 2-3

LEARNING OBJECTIVES

Understanding Art
Students will recognize colors, shapes, and lines in an artwork. Learners will explain that an artwork is made of many small parts contributing to the whole.

Creating Art
Students will follow instructions to manipulate scissors and cut paper correctly.

Appreciating Art
Students will identify art as it appears everywhere.

Vocabulary
magic window, color, shape, line

LESSON PREPARATIONS

Suggested Art Materials
Each student will need: 8½″ x 8½″ white ditto paper, pencil, scissors

Additional Teaching Materials
everyday objects, magnifying glasses, microscope (optional), recorded music (optional)

Planning Ahead
Start a vocabulary chart or set of word cards to assist in review and to encourage students to use the terms learned when discussing artworks. Add the new words and their definitions to the chart after each lesson.

GUIDED TEACHING

Lesson Focus
Introduce the "thumb game" to the students. When they agree with something said, it's thumbs up. When they disagree, it's thumbs down. Now, ask them if they have ever looked very closely at a small part of an object. (A small part of an insect? A small part of a leaf? A small part of a drawing?) Explain that they will start "really seeing" the small parts in a new way.

Focus on Looking and Thinking
• Have on hand leaves, woven fabric, and any other readily available objects for students to observe through magnifying glasses. Let the learner focus in on a part of the whole object.
• Discussion questions:
 1. What small pieces make up the whole stained glass window by Frank Lloyd Wright?
 2. What small pieces make up a tree?
 3. How many things can you think of that would be really interesting to look at very closely?

Focus on Making Art
• As the students complete step one, point out that they are really just folding the paper twice.

• As the students complete step two, point out that the corner to fold up is the corner with no open edges. As the students fold up the triangles, encourage them to use one hand to hold the triangle and the other hand to cut it off.

• Emphasize that the magic window is a very special art finder. Make the activity fun by referring to your students as art detectives.

• Discuss the colors, lines, and shapes the students are able to isolate.

• The viewfinders will come in handy all year. Collect them and save them for another project.

• Cleanup: Have the students check the floor for scraps of paper and throw all the scraps away. Remind the students to store the scissors in a safe place.

EVALUATING PROCEDURES

Learning Outcomes
1. What small parts did you see through your magic window?
2. Did you make a magic window that works?
3. Think about using your magic window as you walk or ride home from school today. What would you like to see closely?

Evaluation
Use these questions to evaluate students' progress:
1. Did students show understanding of the vocabulary during oral discussions?
2. Did the students follow the steps in *Making Art*?
3. Did students criticize artworks by applying art concepts presented?

Encourage the students to evaluate their own work. Students can ask themselves the following questions:
1. Did I follow each step in *Making Art*?

2. What parts of my work do I like?

3. What parts of my work can I improve upon?

LEARNING ENRICHMENT

Lesson Variation
You can make an adjustable viewfinder out of paper or cardboard. Cut out two pieces of paper or cardboard shaped like this.

You can change the size and shape of this viewfinder.

Art Across the Curriculum
Science: Let interested students look closely at an object under a microscope. Have them try to draw what they see. Encourage the students to write about their findings and share them with classmates.

Music and Art
Have the students listen to a musical composition. See if they can hear the small parts or instruments that make up the whole piece.

Lesson 2

Lines Are All Around Us! pages 4-5

LEARNING OBJECTIVES

Understanding Art
Students will recognize a line. Learners will remember that parts and details make up a whole.

Creating Art
Students will draw many different kinds of lines.

Appreciating Art
Students will describe lines in everyday objects.

Vocabulary
line, details

LESSON PREPARATIONS

Suggested Art Materials
Each student will need: pencil, two pieces of white drawing paper

Additional Teaching Materials
students' viewfinders, colored pencils (optional), recorded music (optional)

Planning Ahead
Add the new vocabulary words and their definitions to the vocabulary chart.

GUIDED TEACHING

Lesson Focus
Ask the students to put their imaginary fingerpoint pens in the air and draw as many different kinds of lines as they can. Let them know they will be using a variety of lines to draw today.

Focus on Looking and Thinking
• Have the students identify lines in the classroom. Have them identify lines in nature.

• Distribute the viewfinders, and have the students find different kinds of lines in the artworks throughout the text.

• Discussion questions:
 1. How many kinds of lines do you see in the picture on page 5?
 2. What other types of lines would you add to the box on page 4?
 3. What happens when lines are joined together?

Focus on Making Art
• As the students work to complete step two, circulate among them. Make sure their designs are filling the pages.

• As the students begin step three, you may want to distribute colored pencils. These will add interest to the designs.

• Cleanup: Have the students put away their pencils and tidy up their work areas.

EVALUATING PROCEDURES

Learning Outcomes
1. How many kinds of lines can you name?

2. Does your line picture include many different kinds of lines?

3. Can you see lines all around you?

Evaluation

Use these questions to evaluate students' progress:

1. Did students show understanding of the vocabulary during oral discussions?

2. Did the students follow the steps in *Making Art*?

3. Did students criticize artworks by applying art concepts presented?

Encourage the students to evaluate their own work. Students can ask themselves the following questions:

1. Did I follow each step in *Making Art*?

2. What parts of my work do I like?

3. What parts of my work can I improve upon?

LEARNING ENRICHMENT

Music and Art

As the students are completing this activity, play some music. See if their lines reflect the mood of the music. Talk about the relationship between mood and line. This is an especially good lead-in for Lesson 3.

Creative Movement

Students can be orchestra directors by making lines in space with their hands and fingers while music is playing. Encourage them to use their whole bodies.

Lesson 3

The Lines in Your Name pages 6-7

LEARNING OBJECTIVES

Understanding Art

Students will recognize the connection between feelings and art. Learners will link line quality and colors to mood.

Creating Art

Students will gain manual dexterity by manipulating yarn. Students will plan use of space by filling in a whole surface.

Appreciating Art

Students will describe the Mexican nearika craft.

Vocabulary

nearika, line

LESSON PREPARATIONS

Suggested Art Materials

Each student will need: 5" x 7" paper of any kind for idea sketches, sharp pencils, 5" x 7" heavy cardboard, bottled glue (or glue plus cotton swabs, if short on bottles), yarn in bright colors, scissors

Additional Teaching Materials

paper towels, coffee cans with plastic lids

Planning Ahead

• This activity will take three 30-minute sessions to complete.

• Roll each color of yarn into a large ball, and place the ball in a coffee can. Cut a small hole in the plastic lid for easy dispensing.

Helpful Hints

Set up a yarn table. Students can get the yarn they need from the coffee cans and cut it at the table. All other materials should be at the students' work areas.

GUIDED TEACHING

Lesson Focus

Explain to the students that they will be using lines and the shapes of the letters in their names to create art. Direct them to think about the different letter shapes in their names. Have the students spell out their first names using their bodies. Then work through the whole alphabet using their bodies. Remind the students to *feel* the letters as they move.

Focus on Looking and Thinking

• Focus the students' attention on the Ed Ruscha piece on page 6. Ask several students to write their names on the board. Discuss the use of line.

• Tell the students more about the nearika on page 7. It is done in the style used by the Mexican Indian tribe called the Huichols. These Mexican artworks required a warm climate. Beeswax was applied to wood, and then yarn was pressed into the wax. The wax would only be malleable when warm. Stress that climate and availability of materials often influenced the types of art that ancient civilizations produced.

• Discussion questions:

1. How do you feel about *Annie* as you look at her name?

2. How did the artist use the whole space in the work of art on page 7?

3. Have you ever seen a painting made of yarn before? What do you like about this type of artwork?

4. How do the colors in the nearika on page 7 make you feel?

Focus on Making Art

• Point out the variety of possibilities in step one. Let the students think aloud about the lines in their names.

• As students work on step two, encourage experimentation. Let the students try many solutions. Remind them that the letters must be very wide. They can draw lines around the letters to widen them. When students begin transferring the designs to the cardboard, point out that they can use a sharp pencil to press the design through the paper onto the cardboard.

• As the students begin step four, instruct them to work on small areas, rather than the whole design. They should start in the center of a shape and work outward. As the students press the yarn into place, have handy plenty of paper towels for sticky fingers.

• Cleanup: Students should pick up and throw away any scraps of yarn too small to use. They should save the long pieces of leftover yarn. Instruct the students to put these pieces back into the appropriate coffee cans. Ask the students to clean off the tops of the glue bottles before closing them tightly and storing them.

EVALUATING PROCEDURES

Learning Outcomes

1. What is a nearika?

2. Did you fill the whole space of your design with yarn?

3. Did you enjoy using yarn to create a work of art? Why or why not?

Evaluation

Use these questions to evaluate students' progress:

1. Did students show understanding of the vocabulary during oral discussions?

2. Did the students follow the steps in *Making Art*?

3. Did students criticize artworks by applying art concepts presented?

Encourage the students to evaluate their own work. Students can ask themselves the following questions:

1. Did I follow each step in *Making Art*?

2. What parts of my work do I like?

3. What parts of my work can I improve upon?

LEARNING ENRICHMENT

Art Across the Curriculum

Social Studies: Have the students pretend their nearika designs are to be made into a billboard or a neon sign in the community. What would their names advertise? (a shop, a play or movie, a restaurant, etc.)

Mathematics: Make an alphabet chart with a number corresponding to each letter. Have the children add up the total of each name to see what it is worth. Make the numbers on the chart appropriate for the level of your students.

Bulletin Board Displays

Use the students' nearika name plates as a border for a bulletin board. They make a nice frame for other student art.

Lesson 4

Can You Feel It? **pages 8-9**

LEARNING OBJECTIVES

Understanding Art

Students will identify the element of texture and predict how a texture feels before touching it. Learners will explain what a mold is.

Creating Art

Students will mold clay in the hands and use tools to create texture.

Appreciating Art

Students will explain the importance of ancient art to our understanding of the past. Learners will demonstrate the ability to work with their hands.

Vocabulary

texture, mold, sculpture

LESSON PREPARATIONS

Suggested Art Materials

Each student will need: clay (any kind will work), tools for making lines in clay (scissors, paper clips, pencils, popsicle sticks, marbles, etc.)

Additional Teaching Materials

opaque bag, textured objects with which students are familiar, cardboard squares, rolling pin (optional)

Planning Ahead

• Cover the students' work areas with paper, or place a cardboard square at each desk.

• Divide the clay into approximately 3″ squares.

Helpful Hints

Discuss the fact that some of the tools normally used in one way can be used in other ways, too. For example, scissors can be used to create texture as well as to cut.

Safety Precautions

Warn the students that some of the tools being used are sharp. They should make their texturing motions *away* from the body and remember to store the sharp objects in safe places.

GUIDED TEACHING

Lesson Focus

Have each student turn to his or her neighbor and tell what art activities they have done so far using lines. Tell the students they will be making lines in clay for this lesson. Can they figure out how to do this?

Focus on Looking and Thinking

• Have available a bag filled with textured objects. Let the learners feel the objects in the bag and describe how they feel. Pull other objects out of the bag and have the learners imagine how the textures feel before touching the objects.

• Discuss *real texture*, which you can feel, and *represented texture*, which only looks like texture.

• You may want to discuss how important Zeus was to the Greek people. This will impress upon the students the importance of art as a recorder of events.

• Discussion questions:

1. Why is the statuette of Zeus special for us to see?

2. (Choose a student who is wearing an outfit that includes gathers or pleats. Have the student stand in front of the class.) Can you see textures like the ones in these clothes in the statuette of Zeus?

3. Have you ever worked with clay? What is it like in your hands?

Focus on Making Art

• Have the students work with their clay on cardboard or paper.

• As the students complete step three, ask them if they can identify the lines of their palms on the clay.

• Allow the students to discover on their own different kinds of tools to use for texturing the clay.

• Provide the opportunity for the students to feel the textures created by other students. Display the pieces on a table covered with cardboard. Make sure the children are gentle when handling others' work.

• Identify the artworks created as useful. They can be used as paperweights.

• Cleanup: Ask the students to wash their hands. Collect the cardboard table covers and put them away for future clay projects.

EVALUATING PROCEDURES

Learning Outcomes

1. What did you use as a mold for your clay?

2. How did you create the textures?

3. How did it feel to work the clay with your hands?

Evaluation

Use these questions to evaluate students' progress:

1. Did students show understanding of the vocabulary during oral discussions?

2. Did the students follow the steps in *Making Art*?

3. Did students criticize artworks by applying art concepts presented?

Encourage the students to evaluate their own work. Students can ask themselves the following questions:

1. Did I follow each step in *Making Art*?

2. What parts of my work do I like?

3. What parts of my work can I improve upon?

LEARNING ENRICHMENT

Lesson Variation

Have the students make class texture tiles. Each student can create a tile approximately 3″ x 3″. Use a rolling pin and a 1″ board on each side to cut the clay into squares prior to the lesson. Each learner can then experiment with textures on the tile. The tiles can be assembled after they dry and/or are fired.

Art Across the Curriculum

Language Arts: Let interested students write stories about "The Clay Blob That Came Alive." Encourage

the students to use the viewpoint of actually being the clay.

Health/Nutrition: Have the students think about the textures of different foods. They can make a collage of pictures of foods, or they can compare real foods.

Lesson 5

Seeing with Your Fingers pages 10-11

LEARNING OBJECTIVES

Understanding Art
Students will state that rubbings show texture.

Creating Art
Students will successfully complete several rubbings.

Appreciating Art
Students will differentiate among the ways things feel.

Vocabulary
rubbing, texture

LESSON PREPARATIONS

Suggested Art Materials
Each student will need: a variety of small textured objects; newsprint; white construction paper; pencil, crayon, or charcoal pencil

Additional Teaching Materials
printing ink (optional), brayer (optional), fish (optional)

Planning Ahead
Set up a table for the textured items you have on hand. Leave room for the students' finds.

GUIDED TEACHING

Lesson Focus
Tell the students that they will be "texture detectives" today. They will be taking a nature walk to seek out textured objects. See how many objects they can predict seeing on the walk. List them on the board.

Focus on Looking and Thinking
• Take the students on the detective nature walk. (A walk along city streets could also yield many textures.) You may want to have the students bring along pencil or crayon and paper to experiment with rubbings. Where possible without harming natural objects, allow the students to bring back to the classroom some examples of textured objects. Discuss with your students the many textures they found. Compare their predictions in the *Lesson Focus* to what they really found.

• Reinforce the concept of real texture vs. represented texture by asking the students to try to recreate the textures they found on the walk. They can only draw the textures, not make rubbings of them. This exercise will also show the students the value of the art of rubbing.

• Discussion questions:
 1. Does the rubbing of the fish (page 10) look real?
 2. Which textures do you like to feel?
 3. Which textures would show up best on a rubbing?

Focus on Making Art
• Discuss the student art on page 11. Let students tell what they like best about the art.

• Have a wide variety of textured objects for students to choose from.

• Demonstrate the second step. Students need to be shown what is meant by smooth, even strokes. Instruct the students to be careful not to let the paper move as they work.

• You may want to have students incorporate represented texture into their compositions. Two sections of their papers could be actual rubbings; the other two sections could then be representational drawings of the same objects.

• Cleanup: Collect all drawing materials. Ask the students to return all the textured objects to the texture table.

EVALUATING PROCEDURES

Learning Outcomes
1. What does a rubbing show?
2. Do your rubbings look like the objects they show?
3. Why is texture important to the artist?

Evaluation
Use these questions to evaluate students' progress:
1. Did students show understanding of the vocabulary during oral discussions?
2. Did the students follow the steps in *Making Art*?

3. Did students criticize artworks by applying art concepts presented?

Encourage the students to evaluate their own work. Students can ask themselves the following questions:

1. Did I follow each step in *Making Art*?
2. What parts of my work do I like?
3. What parts of my work can I improve upon?

LEARNING ENRICHMENT

Lesson Variations
Texture can also be realized by making a print of something textured. A fish is one example. Use a brayer to apply printing ink to the fish. Have students put paper over the inked fish and gently smooth the surface with their hands. Remove the paper carefully. A beautiful print is made.

Art in the Environment
Have students do rubbings at home. They should choose objects from the home environment that will work well.

Thinking Critically
Have the students imagine living in the world if they had no sight. What would it be like? Ask them to share their thoughts with the class or write their ideas down. See if the students discover the importance of texture and a heightened sense of touch to the blind.

Planning for Tomorrow's Lesson
Send a note home with the students, requesting assistance in supplying fabric scraps for Lesson 6.

Lesson 6

Feeling with Your Eyes pages 12-13

LEARNING OBJECTIVES

Understanding Art
Students will explain what a collage is. Learners will define the concepts of unity and rhythm.

Creating Art
Students will create unified designs.

Appreciating Art
Students will discuss the artistic value of juxtaposed textures.

Vocabulary
collage, unity, pattern, rhythm, overlap, texture

LESSON PREPARATIONS

Suggested Art Materials
Each student will need: fabric scraps, 12″ x 18″ heavyweight paper or cardboard, scissors, glue or paste

Additional Teaching Materials
shoe boxes

Planning Ahead
• If you are using cardboard for this lesson, cut it prior to beginning the activity.

• Set up a scrap table. Strew the fabric scraps across the table, and supply shoe boxes or others of comparable size for students to place the scraps in.

GUIDED TEACHING

Lesson Focus
Have the students work together to sort the scraps on the scrap table. Let them decide the categories in which to place the scraps (color, texture, pattern, shape, size, etc.). Ask the students to label the boxes accordingly.

Focus on Looking and Thinking
• Spend some time discussing the concepts of unity and rhythm. Use the scrap table for concrete examples. You might even want to quickly lay out several pieces of fabric to form a collage. Then ask the students if your example shows the two concepts. See if volunteers can improve upon your design.

• Make sure the students realize the value of texture in a collage. Ask them how the collages in the lesson would feel to touch. Ask them how different scraps from the scrap table would feel to touch.

• Discussion questions:
 1. How many ways can you think of to create unity?
 2. How many materials can you think of to use in a collage?
 3. Do you think all the materials in a collage should be of the same kind?
 4. Do you think texture is important in a collage?
 5. In your own words, what does rhythm mean?

Focus on Making Art
• Ask the students what they like or dislike about the student art on page 13.

• Discuss with the students the many different kinds of collages that can be made. Name a category of scraps, and have the students list some examples.

• As the students begin step two, encourage them to experiment as much as they want to. Monitor the students to make sure they are using the whole page and not just one small area. Demonstrate how to overlap pieces.

• As the students begin step three, remind them that using too much glue will cause it to show through the fabric.

• When the collages are complete, open up the class for discussion. Discuss textures used by the students. Demonstrate the quality of several textures by unraveling the edges of some of the fabric pieces. Also let students show and tell how they created unity and rhythm.

• Cleanup: Ask the students to store the scissors in a safe place. Have them check the floor for scraps and throw away any that are too small to use. Remind the students to clean off the glue bottle tops and tighten them before storing the bottles in a safe place.

EVALUATING PROCEDURES

Learning Outcomes
1. What is a collage? What things does a collage show?
2. Did you create a collage that shows unity?
3. What do you like about artworks that have different textures?

Evaluation
Use these questions to evaluate students' progress:
1. Did students show understanding of the vocabulary during oral discussions?
2. Did the students follow the steps in *Making Art*?
3. Did students criticize artworks by applying art concepts presented?

Encourage the students to evaluate their own work. Students can ask themselves the following questions:
1. Did I follow each step in *Making Art*?
2. What parts of my work do I like?
3. What parts of my work can I improve upon?

LEARNING ENRICHMENT

Lesson Variations
Let interested students make other collages from other materials.

Puppetry
Have students "dress" stick puppets made from popsicle sticks or twigs. The emphasis here should be on designing clothes that use many textures. Ask the students to tell why a particular puppet character should wear a particular type of fabric. (Should mean characters wear rough clothes? Should sweet characters wear silks? Why?)

Lesson 7

Shapes Fit Together pages 14-15

LEARNING OBJECTIVES

Understanding Art
Students will recognize and name basic geometric shapes. Learners will identify unity in artworks.

Creating Art
Students will fit shapes together in a unified way. Learners will use chalk in a variety of ways.

Appreciating Art
Students will see shapes in the world.

Vocabulary
shape, line, unity, pattern

LESSON PREPARATIONS

Suggested Art Materials
Each student will need: 8½" x 11" newsprint, 8½" x 11" white drawing paper, pencil, many pieces and colors of chalk

Additional Teaching Materials
paper towels, newspaper, jigsaw puzzles, tissues, fixative or hair spray, construction paper (optional), crayons (optional), paint shirts (optional)

Planning Ahead
Cover the students' work areas with newspaper. You may also want the students to wear paint shirts for this project.

GUIDED TEACHING

Lesson Focus
See if the students can name the elements of art learned so far (line, texture). Tell them that today they will learn a third element: shape. Send them on a "shape search" around the classroom. See who

can find the most shapes in the classroom environment.

Focus on Looking and Thinking
• Point out to the students that the visuals in this lesson are like puzzles. The shapes all fit together. Display an actual jigsaw puzzle to help emphasize this point. All the pieces go together to make the whole.

• Discussion questions:
1. How are Kandinsky's and Mondrian's works like puzzles?
2. How did each artist create unity?
3. How do you feel about the colors that each artist used?

Focus on Making Art
• Encourage the students to experiment with shapes they may never have seen before.

• Point out that the students are creating artworks that are like puzzles. They are creatively dividing the whole sheets of paper into small shapes that fit together.

• Remind the students to use paper towels to wipe their hands before touching their clothes and faces.

• Students can create a softer effect by smearing the chalk of individual shapes with a piece of tissue.

• An adult should spray the finished artworks with fixative or hair spray to keep the chalk from smearing. Be sure this is done in a well-ventilated area.

• Cleanup: Collect and put away the chalk. Ask the students to check the floor and work areas for scrap pieces of tissue, paper towels, or newspaper to be thrown away. Have the students wash their hands.

EVALUATING PROCEDURES

Learning Outcomes
1. What shapes fit together well?
2. Does your artwork have unity? Why or why not?
3. Did you like using chalk to create an artwork?

Evaluation
Use these questions to evaluate students' progress:
1. Did students show understanding of the vocabulary during oral discussions?
2. Did the students follow the steps in *Making Art*?
3. Did students criticize artworks by applying art concepts presented?

Encourage the students to evaluate their own work. Students can ask themselves the following questions:

1. Did I follow each step in *Making Art*?
2. What parts of my work do I like?
3. What parts of my work can I improve upon?

LEARNING ENRICHMENT

Lesson Variations
Have the students create actual puzzles. A student can cut a piece of construction paper into shapes and then ask a classmate to put it back together. The students could also use crayons to color shapes on a page and then cut the shapes apart.

Art Across the Curriculum
The concept of a puzzle made of many pieces is one that can be applied to many subject areas. For example, students could create puzzles of multiplication facts, synonyms, parts of the body, or any other concepts to be reinforced.

Planning for Tomorrow's Lesson
Have the students collect boxes, milk cartons, paper cups, bottle caps, cardboard tubes, and other three-dimensional objects to use in Lesson 8.

Lesson 8

Seeing Forms in Buildings pages 16-17

LEARNING OBJECTIVES

Understanding Art
Students will state what makes forms three-dimensional.

Creating Art
Students will work with three-dimensional forms to create and decorate model buildings.

Appreciating Art
Students will recognize three-dimensional forms in buildings and in the natural world. Learners will identify the use of everyday objects in the creation of art.

Vocabulary
form, three-dimensional, model, shape, decorate

LESSON PREPARATIONS

Suggested Art Materials
Each student will need: a large variety of three-

dimensional objects (boxes, cardboard tubes, paper cups, bottle caps, etc.), a variety of materials for surface decorations (paints, crayons, markers, etc.), tape, glue, scissors

Additional Teaching Materials
pictures of buildings, rulers, square piece of paper, square box

Planning Ahead
Have students collect three-dimensional objects for at least one week prior to the lesson. Set up a table for the collection. Students may also bring in photographs of buildings.

GUIDED TEACHING

Lesson Focus
Hold up a square piece of paper. Then hold up a square box. See if the students can explain how the two are different.

Focus on Looking and Thinking
• Have on hand examples of as many of the three-dimensional forms as possible. See if volunteers can use their rulers to prove that the objects are three-dimensional. Identify the three dimensions as *height, width*, and *depth*.

• Have the students work in pairs to find three-dimensional forms in the photographs of buildings. Point out that unity occurs in buildings, too, when repeated forms are used.

• Discussion questions:
 1. What does *three-dimensional* mean?
 2. Do you see many of the same forms repeated around you?
 3. Where do you see three-dimensional forms in nature?
 4. What do you like about the student's artwork on page 17? What would you have done differently?

Focus on Making Art
• As students begin step one, encourage them to closely examine all of the objects available before beginning the project. They should be imaginative thinkers.

• As the students begin joining together their objects, point out that they can cut slits, make tabs, or cut away parts of the objects to make them fit together better.

• Encourage the students to move the objects around a great deal before actually joining them together.

• The students will have to experiment with the application of color. Paint may not adhere to wax cartons, so crayons will have to be used. Nevertheless, the students should be encouraged to add lots of decoration to their models.

• Set aside an area in the room where all the buildings can be placed together to make a community.

• Cleanup: Collect and put away all of the art materials. Ask the students to check the floor and throw away the scraps too small to be used.

EVALUATING PROCEDURES

Learning Outcomes
1. Is your building three-dimensional? How do you know that?
2. Did you use a variety of forms to create your building?
3. Would you like to live in a building like the one you made?

Evaluation
Use these questions to evaluate students' progress:
1. Did students show understanding of the vocabulary during oral discussions?
2. Did the students follow the steps in *Making Art*?
3. Did students criticize artworks by applying art concepts presented?

Encourage the students to evaluate their own work. Students can ask themselves the following questions:
1. Did I follow each step in *Making Art*?
2. What parts of my work do I like?
3. What parts of my work can I improve upon?

LEARNING ENRICHMENT

Art in the Environment
Students may want to study specific buildings in the community. Encourage them to do research to find out who the architect and builders were. They can also draw or take photographs of the buildings. Then each student can compile an illustrated report telling about the building's history.

Lesson Variations
Place all the buildings together to form a community. Then ask the students what details of the community are missing (roads, streetlights, road signs, sidewalks, etc.). Work as a class to make the community complete.

Lesson 9

The Highs and Lows of Printing

LEARNING OBJECTIVES

Understanding Art
Students will describe the printing process.

Creating Art
Students will create printing blocks and use them effectively to make original prints.

Appreciating Art
Students will recognize a clear print.

Vocabulary
print, cube

LESSON PREPARATIONS

Suggested Art Materials
Each student will need: a piece of clay approximately 3″ x 3″, 3 or 4 colors of paint, paint trays, brushes, construction paper, a variety of interesting objects

Additional Teaching Materials
paper towels, newspaper, stamp pads, rubber stamps, markers with fine tips (optional)

GUIDED TEACHING

Lesson Focus
Demonstrate how to use a stamp and a stamp pad. Have volunteers come to the front of the room, examine the stamp, and try to figure out how it works.

Focus on Looking and Thinking
• Let the students experiment with stamps and stamp pads. Show them the difference between a clear stamp print and an unclear stamp print. Point out that you must hold the stamp very still as you make the print. You also must put ink evenly across its printing surface.

• Focus the students' attention on the raised parts of the stamps. Show them that ink does not even get on the indented parts. Therefore, they cannot show up in a print.

• Discussion questions:
 1. How many things in our room have been printed? How can you tell?
 2. What do you like about the prints in this lesson?
 3. Can you see where the paint or ink does not touch the paper at all in the works of art in this lesson? Why is that so?

Focus on Making Art
• As the students begin step two, make sure they are focusing on the shapes *around* the objects pressed into the clay. These are the shapes that will show up in the print.

• As the students complete step two, point out that the surface making the print must be completely flat. Have the students gently press this surface against the table.

• Demonstrate for the students how to completely cover the printing surface with paint.

• Demonstrate *gently* pressing the cube against the paper.

• Tell the students to take time to carefully think about where each print will go. Will they create a certain pattern with the prints?

• Cleanup: Place the prints in a safe place to dry. Collect and wash the indentation objects. Clean the paint containers and brushes, and store them. Put unused clay away. Put the printing blocks in a safe place to dry. Students may want to take them home, too.

EVALUATING PROCEDURES

Learning Outcomes
1. What is a print?
2. Are your block prints clear?
3. Which is the best print that you made?

Evaluation
Use these questions to evaluate students' progress:
1. Did students show understanding of the vocabulary during oral discussions?
2. Did the students follow the steps in *Making Art*?
3. Did students criticize artworks by applying art concepts presented?

Encourage the students to evaluate their own work. Students can ask themselves the following questions:
1. Did I follow each step in *Making Art*?
2. What parts of my work do I like?
3. What parts of my work can I improve upon?

LEARNING ENRICHMENT

Lesson Variations

• Students can make fingerprint characters by putting their fingers on a paint stamp pad and pressing them onto paper. They can decorate the characters using markers with fine tips. Then they can write stories based on the characters.

• Advanced students may want to make a storyboard for a commercial using fingerprint characters.

Lesson 10

Seeing Colors in the World pages 20-21

LEARNING OBJECTIVES

Understanding Art
Students will name and recognize the primary colors. Learners will state that blending the primary colors creates new colors.

Creating Art
Students will use primary colors of tissue paper to create stained-glass window designs.

Appreciating Art
Students will begin to differentiate among colors in the world.

Vocabulary
color, primary colors, overlap

LESSON PREPARATIONS

Suggested Art Materials
Each student will need: 6″ x 11″ waxed paper, several sheets of tissue paper (red, yellow, blue), liquid starch, dish, brush

Additional Teaching Materials
food coloring (red, yellow, blue), 3 large glass bowls, overhead projector, clear acetate overlay, cotton swabs, transparent plastic wrapping paper (red, yellow, blue), crayons (optional), iron (optional), paint (optional), construction paper (optional), stapler (optional)

GUIDED TEACHING

Lesson Focus
Fill three large glass bowls with water. Use food coloring to color the water red, yellow, and blue. Ask the students to name the colors. Have them identify the colors wherever they are found in the room.

Focus on Looking and Thinking
• After you have discussed Looking and Thinking, page 20, demonstrate what is meant by the last sentence. Lay a piece of clear acetate on the overhead projector, and turn on the light. Use cotton swabs to mix the different colors of water together on the transparency. Lead the students to explain what happens. You can achieve the same effect by overlapping red, yellow, and blue transparent plastic wrapping paper.

• Discussion questions:
 1. What do we call the colors with which we started?
 2. What colors did we make from the primary colors?
 3. Which colors on the screen are your favorites? Why?
 4. Why are the primary colors important?

Focus on Making Art
• Point out that cut tissue paper will create a different effect than if the paper is torn. Torn edges will leave a softer effect. Then let the learners decide which way they would prefer to proceed.

• Encourage the students to use plenty of starch. If enough starch is applied, the tissue paper design will be sturdy enough to support itself. However, if this does not happen, you can always tape the design right to the waxed paper.

• When the artworks are dry, you can have the students frame them. Strips of construction paper (primary colors, about 2″ wide) stapled to the top and bottom of each artwork add an attractive finishing touch.

• Have the students hold their designs up to a light source. Have them identify all the colors they see. Point out that a window would be a good place to display the artworks.

• Cleanup: Have the students pick up and discard scraps of tissue paper too small to use. Clean the brushes and dishes, and store them and the starch.

EVALUATING PROCEDURES

Learning Outcomes
1. How many colors do you see in your artwork?
2. Did you overlap your tissue pieces in interesting ways?

3. Why does your artwork look nicest when light shines through it?

Evaluation
Use these questions to evaluate students' progress:
1. Did students show understanding of the vocabulary during oral discussions?
2. Did the students follow the steps in *Making Art*?
3. Did students criticize artworks by applying art concepts presented?

Encourage the students to evaluate their own work. Students can ask themselves the following questions:
1. Did I follow each step in *Making Art*?
2. What parts of my work do I like?
3. What parts of my work can I improve upon?

LEARNING ENRICHMENT

Lesson Variations
• Advanced students might enjoy doing a design using chips of red, yellow, and blue crayons that are ironed between two sheets of waxed paper. The melted effect is very interesting.

• Special education students can make secondary colors by creating handprints. First, one hand is painted blue. The other hand is painted yellow. The painted hands are placed on paper one at a time. Then, the hands are painted again. This time, they are rubbed together and placed on paper at the same time. The prints are green. Do the same for other combinations of the primary colors.

Art Across the Curriculum
Science: Let interested students research color and the way the eyes work to see color. They can share their findings with the class.

Lesson 11

| More Colors in the World | pages 22-23 |

LEARNING OBJECTIVES

Understanding Art
Students will describe and use the color wheel. Learners will identify primary and secondary colors.

Creating Art
Students will create colorful crayon drawings using primary and secondary colors.

Appreciating Art
Students will describe the many colors in the world.

Vocabulary
color wheel, secondary colors, title, primary colors

LESSON PREPARATIONS

Suggested Art Materials
Each student will need: drawing paper, crayons, writing paper

Additional Teaching Materials
recorded music (optional), brightly colored fruits and vegetables (optional)

GUIDED TEACHING

Lesson Focus
Make sure each child has red, yellow, blue, orange, green, and violet crayons. Then ask the students to arrange the crayons like the spokes of a wheel. They should put the colors where they think they look best.

Focus on Looking and Thinking
• Have the students carefully study the color wheel on page 22. See if any of the students arranged their crayons like the color wheel.

• Make sure the students can name the secondary and primary colors.

• Point out that the color wheel could be greatly expanded to include colors like blue-green, yellow-green, red-orange, etc.

• Discussion questions:
 1. Why do you think red, yellow, and blue are called *primary* colors?
 2. Why do you think orange, violet, and green are called *secondary* colors?
 3. Do you have another name for the color the text labels *violet*?

Focus on Making Art
• You may want to set up a colorful still life for those students who can't remember a colorful scene. Fruits and vegetables have rich colors.

• Stress the concepts of unity and of filling the whole space as the students work.

• Encourage experimentation with different crayon techniques.

• If the students are asked to orally share their titles, they may make more of an effort to be creative.

• Cleanup: Ask the students to store the crayons where they belong.

EVALUATING PROCEDURES

Learning Outcomes
1. What primary and secondary colors did you use in your drawing?
2. Does your drawing look colorful?
3. How do bright colors make you feel?

Evaluation
Use these questions to evaluate students' progress:
1. Did students show understanding of the vocabulary during oral discussions?
2. Did the students follow the steps in *Making Art*?
3. Did students criticize artworks by applying art concepts presented?

Encourage the students to evaluate their own work. Students can ask themselves the following questions:
1. Did I follow each step in *Making Art*?
2. What parts of my work do I like?
3. What parts of my work can I improve upon?

LEARNING ENRICHMENT

Lesson Variation
Play recorded music as the students draw with crayons. Ask them to draw with the colors they feel fit the mood of the music.

Art Across the Curriculum
Health/Nutrition: Ask interested students to think about the colors of the foods we eat. Have them make two lists: one of foods that have primary colors and one of the foods that have secondary colors. Lead them to conclude what colors of food we eat the most.

Lesson 12

Seeing Light in the World pages 24-25

LEARNING OBJECTIVES

Understanding Art
Students will recognize tints in artworks. Learners will explain the concept of value.

Creating Art
Students will experiment with creating tints. Learners will arrange tints by value.

Appreciating Art
Students will state how artists portray light in their works.

Vocabulary
tint, value

LESSON PREPARATIONS

Suggested Art Materials
Each student will need: tempera paint (white, plus one other color), paintbrush (sponge brushes work well), index card (unlined)

Additional Teaching Materials
newspaper, mixing trays (optional), tape, waxed paper (optional), 5" x 7" cardboard (optional), paint sample chips, pins, stapler, construction paper (optional), scissors (optional), markers (optional)

Helpful Hints
You may want to make reuseable palettes for paints by stapling 15 to 20 pieces of waxed paper to a 5" x 7" piece of cardboard. After each painting project, just have the students tear the top sheet of waxed paper off each of their palettes.

GUIDED TEACHING

Lesson Focus
Ask the students where pink should appear on a color wheel. After they have made suggestions, explain that pink is really red mixed with white. Is white on the color wheel?

Focus on Looking and Thinking
• Have available paint sample chips from a paint store. Usually these samples will be grouped by tints. Ask the learners to compare and contrast the colors.

• Focus the students' attention on the colors around the classroom. Can the students find examples of tints?

• Talk about the Bingham painting and the way it shows light. Identify the painting as an example of the style called Luminism.

• Discussion questions:
 1. Does light change the way colors look? How?
 2. Do you like tints better than bright colors? Why or why not?
 3. How does Bingham's painting make you feel?

Focus on Making Art
• The students will need some instructions about painting, since this is their first painting lesson.

1. Suggest that the students try using their paintbrushes in a variety of ways: make thin lines with the point, make fat lines with the sides, make swirls and blobs, etc.

2. Point out that the paint should be on the hairs of the brush, not all the way up to the wooden handle.

3. Explain that before the students change from one color of paint to another they should clean the brushes in water and dry them by blotting.

• Let the students have a lot of time to experiment in step one. Supervise them so that only very small amounts of paint are used.

• When the students are painting the index cards, instruct them to paint in only one direction. Make sure that the index cards are on newspaper.

• Cleanup: Have the students or your art monitors clean, dry, and put away the brushes. Have the students clean their work areas, throwing away the newspapers and any scraps.

EVALUATING PROCEDURES

Learning Outcomes

1. How do you create a tint?

2. Did your group arrange your cards correctly by value?

3. Does the class rainbow look like any rainbow you've ever seen?

Evaluation

Use these questions to evaluate students' progress:

1. Did students show understanding of the vocabulary during oral discussions?

2. Did the students follow the steps in *Making Art*?

3. Did students criticize artworks by applying art concepts presented?

Encourage the students to evaluate their own work. Students can ask themselves the following questions:

1. Did I follow each step in *Making Art*?

2. What parts of my work do I like?

3. What parts of my work can I improve upon?

LEARNING ENRICHMENT

Art Across the Curriculum

Language Arts: Have the students write poems or stories about rainbows. A rainbow is a magical phenomenon that most children find enchanting, so creativity should be natural.

Bulletin Board Display

Staple or pin the class rainbow to a bulletin board.

Then ask interested students to create a pot of gold for the rainbow. Construction paper, scissors, and markers can be used with good results.

Lesson 13

Colors Can Be Dark pages 26-27

LEARNING OBJECTIVES

Understanding Art
Students will explain how to create shades. Learners will identify shades in a work of art.

Creating Art
Students will create paintings based on the use of shades.

Appreciating Art
Students will evaluate scenes in terms of whether they could best be portrayed with tints or with shades.

Vocabulary
photograph, photographer, shade, tint

LESSON PREPARATIONS

Suggested Art Materials
Each student will need: drawing paper, blue and black tempera paint, paintbrush, palette

Additional Teaching Materials
newspaper, pictures of night skies, paint chip samples, recorded sounds or music

GUIDED TEACHING

Lesson Focus
Have the students select those paint chips which they feel are tints. Ask them what they think the other colors might be.

Focus on Looking and Thinking
• Have the students make a class tint and shade painting. Have one child paint a line of blue horizontally across the center of a piece of paper. Have two other children be the paint mixers. One should mix tints of blue by adding color to white. The other should mix shades of blue by adding black. As each drop is added, a student should paint a line across the page (shades on one side of the center line, tints on the other). In a matter of minutes the painting will

be complete. It should go from light blue all the way down to dark blue.

- Discussion questions:
 1. Do you think El Greco could have painted a stormy scene using tints? Why or why not?
 2. How do the artworks in this lesson make you feel?
 3. How would the picture on page 24 be different if shades had been used instead of tints?

Focus on Making Art

- Experimentation in step two is important for the students, even if they end up with black paint and have to start over.
- Point out as the students begin step three that too much paint on the brush can cause the paper to wrinkle and look messy.
- Use pictures of night skies to give students ideas about what to add to their pictures.
- Cleanup: Have the students place their paintings in safe places to dry. Ask them to tear off the top sheets of waxed paper from their palettes and throw them away. Encourage the students to properly wash, dry, and put away the paintbrushes. Check the floor for spots of paint, and throw away the newspaper.

EVALUATING PROCEDURES

Learning Outcomes

1. How can you show shadows in a painting?
2. Did you have any problems mixing shades?
3. Describe how the colors of your painting create a mood or feeling.

Evaluation

Use these questions to evaluate students' progress:
1. Did students show understanding of the vocabulary during oral discussions?
2. Did the students follow the steps in Making Art?
3. Did students criticize artworks by applying art concepts presented?

Encourage the students to evaluate their own work. Students can ask themselves the following questions:
1. Did I follow each step in Making Art?
2. What parts of my work do I like?
3. What parts of my work can I improve upon?

LEARNING ENRICHMENT

Seasonal Art

This lesson works out well for Halloween. The night sky filled with nocturnal creatures will delight the children. Encourage the students to create artworks that can accompany creative stories or poems about Halloween.

Music and Art

Tapes of storms, night sounds, or "spooky" music played while the students create will add another dimension to this lesson. Students themselves may want to create an appropriate tape.

Lesson 14

Art of the Orient pages 28-29

LEARNING OBJECTIVES

Understanding Art

Students will recognize the characteristics of Oriental art.

Creating Art

Students will use the colors and designs common to Oriental art. Learners will manipulate paper to create folding fans.

Appreciating Art

Students will describe the uniqueness of Oriental art. Learners will explain that art can be used to decorate functional objects.

Vocabulary

Oriental art, primary colors

LESSON PREPARATIONS

Suggested Art Materials

Each student will need: 8″ x 11″ drawing paper, pencil, a variety of thick and thin colorful felt-tip markers

Additional Teaching Materials

newspaper, stapler, examples of Oriental art, a map or globe, green India ink (optional), straws (optional), paint (optional)

GUIDED TEACHING

Lesson Focus

Talk with the students about how it would be to travel to the Far East. What would they see?

Focus on Looking and Thinking

• Have a map or globe available so the students can locate Japan and China.

• Take a pretend trip to Japan. Show pictures, prints, or objects you or the students may have collected.

• Stress that the objects pictured in this lesson are useful as well as beautiful. Focus in on the details of the robe and bowl. The students should understand that Oriental art is sometimes very simple and sometimes very ornamental.

• Discussion questions:
 1. What else can you think of to wave in the air to create breezes?
 2. Have you ever traveled to the Far East? Have you ever eaten with chopsticks?
 3. Why do you think there are so many designs from nature in the art from Japan and China?
 4. What do you like most about Oriental art?

Focus on Making Art

• Demonstrate step one for your students. Point out that the folds should be creased flat. The folding process should not be rushed.

• As the students begin step three, make sure they have their fans on newspaper. The markers will bleed through.

• Supervise the stapling process.

• Cleanup: Collect and put away the markers. Ask the students to throw away the newspaper and any other scraps.

EVALUATING PROCEDURES

Learning Outcomes
1. Why does your fan look like Oriental art?
2. Did you fold your fan correctly?
3. Do you like the colors you used in your designs?

Evaluation
Use these questions to evaluate students' progress:
1. Did students show understanding of the vocabulary during oral discussions?
2. Did the students follow the steps in *Making Art*?
3. Did students criticize artworks by applying art concepts presented?

Encourage the students to evaluate their own work. Students can ask themselves the following questions:
1. Did I follow each step in *Making Art*?
2. What parts of my work do I like?
3. What parts of my work can I improve upon?

LEARNING ENRICHMENT

Careers in Art
Invite a Chinese brush painter to visit your class. Students would enjoy trying to paint using a bamboo brush, an ink stone, and rice paper. If this is impossible, have interested students research what supplies they would find in a Chinese or Japanese art studio.

Art Heritage
Let interested students study the land and culture of peoples from the Far East. They may want to listen to music from these countries, make Chinese opera puppets, or create their own projects according to their interests.

Lesson Variation
Some students may want to make another fan, using a different technique. First, they blow green India ink around the fan with a straw. This creates branches. Then the flowers can be printed with paint applied to the ends of pencil erasers.

Planning for Tomorrow's Lesson
Ask the students to bring in sets of 3-5 objects which are the same size and shape (examples: miniature cars, trucks, dolls, or toy animals).

Lesson 15

Seeing Near and Far pages 30-31

LEARNING OBJECTIVES

Understanding Art
Students will explain how overlapping and size differences show perspective. Learners will recognize which objects in a picture are near and which are far.

Creating Art
Students will use scissors to cut out simple animal shapes. Learners will arrange shapes, using size and overlapping, to show perspective.

Appreciating Art
Students will identify the differences among near and far objects in the environment.

Vocabulary
perspective, overlap

LESSON PREPARATIONS

Suggested Art Materials

Each student will need: pencil, drawing paper, 5 sheets one color construction paper (8½″ x 11″), 5 sheets another color construction paper (8½″ x 5½″), 5 sheets third color construction paper (4½″ x 5½″), scissors, butcher paper (25″ x 50″), glue or paste

Additional Teaching Materials

a variety of objects in sets of three or more, old magazines

Planning Ahead

Cut the construction paper into the sizes suggested. You can choose three colors, or you could cut sheets of all the same color. Using different colors just makes it easier to see the different shapes.

GUIDED TEACHING

Lesson Focus

Have the students leaf through old magazines and cut out pictures that they think show near and far objects. Why do they think these pictures are examples?

Focus on Looking and Thinking

• Discuss the text on page 30 by using the pictures your students chose and the sets of objects they or you brought to class. First, focus their attention on the photograph of trucks (page 30). Then ask them to line up the objects to compare with the photograph. Encourage the students to discuss using size and overlapping to arrange the objects correctly.

• Discuss the visual on page 31. Point out that perspective could have been achieved more successfully if the artist had used size differences.

• Discussion questions:
1. Can you think of things in nature or the man-made environment that show perspective? (mountains, telephone poles, fences, trees)
2. Why would you make or paint objects different sizes?
3. Do the pictures you chose at the beginning of class really show perspective?

Focus on Making Art

• As the students begin drawing their animal shapes, point out that it is the outline or shape of the animal that is important, not details.

• You may want the students to discuss the two clues of size and overlapping with you or a classmate before beginning step four.

• Remind the students to use only small amounts of glue around the edges of the animal shapes so that the paper will not wrinkle.

• Cleanup: Collect and put away the scissors and glue. Have the students check the floor, throwing away any scraps too small to use again.

EVALUATING PROCEDURES

Learning Outcomes

1. What is perspective?
2. Does your completed artwork show perspective? How?
3. Which of your classmates' artworks do you like best? Why?

Evaluation

Use these questions to evaluate students' progress:
1. Did students show understanding of the vocabulary during oral discussions?
2. Did the students follow the steps in *Making Art*?
3. Did students criticize artworks by applying art concepts presented?

Encourage the students to evaluate their own work. Students can ask themselves the following questions:
1. Did I follow each step in *Making Art*?
2. What parts of my work do I like?
3. What parts of my work can I improve upon?

LEARNING ENRICHMENT

Lesson Variation

Your students may want to create other compositions based on perspective. They can experiment with other media such as chalk, paint, or clay.

Creative Movement

Have a small group of students move to show overlapping and size differences. They can keep circulating in a loose formation until they hear a drum beat. Then, they should freeze. A student director can lead a discussion about whether or not the participants are arranged to show perspective. If not, changes in sizes and overlapping should be made.

Unit 1 Extension and Application

EXPLORING ART

Art Careers

The Exploring Art feature for Unit 1 describes the work of one type of artist: the billboard painter. Billboard painting is a type of art to which all students have been exposed; however, they possibly have not labeled billboards as valid art forms. By introducing this as a valuable art career, the Exploring Art activity opens up the students' eyes to all the many parts of their world that are created by artists. They begin to see art as important in their daily lives and to realize that it is not unusual to have a career related to art.

To extend this activity:

• Demonstrate for the students how a grid works. Your chalkboard can be the billboard. Divide it into squares. Prepare a simple design on a grid. Show the students how to transfer one part of the design to the chalkboard. Then have volunteers complete the billboard. Interested students may enjoy creating their own designs, grids, and billboards. (Butcher paper serves well as a billboard.)

• Provide the students with a list of interesting art careers before they begin research. Some suggestions are listed below.

Industrial designer	Fashion designer
Furniture designer	Cartoonist
Ceramicist	Landscape designer
Make-up artist	Floral arranger
Wallpaper designer	Portrait artist
Technical illustrator	Interior designer

• Prepare for an Art Careers Day. The students can tell about all the different careers they have researched. Ask artists from your community to demonstrate techniques or talk about their work.

REVIEW

These answers are suggested responses only.

1. There are straight lines, jagged lines, dotted lines, wavy lines, thick and thin lines. Shapes include squares, rectangles, circles, and triangles.

2. Forms include cubes, slabs, and cylinders.

3. All three primary colors are included in the painting. Secondary colors include orange and green. Tints of blue and red are found in the painting.

4. Texture is not very apparent in the painting. Most of the surfaces seem uniformly smooth.

5. Perspective is achieved by overlapping the buildings and by making the buildings in the background smaller.

6. Different students might select different centers of interest. However, the eye is drawn to the conglomeration of lines portraying the elevated street.

7. Students' answers will vary.

Unit 2

WORKING AS AN ARTIST

The purpose of Unit 2 is to continue involving students in the exploration of visual phenomena. They learn why artworks look as they do, and why artists must consciously make decisions concerning how to go about creating art. Principles of art (balance, unity, emphasis, variety, and rhythm) are explored in more complex ways as the students become increasingly confident using different media and techniques. The emphasis is on working as an artist, since the students are already seeing and responding to the world as artists.

The visuals in the unit opener were chosen because they include combinations of the elements and principles of art. They require more complex reactions and interpretations than some of the earlier pieces. Allow some time for in-depth discussions of these visuals. When discussing the Eastman Johnson painting on page 35, you might want to give some background information. Johnson was apparently quite effective in portraying what he saw. A photograph of the Brown family (these are grandparents and grandson) taken in their parlor near the time of the portrait reveals Johnson's close attention to details and accurate rendering of the scene. Make sure the students understand that realism is only one style of art. Lead them to tell why realistic artworks are especially valuable for the exploration of the "tricks" of artists.

As the students complete this unit, they will need assistance in handling the different media. They should be comfortable with their creativity by now, so you should not allow them to become frustrated over harder tasks. This will only interrupt their growth as artists. The suggestions in the teacher's guide to each lesson are designed for your use should any problems of this nature develop.

This art is from page 35 of the student book.

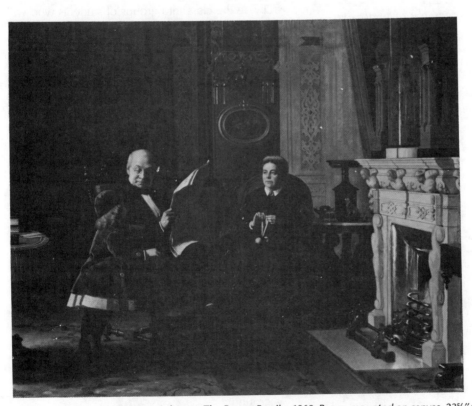

Eastman Johnson, The Brown Family, 1869, Paper, mounted on canvas, 23⅝" x 28½. National Gallery of Art, Washington, Gift of David Edward Finley and Margaret Eustis Finley.

Lesson 16

Seeing Background and Foreground pages 36-37

LEARNING OBJECTIVES

Understanding Art
Students will explain the concepts of background and foreground.

Creating Art
Students will use the technique of blotting.

Appreciating Art
Students will describe the parts of a landscape painting.

Vocabulary
background, foreground, landscape

LESSON PREPARATIONS

Suggested Art Materials
Each student will need: a variety of colors of tempera paint, paintbrush, palette, 8½" x 11" heavy white paper, 8½" x 11" newsprint

Additional Teaching Materials
newspaper, a variety of photographs of landscapes

Planning Ahead
Set up an art center for this project. Cover a large table with newspaper. Then set out containers of paint (including white), paintbrushes, and paper for four or fewer students to use. If possible, have an adult monitor available to assist the students. Have the students work in shifts to complete the project.

Helpful Hints
The visuals in this lesson serve two purposes. They cause students to really look hard to find background and foreground. They also stimulate the students' imaginations as the learners attempt to visualize what should be seen. However, having examples of clear backgrounds and foregrounds on hand will assist students in understanding the concepts. Photographs are good helpers for this, but encourage the students to find good examples on their own. This will confirm for you their grasp of the concepts.

GUIDED TEACHING

Lesson Focus
Ask the students each to recall an outdoor scene which they see every day on the way to school and especially like. Can they remember all the different parts of the scenes?

Focus on Looking and Thinking
• Have the students look through their books to find examples of paintings with clear backgrounds and foregrounds. Then display some photographs. Compare the style of a photograph or a realistic painting to that of Georges Seurat.

• Ask the students to again recall the outdoor scenes they observe daily on the way to school. Can they list the parts in two categories: background and foreground?

• Discussion questions:
 1. Can you see spots of color in Seurat's painting? Can you see shapes of color in Delaunay's painting? How else do the two paintings differ? How are they alike?
 2. Do you ever notice the background before you notice the foreground of a landscape scene?
 3. Do landscape paintings have to show nature? (Have the students turn to page 5 and look at Stuart Davis' painting. Inform them it is called a *cityscape*. It is an outdoor city scene.)

Focus on Making Art
• Divide the class into groups of students who will work together at the art station. The students not at work should continue discussing the different artworks you have available.

• Remind the students to start with white when mixing tints. They should mix the paints on their palettes, being careful not to change the colors of the paints in the containers. Encourage the students to choose colors that would be found in the background of a landscape painting (sky, water, earth).

• The students must work quickly so the paints do not dry before blotting occurs.

• Demonstrate how to use consistent pressure when rubbing the blotting paper.

• Cleanup: Have each student clean up his or her mess before leaving the station. They should tear off the top sheets of the palettes, clean the brushes, and replace the paper for the next students.

EVALUATING PROCEDURES

Learning Outcomes
1. What colors did you mix to create your background?
2. Were you able to fill the whole space with paint and get all the colors to blend together?

3. Does your background create a certain mood or feeling?

Evaluation
Use these questions to evaluate students' progress:
1. Did students show understanding of the vocabulary during oral discussions?
2. Did the students follow the steps in *Making Art*?
3. Did students criticize artworks by applying art concepts presented?

Encourage the students to evaluate their own work. Students can ask themselves the following questions:
1. Did I follow each step in *Making Art*?
2. What parts of my work do I like?
3. What parts of my work can I improve upon?

LEARNING ENRICHMENT

Lesson Variations
Let the students experiment with the blotting activity as much as time allows. They can try different colors. They can also try changing the sizes of the blobs, even filling the page with very small blobs.

Art Across the Curriculum
Language Arts: Have the students write descriptive sentences about their background pictures. How do the colors make you feel? What do you see in your background?

Lesson 17

Seeing with Your Mind's Eye
pages 38-39

LEARNING OBJECTIVES

Understanding Art
Students will explain how background and foreground work together in an artwork.

Creating Art
Students will create ink drawings against backgrounds of colorful blobs.

Appreciating Art
Students will use the imagination to describe a landscape in a picture of colorful blobs.

Vocabulary
Impressionism, Claude Monet, Impressionist, background, foreground

LESSON PREPARATIONS

Suggested Art Materials
Each student will need: colorful blob artwork from Lesson 16, drawing paper, black marker

GUIDED TEACHING

Lesson Focus
Have the students study their colorful blobs from the last lesson and think of three different backgrounds they could represent. Point out that the imagination could come up with countless other solutions.

Focus on Looking and Thinking
• Ask the students to close their eyes and visualize what a foggy morning does to our perception of things. Have them imagine the classroom cloaked in fog. How would it look?

• The key to this lesson is imagination, so encourage as many imaginative responses in your discussion as possible.

• Ask the students to remember all the different kinds of lines they learned about in Lesson 2. Does Fra Bartolommeo use all the kinds of lines? Does Monet use lines?

• Discussions questions:
 1. Study your neighbor's colorful blobs. Let your imagination run free. What do you see?
 2. The Impressionists sometimes did many paintings of the same scene, changing slightly only the colors used. What were they experimenting with by changing color just a little each time? How? (They were experimenting with light by using tints and shades.)
 3. Which picture in this lesson attracts your eye? Why?

Focus on Making Art
• As the students complete step one, have them use their fingers (imaginary pens) to draw their ideas on the colorful blobs. This will help them see and use the whole space.

• Point out the importance of using the space wisely, only adding details where needed.

• Let the students share ideas as they work. Encourage them to use many kinds of lines.

• Cleanup: Have the students cap the markers and put them away.

EVALUATING PROCEDURES

Learning Outcomes

1. How do you think the foreground and background work together in your artwork?
2. Were you able to create an effective landscape?
3. What did you like about doing an ink drawing on a background that you had already created? Were you challenged?

LEARNING ENRICHMENT

Lesson Variation

Let interested students create another colorful blob artwork. This time, instruct the students to cut the artwork into fourths and make a book out of the pages. Each page can represent a part of a story— beginning, middle (2 pages), and end. Students should use ink pens to draw on the blobs and create a corresponding story.

Art Across the Curriculum

Language Arts: Some students may enjoy writing stories that use their landscapes as settings. They can create characters to live in the settings. Adventure stories would be good vehicles.

Science: Some students will enjoy researching color and light. Others might enjoy studying about the psychological use of ink blots. Results of research can be shared with the class.

Lesson 18

Art Can Fly! pages 40-41

LEARNING OBJECTIVES

Understanding Art

Students will describe the concept of wax resist.

Creating Art

Students will create colorful kites using crayons and watercolors.

Appreciating Art

Students will tell about art forms that stem from the customs of another land.

Vocabulary

shape, color, wax resist

LESSON PREPARATIONS

Suggested Art Materials

Each student will need: white kite form (height, 34"; width, 28"; widest part of diamond located 8" from the top), crayons, watercolor paints in many colors, paintbrush, string or ribbon, scissors, construction paper, ½" pad of newspaper

Additional Teaching Materials

These materials will be needed to actually make the kites flyable: glue, ruler, coping saw, old sheets, kite sticks

Planning Ahead

You might want to send a note home with your students when they complete the kite faces. In the note, you could give complete instructions on making the kites flyable. Alternatively, you could have volunteers (parents, monitors, etc.) come to the classroom and help your students complete the project themselves. It would be a wonderful field trip to have all your students fly their kites in an appropriate location.

Helpful Hints

You might want to set up a paint station for this project. The painting takes only moments, so it would be practical to have two students work on it at a time. The mess would also be limited to a small area.

GUIDED TEACHING

Lesson Focus

Have the students name some liquids that don't blend when poured together. You can spur their memories by mentioning rain on oil spills in the driveway, oil and vinegar salad dressing, etc.

Focus on Looking and Thinking

• See if the students can name other art forms that have evolved from the customs of a people. (Already this year they have learned about fans and yarn paintings.)

• Inform the students that today they will be using the method called *wax resist* to create art. Let them discover exactly what the term means as they work.

• Discussion questions:
 1. What colors do you think would make a kite look pretty against the sky?

2. What shapes were kites that you have seen? Do you think a diamond is a good shape for a kite?

3. Paint that you can see through is called *transparent*. Paint that you can't see through is called *opaque*. Which kind of paint would you use if you wanted to see colorful crayon designs through it?

Focus on Making Art

• Make sure the students plan their designs carefully. They should take time to use shapes and colors that fit their designs and will show up from a distance. Stress that pencil lines must be very light, or else they will show through the crayon and paint.

• Have a sample ready. It should be complete up to the application of paint. Make sure the sample has areas that are not crayoned. Demonstrate what happens when the paint is added. Emphasize that the paint is applied gently in only one direction. Suggest that the paintbrush is on a one-way street and can only go one way.

• Monitor the students as they paint to make sure they are not selecting colors that appear in their crayon designs. (This would prevent the designs from showing up.)

• When the artworks are complete, discuss what the students discovered about the process of wax resist. See if the students can find any areas on their kites where too little crayon (wax) was applied. What happened at these places?

• Have the students add decorative tails to their kites only if you do not plan to make the kites flyable.

• Cleanup: Place the kites in a safe place to dry. The painting area should be neat, since the students should have cleaned up after themselves. However, you will need to store the paints and brushes. Also ask the students to put away the scissors and crayons and to throw away any scraps of string and paper.

EVALUATING PROCEDURES

Learning Outcomes

1. How does the process of wax resist work?

2. Did you press hard enough on your crayons as you colored your design? Did you use the paint correctly?

3. How will your kite look against a blue sky?

Evaluation

Use these questions to evaluate students' progress:

1. Did students show understanding of the vocabulary during oral discussions?

2. Did the students follow the steps in *Making Art*?

3. Did students criticize artworks by applying art concepts presented?

Encourage the students to evaluate their own work. Students can ask themselves the following questions:

1. Did I follow each step in *Making Art*?

2. What parts of my work do I like?

3. What parts of my work can I improve upon?

LEARNING ENRICHMENT

Lesson Variation

Here are instructions to make the kites flyable:

1. Fold under the edges of the kite face. Make the folds 1 inch. Cut off the corners of the kite face.

2. Cut the kite sticks with the coping saw. One stick should extend ⅜" beyond the longest vertical. The other should extend ⅜" beyond the widest horizontal. Cut ¼" notches in the ends of each stick, also.

3. Glue the vertical stick on top of the horizontal stick. Also tie them together with string.

4. Put string around the edges of the kite (under the fold) and through the notches on the sticks. Glue the folds down over the string.

5. To bow the kite, tie a piece of string to one end of the short stick. Put the other end of the string through the notch at the other end of the stick. Pull the string until the kite is bowed and the string extends about 4 inches out from the back of the kite.

6. Make a bridle of string. The long kite string will attach to the bridle instead of to the kite, and that attachment will control the angle of flight. One end of the bridle should pass through the kite face about ⅓ from the top of the kite. The other end of the bridle ties to the bottom of the kite. The bridle should extend out and away from the kite about 12 inches.

7. Tie a tail to the bottom of the kite. The tail should be about 50" long, with crosspieces of old, cut-up sheets every 6".

8. Use a slip knot to tie a ball of string to the bridle. Go fly that kite! For most circumstances, the kite should angle up about 20°–35° from the horizontal.

Art Across the Curriculum

Language Arts: Have the children write short stories telling how the kite might have been discovered. Alternatively, they could write about their experiences flying the kites.

Lesson 19

Does Your World Have Only One Color? pages 42-43

LEARNING OBJECTIVES

Understanding Art
Students will define the term *monochromatic*.

Creating Art
Students will create monochromatic paintings using tints and shades of blue. Learners will demonstrate blending paints effectively.

Appreciating Art
Students will tell about monochromatic scenes from their own experiences.

Vocabulary
monochromatic, tint, shade, blend, overlap

LESSON PREPARATIONS

Suggested Art Materials
Each student will need: chalk, white construction paper, tempera paint (blue, black, white) in containers, palette, paintbrush

Additional Teaching Materials
pictures from interior design magazines showing monochromatic interiors, tinted sunglasses or pieces of colored cellophane, recorded music (easy listening)

GUIDED TEACHING

Lesson Focus
Have each student name his or her favorite color, close the eyes, and envision the world as all that color. Would the students like this kind of world?

Focus on Looking and Thinking
• Let the students try on the colored sunglasses or look through pieces of colored cellophane to experience everything being monochromatic.

• Show pictures of monochromatic rooms or scenes. How do the different colors make the students feel? Make sure the students don't assume that only blue can create a monochromatic scene.

• Discussion questions:
1. Do you believe the photographer really saw an all-blue world? Have you ever seen a monochromatic world?

2. Do you think an all-red room would have a different effect on you than an all-blue room? Why?

3. Do you think you would like your favorite color as much as you do if you saw only that color all of the time?

Focus on Making Art
• Play soft music in the background while the students think of blue ideas.

• The students' sketches should be rough. They should not spend time worrying about the details. The object is just to get their ideas down on paper.

• Experimentation during step three should be expected. The students can even use their waxed paper palettes to practice blending the colors. Demonstrate how a touch of water will help to blend or brush the colors together.

• Cleanup: Have the students set the brushes in the cleanup can. Art monitors can wash, dry, and put them away. The students will need to wash their hands.

EVALUATING PROCEDURES

Learning Outcomes
1. What does *monochromatic* mean? Is your painting truly monochromatic?

2. Did you blend your tints and shades of blue together?

3. While painting, did you think of any other monochromatic scenes you've seen?

Evaluation
Use these questions to evaluate students' progress:
1. Did students show understanding of the vocabulary during oral discussions?

2. Did the students follow the steps in *Making Art*?

3. Did students criticize artworks by applying art concepts presented?

Encourage the students to evaluate their own work. Students can ask themselves the following questions:
1. Did I follow each step in *Making Art*?

2. What parts of my work do I like?

3. What parts of my work can I improve upon?

LEARNING ENRICHMENT

Lesson Variations
Have interested students create other monochromatic artworks, using other colors and media (such

as chalk blended with tissues). An abstract piece of art would be a good variation.

Art Across the Curriculum
Language Arts: Students may want to write stories entitled "I Woke up One Morning and Everything Was _____ !" Encourage the students to use all five of their senses to describe what the world was like.

Bulletin Board Display
Arrange the students' artworks to form a bulletin board called "The Blue Board."

Lesson 20

Do You Feel Warm or Cool?	pages 44–45

LEARNING OBJECTIVES

Understanding Art
Students will define the terms *warm color* and *cool color*.

Creating Art
Students will create warm or cool works linked to mood.

Appreciating Art
Students will determine that a link exists between art and feelings. Learners will evaluate artworks in terms of mood.

Vocabulary
cool colors, warm colors, mood, color wheel

LESSON PREPARATIONS

Suggested Art Materials
Each student will need: white construction paper, tempera paint (have available all primary and secondary colors), paintbrush, scissors, pencil or pen, glue

Additional Teaching Materials
newspaper, construction paper in the primary and secondary colors, old magazines

Planning Ahead
You may want to once again set up a painting station where two students at a time can quickly work and then move on.

GUIDED TEACHING

Lesson Focus
Have the students name all the different ways they have felt in their lives.

Focus on Looking and Thinking
• Reintroduce the thumb game. This time students should identify a color as warm by thumbs up. Thumbs down means a color is cool. Thumbs sideways means "I don't know." Hold up sheets of colored construction paper and have the students respond. Do the same for crayons and the colors in the color wheel on page 22.

• Ask the students if the picture on page 45 would make sense if it were painted with cool colors. Spend some time comparing the visuals in these lessons. They are alike in many ways, yet the feeling of each painting is quite different.

• Discussions questions:
1. Why do you think colors make you feel certain ways?
2. How can an artist make you feel a certain way about his/her artwork? (Lead the students to mention the use of certain kinds of lines and shapes, as well as colors.)
3. Do you wear certain colors when you feel certain ways?

Focus on Making Art
• As you introduce the word *mood* to the students, begin interchanging it with the word *feeling*. This will help students better understand the term.

• Students could possibly choose two colors if they are feeling more than one way (happy, but thoughtful).

• Encourage the students to draw their self-portraits fairly large. You might want to mention proportions: Eyes belong in the middle of the face. Nose belongs halfway between the eyes and the chin. Mouth goes halfway between nose and chin. Ears extend from eyebrows to nose. Also point out that wrinkles can be used effectively to reveal feelings.

• As the students write their stories, emphasize that they should reveal their moods. This means telling how the world appears to the senses today.

• Cleanup: Ask the students to store the scissors and glue in safe places. Have them check the floor for scraps to be thrown away. Have the monitors clean up the paint area.

EVALUATING PROCEDURES

Learning Outcomes
1. Did you use a warm color or a cool color?
2. Did you create an artwork that matches your mood?
3. Can you think of an artwork you have learned about that has a certain mood? Tell about it.

Evaluation
Use these questions to evaluate students' progress:
1. Did students show understanding of the vocabulary during oral discussions?
2. Did the students follow the steps in *Making Art*?
3. Did students criticize artworks by applying art concepts presented?

Encourage the students to evaluate their own work. Students can ask themselves the following questions:
1. Did I follow each step in *Making Art*?
2. What parts of my work do I like?
3. What parts of my work can I improve upon?

LEARNING ENRICHMENT

Lesson Variation
You may want to do this activity another day, too, to demonstrate how mood changes.

Enhancing Self-Concept
See how tuned-in the students really are to their feelings. Have them create collages that use faces from magazines. The students should each choose only those faces that mirror how he or she feels. All the faces can be arranged in interesting ways to cover an appropriate color of construction paper.

Creative Dramatics
Let interested students express themselves through pantomime. See if the students can convey different moods using facial expressions which silently communicate to others.

Lesson 21

What is Cloth Made Of? pages 46-47

LEARNING OBJECTIVES

Understanding Art
Students will explain the concept of weaving and the terms *warp* and *weft*. Learners will perceive the importance of preplanning an artwork.

Creating Art
Students will create weavings out of paper strips.

Appreciating Art
Students will identify fabrics and other woven textiles as art forms.

Vocabulary
fabrics, woven, weft, warp

LESSON PREPARATIONS

Suggested Art Materials
Each student will need: 24 paper strips 1″ x 18″ (assorted colors), wire coat hanger, scissors, tape

Additional Teaching Materials
small pieces of woven fabric, magnifying glasses, newspaper strips (optional), fabric strips (optional), natural fibers such as rope or palmetto leaves (optional)

GUIDED TEACHING

Lesson Focus
Ask the students to remember all the times they have planned someting before doing it (a Saturday, a vacation, a Halloween costume). Inform them that planning is an important part of creating art.

Focus on Looking and Thinking
• Have the students observe pieces of woven fabric through magnifying glasses. See if they can unravel some threads from the fabrics. Focus their attention on the details of woven fabric. Ask them to find the threads that go up and down. Then ask the learners to find the threads that go across.

• Discussion questions:
 1. Why do you think Anni Albers made a plan for her woven wall hanging before she began making it?
 2. Why do threads have to go over and under one another to make a weaving? Would it hold together if the threads only went over?
 3. Which piece of fabric that you observed did you like the best? Why?

Focus on Making Art
• Make sure the students are thinking about colors as they plan. Ask them why they are putting two colors next to each other.

- It is important that the students keep the weft and warp strips tightly together. Urge them to keep pushing the weft strips up tightly against the ones above, making sure the strips are straight across.

- If the taping process becomes awkward, have the students work in pairs. One can weave while the other secures the strips. Then they can switch roles.

- Monitor the students as they work. Ask them if they are following their plans.

- The students can remove their weavings from the hangers by cutting the strips off the top and taping them down in back. However, the hanger serves as a natural means of displaying the finished artwork.

- Cleanup: Ask the students to check the floor for any scraps that should be thrown away. Remind them to store the scissors in a safe place.

EVALUATING PROCEDURES

Learning Outcomes
1. What are the weft and the warp in a weaving?
2. Did you create a weaving that followed your plan?
3. Which student's weaving catches your eye? Why?

Evaluation
Use these questions to evaluate students' progress:
1. Did students show understanding of the vocabulary during oral discussions?
2. Did the students follow the steps in *Making Art*?
3. Did students criticize artworks by applying art concepts presented?

Encourage the students to evaluate their own work. Students can ask themselves the following questions:
1. Did I follow each step in *Making Art*?
2. What parts of my work do I like?
3. What parts of my work can I improve upon?

LEARNING ENRICHMENT

Lesson Variation
Students may want to create more elaborate weavings in which the weft strips are different fabrics such as newspaper, cloth, or leaves. These weavings are valuable lessons in juxtaposed textures.

Art Across the Curriculum
Mathematics: Point out the mathematics (ratios) involved in choosing strips. Ask questions such as: How many strips are blue? How many strips make up the warp? The weft? How many strips are cool colors? How many strips are primary colors?

Careers in Art
Have interested students find out about as many jobs related to fabrics as they can. You can make it a contest to see who can find the most careers. Then ask each student to choose one of the careers to write about.

Lesson 22

| Going 'Round and 'Round | pages 48-49 |

LEARNING OBJECTIVES

Understanding Art
Students will recognize spirals in the natural and man-made world.

Creating Art
Students will manipulate scissors to create spirals. Learners will create three-dimensional designs out of paper spirals.

Appreciating Art
Students will state that design is inherent in many objects.

Vocabulary
spiral, Vincent van Gogh, circle

LESSON PREPARATIONS

Suggested Art Materials
Each student will need: 10-12 brightly colored 5" x 5" squares of construction paper, scissors, tape, 6" x 9" cardboard

Additional Teaching Materials
yarn or string, a variety of objects with spirals, popsicle sticks (optional), plastic clay (optional)

GUIDED TEACHING

Lesson Focus
Have the students hold pencils in their fists and quickly draw circles on scratch paper. Ask them how many of the circles are shapes. (The lines must meet and enclose space for a shape to be formed.)

Focus on Looking and Thinking
• Display objects with spirals. Let students trace with their fingers the way the line curves around and around toward a center point. Ask the students if they would like to have a spiral slide in the playground.

• Give each student a piece of yarn or string. Then have them show a circle, a square, a triangle, etc. Finally have them show a spiral. Lead them to determine the difference between an open and a closed formation. Let them rediscover that a shape is formed when lines meet.

• Discussion questions:
1. Can you tell me what a shape is?
2. Where do you see spirals in the artwork by van Gogh?
3. Where do your eyes go when you look at a spiral?
4. What other spirals have you seen in the world?

Focus on Making Art
• The students should be given a wide assortment of colors to choose from in step one.

• Show the students how cutting the corners off the squares makes cutting circles easier. The more paper they cut away from the corners, the smaller the circles will be.

• Demonstrate how to cut a spiral. Use a large circle so all the students can see what you are doing.

• Focus the students' attention on the springiness of spirals. They are fun to work with.

• Cleanup: Ask the students to throw away any scraps too small to use again. Have them store the scissors in a safe place.

EVALUATING PROCEDURES

Learning Outcomes
1. How do you make a square into a circle? How do you turn a circle into a spiral?
2. Did you create a colorful and three-dimensional artwork?
3. As you were working, did you think of any other spirals you have seen in the world?

Evaluation
Use these questions to evaluate students' progress:
1. Did students show understanding of the vocabulary during oral discussions?
2. Did the students follow the steps in *Making Art*?
3. Did students criticize artworks by applying art concepts presented?

Encourage the students to evaluate their own work. Students can ask themselves the following questions:
1. Did I follow each step in *Making Art*?
2. What parts of my work do I like?
3. What parts of my work can I improve upon?

LEARNING ENRICHMENT

Seasonal Art
Have the students create bouquets of spiral flowers. They can attach spirals to popsicle sticks and anchor the sticks in clay to create balanced bouquets. This is a good project for Mother's Day.

Art Across the Curriculum
Mathematics: Extend this lesson to include all geometric shapes. Although it is not technically correct to name them spirals, angular shapes can be cut in the same way as spirals. The students can create interesting designs using all shapes. Cities can even be built from paper cut in this fashion.

Lesson 23

Lines Can Be Joined in Space	pages 50-51

LEARNING OBJECTIVES

Understanding Art
Students will state the principle of balance. Learners will recognize the importance of experimenting before creating.

Creating Art
Students will effectively join lines together in space to create balanced artworks.

Appreciating Art
Students will describe the malleability of wire as they work with it.

Vocabulary
sculpture, balance, line

LESSON PREPARATIONS

Suggested Art Materials
Each student will need: pipe cleaners or 2' of 18-gauge wire, pencil, drawing paper, tape, 8" x 12" cardboard

Additional Teaching Materials

balance scales, objects to put on scales, mobiles, string (optional)

Safety Precautions

If you are using wire for this lesson, point out to the students that the ends may be sharp.

GUIDED TEACHING

Lesson Focus

Have volunteers try to make the scales balance by adding the appropriate number of objects to each side.

Focus on Looking and Thinking

• Discuss formal and informal balance with your students. Explain that formal balance exists when the two sides of an artwork are exactly alike. (Example: Exactly the same objects on each side of the scale create formal balance.) Informal balance occurs when the two sides are not exactly alike, but yet do not look too different to the eye. (Example: Different objects on each side of the scale can still create balance.) Have the students identify the Lassaw piece as exhibiting informal balance.

• Mobiles illustrate balance well. Have a few on display for the students to examine.

• Discussion questions:
 1. Why is it important to consider balance when planning a sculpture?
 2. Have you ever seen a sculpture in a public place? What was it like?
 3. What do you like best about the student artworks on page 51?

Focus on Making Art

• Encourage experimentation from the beginning of this lesson. Let the students discover how many different ways they can bend the wire.

• Emphasize the variety of ways that lines can be joined together.

• Students can turn up the ends of the bottom lines of their sculptures to create "crow's feet." These will help the sculpture to stand up.

• Cleanup: Collect and put away all extra pipe cleaners and pieces of wire. Ask the students to clean their areas, throwing away any scraps.

EVALUATING PROCEDURES

Learning Outcomes

1. Is your sculpture balanced?

2. Did you create a sculpture that looks good from all sides?

3. What do you like best about wire sculptures?

Evaluation

Use these questions to evaluate students' progress:
1. Did students show understanding of the vocabulary during oral discussions?
2. Did the students follow the steps in *Making Art*?
3. Did students criticize artworks by applying art concepts presented?

Encourage the students to evaluate their own work. Students can ask themselves the following questions:
1. Did I follow each step in *Making Art*?
2. What parts of my work do I like?
3. What parts of my work can I improve upon?

LEARNING ENRICHMENT

Lesson Variation

Advanced students can make mobiles out of pipe cleaners or wires. Calder examples can be used for motivation. The students should attach pieces of string to their artworks as they create, periodically holding the artworks up to see if balance is being achieved.

Creative Movement

Encourage small groups of children to create a sculpture with their bodies. Let one child each time be the sculptor. The sculptor can direct the assembling of the sculpture.

Lesson 24

Right Side, Left Side, or Both? pages 52-53

LEARNING OBJECTIVES

Understanding Art

Students will define the term *symmetry*.

Creating Art

Students will create symmetrical drawings.

Appreciating Art

Students will identify symmetrical balance in the world.

LESSON PREPARATIONS

Suggested Art Materials

Each student will need: 12″ x 18″ white construction

paper, pencil, black felt-tip pen, crayons or colorful pens

Additional Teaching Materials
drawing paper, rulers, scissors, hand mirrors, foods for mosaics (optional), glue (optional), old magazines (optional)

GUIDED TEACHING

Lesson Focus
Have the students hold their hands, palms up, little fingers touching. Now ask them to bring their palms together. What do they observe? Do their fingers match? Are their hands the same size?

Focus on Looking and Thinking
• Have mirrors available so students can identify the symmetry of their own faces.

• Point out that symmetry is a type of balance. Ask the students if it is informal or formal balance.

• You may want to introduce the concept of asymmetry. Then have the students differentiate among symmetrical and asymmetrical objects in the classroom.

• Discussion questions:
1. Exactly how do the photographs on page 52 show symmetry?
2. What other shapes besides hearts can you think of that have symmetry?
3. What man-made things can you name that are symmetrical? (pants, eyeglasses, cars, etc.)

Focus on Making Art
• Encourage the students to carefully study the pictures of butterflies before drawing. They need to become familiar with the parts of a butterfly.

• Stress that it is easiest to draw the head, thorax, and main body first. Then the antennae and wings will be in proportion.

• Remind the students to look at the right sides of their butterflies as they draw the left sides in step three.

• The students should work on newspaper to complete step four. Remind the students that symmetry refers to color, too.

• Cleanup: Have the students clean their areas, storing art supplies in their proper places.

EVALUATING PROCEDURES

Learning Outcomes
1. What is symmetry?

2. How does your butterfly show symmetry?
3. Use art terms to tell why the butterfly of one of your classmates is your favorite.

Evaluation
Use these questions to evaluate students' progress:
1. Did students show understanding of the vocabulary during oral discussions?
2. Did the students follow the steps in *Making Art*?
3. Did students criticize artworks by applying art concepts presented?

Encourage the students to evaluate their own work. Students can ask themselves the following questions:
1. Did I follow each step in *Making Art*?
2. What parts of my work do I like?
3. What parts of my work can I improve upon?

LEARNING ENRICHMENT

Lesson Variations
Let interested students use other media to create a symmetrical design. They may want to use dried beans, peas, macaroni, and rice to make symmetrical butterfly mosaics.

Art Across the Curriculum
Mathematics: Encourage the students to make symmetrical geometric designs. Different geometrical shapes should be used. Supply the students with rulers to use in creating their designs.

Enhancing Self-Concept
Students can use mirrors and the idea of symmetry to draw self-portraits. Alternatively, they could complete the missing halves of magazine faces that have been halved.

Bulletin Board Display
Have the students cut out their butterflies and fold them along the vertical center. These create lively three-dimensional items for a bulletin board on symmetry.

Lesson 25

Thumbs up for Art **pages 54-55**

LEARNING OBJECTIVES

Understanding Art
Students will explain the concept of variety.

Creating Art
Students will create simple artworks that show variety. Learners will create clear prints.

Appreciating Art
Students will state that variety adds interest to artworks.

Vocabulary
variety, advertisement, rhythm

LESSON PREPARATIONS

Suggested Art Materials
Each student will need: tempera paint, paint trays, 5½" x 8½" white construction paper (optional), stapler (optional)

Helpful Hints
This lesson works best if you have a printing station set up where four or five students at a time can work. You can more easily supervise the amount of paint on the thumbs and be more aware of students who are playing instead of completing the project. If you have enough adults assisting you, set up several stations so all the students can work at once.

GUIDED TEACHING

Lesson Focus
Ask the students if they like ice cream. Have them identify their favorite flavors. Point out that the different flavors are *varieties* of a basic recipe.

Focus on Looking and Thinking
• Point out that even though the poster is very simple, the variety gives it interest.

• Ask the students to name other ways the poster could have achieved variety.

• Spend some time letting the students discover all the little differences among the dolls' heads on page 55. Ask them to tell you other ways variety could have been achieved.

• Mention that most people are basically the same. Yet the variety of height and weight, of skin, hair, and eye color makes each of us unique. This makes us interesting to look at.

• Discussion questions:
 1. How would it be to live in a world in which all people looked exactly alike? How would that make you feel?
 2. Would you like the picture on page 55 if all the dolls were exactly alike?
 3. What would you add to the poster on page 54?

Focus on Making Art
• Let the students practice holding their thumbs in different ways.

• As the students work on their prints, remind them that every print does not have to be unique. Using some prints more than once will give the artwork unity and rhythm.

• As the students critique their finished artworks, ask them to find the prints that are most clear.

• Cleanup: The students will need to wash their hands. Wash the paint containers and brushes and put them away. Place the artworks in a safe place to dry.

EVALUATING PROCEDURES

Learning Outcomes
1. What is variety?
2. Does your artwork show variety? How?
3. How could you make your artwork better?

Evaluation
Use these questions to evaluate students' progress:
1. Did students show understanding of the vocabulary during oral discussions?
2. Did the students follow the steps in *Making Art*?
3. Did students criticize artworks by applying art concepts presented?

Encourage the students to evaluate their own work. Students can ask themselves the following questions:
1. Did I follow each step in *Making Art*?
2. What parts of my work do I like?
3. What parts of my work can I improve upon?

LEARNING ENRICHMENT

Lesson Variations
Students might enjoy creating pictures by using thumbprints to show modes of transportation. Trains can be shown well with this technique, but let the students invent their own designs.

Bulletin Board Display
Create a bulletin board called "Thumbody Loves Me." Each student can start out with the same basic design on a 3" x 3" piece of paper: a flat thumbprint for a body, the tip of the thumb for the head. Then each student can use other media to make his or her thumbody look a special way. Again, this shows the concept of variety. Staple all the thumbodies to the bulletin board.

Lesson 26

By the Light of the Moon pages 56-57

LEARNING OBJECTIVES

Understanding Art
Students will recognize that dark silhouettes appear against a light background. Learners will define the term *horizon*.

Creating Art
Students will use paints to create moonlit skies. Learners will cut out properly sized silhouettes.

Appreciating Art
Students will recognize the artistic contrast between light and dark. Learners will identify silhouettes with real-life objects.

Vocabulary
horizon, shade, silhouette

LESSON PREPARATIONS

Suggested Art Materials
Each student will need: heavy white 12″ x 18″ paper, pencil, tempera paints in a variety of colors (including black), scissors, black construction paper, paintbrush, palette, glue

Additional Teaching Materials
filmstrip projector or bright light, tape, black marker, chalk (optional), tissues (optional), tape recorder (optional)

GUIDED TEACHING

Lesson Focus
Have the students create shadow puppets in the light of a film projector. Can they create alligators, bunnies, and cats?

Focus on Looking and Thinking
• Have a student sit so that his or her profile is cast on a sheet of white paper on the wall. Trace around the silhouette, quickly color it black with a wide-tip marker, and cut it out. Hold the silhouette against a sheet of black paper. Can the students see it? Now hold it against a white sheet of paper. Identify the profile as a silhouette (a shadow against a light background).

• Lead the students to identify the real-life objects that are silhouetted in the visuals for this lesson.

• Discussion questions:
1. Can you identify the backgrounds and foregrounds in these two pictures?
2. Could you see silhouettes if the pictures were full of sunlight?
3. Do these pictures use tints or shades?

Focus on Making Art
• Explain that the horizon does not have to be in the center of the paper.

• Remind the students that they must use only tiny amounts of black paint to darken their shades.

• If the students *pull* their brushes across the paper, going in only one direction (*away* from the moon), it will be easier to blend the paints. Make sure the paint is not too thick.

• As the students work on their silhouettes, stress sizes of objects in relationship to one another.

• Cleanup: Have the students put the scissors and glue away. Ask them to tear off the top sheets of their palettes. Have the art monitors clean and dry the brushes and paint containers. Ask the students to check for scraps and throw them away.

EVALUATING PROCEDURES

Learning Outcomes
1. Find the horizon in your neighbor's painting.
2. Are your silhouettes the right sizes?
3. Do you like the shade you used to show moonlight?

Evaluation
Use these questions to evaluate students' progress:
1. Did students show understanding of the vocabulary during oral discussions?
2. Did the students follow the steps in *Making Art*?
3. Did students criticize artworks by applying art concepts presented?

Encourage the students to evaluate their own work. Students can ask themselves the following questions:
1. Did I follow each step in *Making Art*?
2. What parts of my work do I like?
3. What parts of my work can I improve upon?

LEARNING ENRICHMENT

Lesson Variation
Students can also use chalk to complete this artwork. A piece of tissue will facilitate the blending process.

Art Across the Curriculum
Language Arts: Let interested students write stories or poems about their night scenes. Have them record these stories, complete with appropriate background noises or music.

Lesson 27

| Let's Get to the Important Part | pages 58-59 |

LEARNING OBJECTIVES

Understanding Art
Students will describe what the artistic center of interest is.

Creating Art
Students will create artworks showing perspective and center of interest.

Appreciating Art
Students will locate the center of interest in real, portrayed, and imagined scenes.

Vocabulary
details, center of interest, perspective, overlapping

LESSON PREPARATIONS

Suggested Art Materials
Each student will need: white drawing paper, crayons

Additional Teaching Materials
art prints, monochromatic objects, object of contrasting color

GUIDED TEACHING

Lesson Focus
Have the students think about clowns they have seen. What parts of the clowns do they remember most? Why? (feet, because they were big; nose, because it was brightly colored, etc.)

Focus on Looking and Thinking
• Have available a variety of art prints. Ask students to locate the center of interest in each one.

• Illustrate color as a key to finding the center of interest. Set up a still life using objects that are all the

same color. Then add an object of a different color. Ask the students to find the center of interest.

• Discussion questions:
 1. What two things do you need to remember about perspective?
 2. Why do you think artists include centers of interest in their works?
 3. What clues can help you to show a center of interest?

Focus on Making Art
• The students have quite a few things to remember when creating their artworks. You might want to list them on the board: center of interest, perspective, details.

• Remind the students of the clues that help show the center of interest.

• Cleanup: Have the students tidy their areas and put the crayons away.

EVALUATING PROCEDURES

Learning Outcomes
1. What is a center of interest?
2. Can other students guess your center of interest?
3. What clues did you use when creating a center of interest in your drawing?

Evaluation
Use these questions to evaluate students' progress:
1. Did students show understanding of the vocabulary during oral discussions?
2. Did the students follow the steps in *Making Art*?
3. Did students criticize artworks by applying art concepts presented?

Encourage the students to evaluate their own work. Students can ask themselves the following questions:
1. Did I follow each step in *Making Art*?
2. What parts of my work do I like?
3. What parts of my work can I improve upon?

LEARNING ENRICHMENT

Lesson Variations
• Have advanced students create nonobjective pieces of art that show centers of interest. They could use colorful construction paper cut into different shapes.

• Students who have a hard time understanding perspective might find this project easier if they do it

in pieces. That is, they can draw and color the center of interest. Then they can draw other objects to appear in the picture. The drawings can be cut out and glued in the correct way (overlapping and size considered) to reveal perspective.

Creative Dramatics
Have the students write plays set in their favorite places. The drawings could be expanded into backdrops through the use of a grid. The skits could then be acted out against the settings.

Planning for Tomorrow's Lesson
Send a note home with each student. Ask for interesting scraps such as yarn, trims, buttons, egg cartons, or fabric pieces.

Lesson 28

Animals in Art pages 60-61

LEARNING OBJECTIVES

Understanding Art
Students will determine which art materials are best for certain purposes. Learners will explain the difference between something that is flat and something that has form.

Creating Art
Students will use a variety of materials to create animals with form.

Appreciating Art
Students will tell about the role of animals in art throughout time. Learners will recognize the fanciful nature of imaginative art.

Vocabulary
form

LESSON PREPARATIONS

Suggested Art Materials
Each student will need: small brown sack, newspaper, 12″ string, scissors, a variety of art materials and tools

Planning Ahead
Set up a Creature Creation Table at least a week prior to this lesson. Students can add to the table daily. This will create excitement for the project and help to organize the materials.

Helpful Hints
Have the students actually work at their stations, only coming to the Creature Creation Table for needed supplies.

GUIDED TEACHING

Lesson Focus
Ask the students to name their favorite animals. Then ask them to name parts of other animals that they would like to combine to make the perfect pet.

Focus on Looking and Thinking
• Have the students silently imitate their favorite animals. This will get the students thinking about specific parts of animals. They will begin to develop ideas for the creation of the artworks.

• Discussion questions:
 1. Why were people long ago afraid of animals?
 2. Why do you think many artists show animals in their works?
 3. Does a creature you make up have to look real? Can some parts look more real than others?

Focus on Making Art
• Stress that the students can make either real or imaginary animals. They can even create parts of real animals and put them together to create a new creature.

• Focus the students' attention on form. Discuss the difference between something that is flat and something that has form.

• Help the students experiment with different materials. For example, you might show them how to wrap strips of construction paper around a pencil or finger to make everything from fish scales to eyelashes.

• Remind the students to look at their animals from all sides as they work.

• Periodically ask the students if they are using the media correctly. They need to be aware of why they are doing what they are doing.

• Cleanup: Have the students return the useable scraps and the art materials to the Creature Creation Table. Have volunteers help you store everything.

EVALUATING PROCEDURES

Learning Outcomes
1. Did you use materials that worked best for what you needed them?
2. Does your animal seem to come alive? Why or why not?

3. Which animals do you think are most imaginative? Why?

Evaluation
Use these questions to evaluate students' progress:
1. Did students show understanding of the vocabulary during oral discussions?
2. Did the students follow the steps in *Making Art*?
3. Did students criticize artworks by applying art concepts presented?

Encourage the students to evaluate their own work. Students can ask themselves the following questions:
1. Did I follow each step in *Making Art*?
2. What parts of my work do I like?
3. What parts of my work can I improve upon?

LEARNING ENRICHMENT

Art Centers
Work as a class to create a special zoo for your animals to live in for a few weeks.

Art Across the Curriculum
Language Arts: Have interested students read about unicorns and other mythological animals. Then ask them to write and illustrate poems about the special magic of these animals.

Lesson 29

Give Your Finger a Face	pages 62-63

LEARNING OBJECTIVES

Understanding Art
Students will identify the properties of papier-mâché.

Creating Art
Students will create and decorate puppet heads.

Appreciating Art
Students will explain the interrelatedness of the different types of art needed for a stage production.

Vocabulary
play, role, backdrop, papier-mâché

LESSON PREPARATIONS

Suggested Art Materials
Each students will need: round balloon, petroleum jelly, newspaper cut into 1" strips, wheat paste or library paste, scissors, a variety of paints and brushes, a variety of materials to use to decorate puppet heads (yarn, beads, buttons, etc.)

Additional Teaching Materials
paper towels, paper to cover work areas, buckets for wheat paste, liquid latex (optional), clay (optional), large box (optional)

Planning Ahead
• You may want to set up 2 to 4 work stations and have the students work in groups. Since the lesson will take approximately two 45-minute sessions to complete, the first day's stations should be papier-mâché stations. See the *How to Do It* section for instructions on papier-mâché activities. The second day, the stations should be paint stations. Adding decorations to the heads can be done at each student's desk.

• Have the paper strips cut prior to the lesson.

Helpful Hints
Balloons are wonderful for this activity. However, you should probably anchor them down somehow (string tied or taped to chair or table). Alternatively, you could use liquid latex over molds made of oil-based or water-based clay, or the standard armature of crumpled newspaper.

Safety Precautions
• Make sure the students understand that the wheat paste is *not* edible.

• The students need to be cautioned as they cut the holes out of the bottoms of the puppets' heads. They should proceed slowly and carefully, not jamming the scissors in through the opening.

GUIDED TEACHING

Lesson Focus
Find out how many of your students have seen plays. Can they tell you the differences among plays, television shows, and movies?

Focus on Looking and Thinking
• Discuss the puppets made by students (page 62). Have the students identify possible roles for the puppets. Remind them to study the faces and clothes of the puppets for clues. Ask the students to think of a

possible story that could include a dog, an elephant, and a person.

- Discussion questions:
 1. People seem to like puppets that have moveable things on them. What would move on the puppets shown on page 62 if the puppets were dancing?
 2. What do you like best about the puppets on page 62? What would you add to each one?
 3. Have you ever seen a backdrop? Where?

Focus on Making Art

- Demonstrate steps 1 and 3 for your students before they begin the project at their stations.

- If you are using group stations, you might want to have each group (rather than the whole class) create a play. Ask each group to choose a "recording secretary" to write down the group's ideas about the play.

- Remind the students to use at least five layers of newspaper strips and to each leave a hole at the base of the head.

- Encourage the students to paint their puppets with bright colors. They should use a wide variety of materials to decorate the puppets. Remind them to develop the role of each puppet and to include moveable parts such as hair that swings.

- Cleanup: Have monitors clean up the paint and papier-mâché stations. Ask the students to wash their hands and then return all art materials to their proper places.

EVALUATING PROCEDURES

Learning Outcomes

1. Can your puppet be seen from far away? Does one side look like its face and the other side the back of its head?
2. Does your puppet's face fill the role you decided upon?
3. Which puppet faces have personality? Why do you think so?

Evaluation

Use these questions to evaluate students' progress:
1. Did students show understanding of the vocabulary during oral discussions?
2. Did the students follow the steps in *Making Art*?
3. Did students criticize artworks by applying art concepts presented?

Encourage the students to evaluate their own work.

Students can ask themselves the following questions:
1. Did I follow each step in *Making Art*?
2. What parts of my work do I like?
3. What parts of my work can I improve upon?

LEARNING ENRICHMENT

Lesson Variation

Advanced students can learn about the "talking heads" of television. Have the students create a short dialogue between two puppets, or talking heads. A box can be used to represent a television.

Art Heritage

The students can use papier-mâché to create representational ancient masks. First they should learn about the wide variety of masks created by civilizations. They can then each choose a mask with significance to create.

Lesson 30

Clothes Are Art, Too pages 64-65

LEARNING OBJECTIVES

Understanding Art

Students will recognize that certain art materials work best for certain activities and effects.

Creating Art

Students will work creatively to make costumes for the puppet heads.

Appreciating Art

Students will determine that clothes are a form of art. Learners will relate art to function.

Vocabulary

pattern, texture

LESSON PREPARATIONS

Suggested Art Materials

Each student will need: a variety of papers; a variety of fabrics; crayons, paints, markers, etc.; buttons, ribbons, lace, trims, yarn, etc.; tape, glue, pins, stapler, etc.

Additional Teaching Materials

tagboard strips (1" x 5")

Planning Ahead

You may want to set up a paint station, a paper/fabric station, and a trim station. The students can choose the materials they need from each station, use the materials at their own work areas, and then return useable scraps to the stations.

Helpful Hints

A strip of tagboard rolled to form a tube and then pushed into the hole at the base of each puppet head provides a "neck" to which the clothes can be attached.

GUIDED TEACHING

Lesson Focus

Ask interested students to stand at the front of the room and talk about the clothes they are wearing. Ask questions such as, "Why did you choose to wear that today? What do you like about your clothes? Why are those clothes good to wear to school?"

Focus on Looking and Thinking

• Ask the students what kinds of clothes their parents wear to work. Do their clothes reflect their jobs?

• Spend some time discussing the costumes on page 64. Note the colors and patterns of the Chinese dress. Discuss the fiber of the African costume.

• Discussion questions:
 1. Look at the patterns or designs of the fabrics in the clothes you are wearing. Describe what you see.
 2. Do your clothes have different textures?
 3. How are your clothes different from the clothes on page 64?
 4. What types of clothes catch your eye? Why?

Focus on Making Art

• Discuss the stations you have set up. Show the children the materials that are available at each station.

• Encourage the students to experiment with many different fabrics and papers.

• Remind the students that puppets which have moveable objects attached are most interesting to the audience.

• Cleanup: Remind the students to return the materials to the proper work stations. Ask them to clean up their own work areas.

EVALUATING PROCEDURES

Learning Outcomes

1. Did the materials you used in making your puppet work well? Why or why not?
2. How does the costume you made for your puppet fit its role?
3. Which costumes made by other students do you like best? Why?

Evaluation

Use these questions to evaluate students' progress:
1. Did students show understanding of the vocabulary during oral discussions?
2. Did the students follow the steps in *Making Art*?
3. Did students criticize artworks by applying art concepts presented?

Encourage the students to evaluate their own work. Students can ask themselves the following questions:
1. Did I follow each step in *Making Art*?
2. What parts of my work do I like?
3. What parts of my work can I improve upon?

LEARNING ENRICHMENT

Art Careers

Some students may be interested in learning about fashion designers. Have each interested student select a designer whose name is familiar and then learn more about him or her. Encourage the students to share their findings through words or illustrations.

Art in the Environment

Let interested students start collections of fabrics they like. They can categorize and display small pieces of the fabrics, grouping them by color, texture, or pattern.

Unit 2 Extension and Application

EXPLORING ART

Putting on a Puppet Show

The value of this Exploring Art activity lies in putting together all the pieces of a puppet play. The students should be reminded that everything involved in the play—the puppet characters (their roles, clothes, and voices), the backdrop, and the other parts of the set—should all fit together. Supervise the students as they create the backdrop, making sure they are all working together. As you prepare the stage, leave enough room between the draped table and the backdrop for the puppeteers to sit. As the play is rehearsed, direct the students. Let them know if their arms are in view or if the puppets could be in better positions. To further extend this activity:

• Have the students select music that is appropriate for the play.

• Have the students attend a local theater's production. Ask them to critique the appropriateness of the costumes, set, etc.

REVIEW

Looking at Art

These answers are suggested responses only.

1. Fragonard employed warm colors and soft lines and facial expressions to create a tender mood.

2. The background consists of a wall, a large piece of furniture with hats and cloth atop it, and space behind the open door. In the foreground are the figures, the cradle, the window and its drapings, and the open door. Fragonard differentiated background from foreground by omitting details and colors from the background.

3. The center of interest is shown by effective use of light and by the direction of the figures' line of vision.

4. Symmetry occurs only in the faces of the figures.

5. The light seems to come from the window and from a source behind and above the children on the right.

6. The artist effectively portrayed the textures of soft hair, soft fabric, smooth skin, rough basketry, worn wood, etc., by attention to details such as light reflection, shadow, folds, and color.

7. Students' answers will vary.

Unit 3

THE MANY FACES OF ART

In this unit the students will be exposed to many styles of art, to pieces of art that have been created throughout time all over the world. They learn that art can decorate or embellish utilitarian objects, that art creates living spaces, that art records and celebrates important events, and that art intensifies man's creative and spiritual existence.

The unit opener touches upon all of these aspects of art. A modern goblet, an old quilt, and an example of Mexican folk art work together to give the students a sense of what the unit is all about. The students begin the unit knowing that there is a significant continuum of art history. They are prepared for a huge variety of time periods and activities.

As your students proceed with this unit's activities, constantly ask the question *Why*? Why is this artwork important? Why are these colors and designs used? Why was this artwork created? Your questions can stimulate valuable critical thinking responses from your students. At the same time, art becomes for them a valid and important means of self-expression.

This art is from page 68 of the student book.

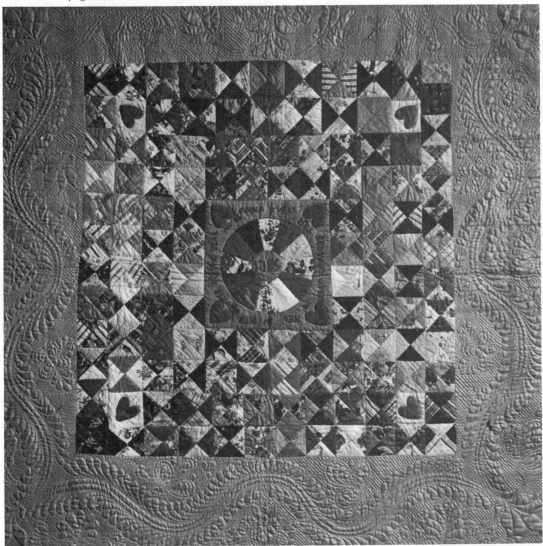

Anna Tuell, Marriage Quilt, *1785, Wadsworth Atheneum.*

Lesson 31

Art That's Black and White
pages 70-71

LEARNING OBJECTIVES

Understanding Art
Students will explain the role art plays in the study of history.

Creating Art
Students will create chalk line drawings.

Appreciating Art
Students will recognize cave paintings as the oldest art form.

Vocabulary
cave painting

LESSON PREPARATIONS

Suggested Art Materials
Each student will need: white drawing paper, black chalk or charcoal

Additional Teaching Materials
tissues, paper to cover work areas, as many examples as possible of cave paintings, paint (white, red, yellow—optional)

GUIDED TEACHING

Lesson Focus
Ask the students to think about what could be the oldest art. Then have them use the thumb game to respond to your suggestions: oil painting? marble sculpture? pencil drawing? nearika? crayon drawing? Oriental art? . . . Continue with all the forms your students have learned about so far. Ask them why they think certain art forms came first.

Focus on Looking and Thinking
• Have available examples of cave paintings for the students to observe and discuss.

• Encourage students to think about the first recorded history and why that is important for us today.

• Discussion questions:
 1. Why do you think most cave paintings showed animals?

 2. Why did early artists use charcoal?

 3. Where did early artists get red, white, and yellow paint?

 4. How are the two drawings in this lesson alike? How are they different? What story does each one tell?

Focus on Making Art
• Stress to the students that there is a variety of ways to use the chalk. Pass out tissues for students to use to smear the lines if they wish to. This technique is also effective in creating shadows.

• When the drawings are completed, have the students work in pairs. They can trade drawings and make up stories about each other's work. How close is the made-up story to the story intended by the artist?

• Cleanup: Have the students put away the chalk or charcoal and wash their hands. Throw away the paper used to cover the work areas.

EVALUATING PROCEDURES

Learning Outcomes
1. Why are cave paintings so important to us today?
2. Does your drawing tell a story?
3. Which drawings do you like best? Why?

Evaluation
Use these questions to evaluate students' progress:
1. Did students show understanding of the vocabulary during oral discussions?
2. Did the students follow the steps in *Making Art*?
3. Did students criticize artworks by applying art concepts presented?

Encourage the students to evaluate their own work. Students can ask themselves the following questions:
1. Did I follow each step in *Making Art*?
2. What parts of my work do I like?
3. What parts of my work can I improve upon?

LEARNING ENRICHMENT

Lesson Variations
Students can do other cave paintings using chalk and yellow, white, or red paint.

Art Across the Curriculum
Language Arts: Have the students create a series of drawings to illustrate the beginning, middle, and

end of a story they are reading this week. Line drawings are appropriate for sequencing, which comes naturally when the students begin to illustrate and label the parts of a story.

Lesson 32

Art from Small Pieces pages 72-73

LEARNING OBJECTIVES

Understanding Art
Students will recognize a mosaic.

Creating Art
Students will create mosaics from torn construction paper.

Appreciating Art
Students will identify unity and balance in artworks.

Vocabulary
mosaic, unity, balance, texture

LESSON PREPARATIONS

Suggested Art Materials
Each student will need: a variety of colorful construction paper, scissors, 8½″ x 11″ heavy white paper or cardboard, glue

Additional Teaching Materials
a bag of objects that could be used to make a mosaic (dried beans, beach pebbles, small tiles, etc.), shoe boxes, various dried foods (optional)

Helpful Hints
This is a great project for using up all those scraps of construction paper you have accumulated this year. You may wish to go ahead and shred or tear them and set up a station where students can choose the right colors of scraps.

GUIDED TEACHING

Lesson Focus
Have the students organize the scraps of paper. Ask them to box the scraps by color, size, shape, etc. Encourage them to begin thinking which colors look good side-by-side.

Focus on Looking and Thinking
• Ask the students to think about all of the different

things you could place closely together to make a mosaic. Have several volunteers manipulate the various pieces in your bag of mosaic items to create a quickie mosaic. See how different groups of students arrange the pieces in different ways.

• Discuss the balance of the Syrian mosaic. Remind the students that although it is not quite symmetrical, it still represents informal balance, which is just as effective.

• Discussion questions:
 1. How can you tell that a work of art is a mosaic?
 2. Tell how each of the mosaics in this lesson show unity and balance.
 3. How many repeated shapes can you find in each mosaic?

Focus on Making Art
• Tell the students they can estimate the amount of paper scraps they will need by noticing the size of the space to be filled with each color.

• Remind the students to follow their plans so that their artworks will demonstrate unity.

• You may want to demonstate using the proper amount of glue and placing the pieces very closely together. Encourage the students to fill the *whole* space.

• Have the students place their finished mosaics along the chalk rail for discussion. Encourage them to talk about how the artworks look from afar and how the pieces all go together to create a unified, whole design.

• Cleanup: Collect and store the scissors in a safe place. Ask the students to throw away all the tiny scraps left in their work areas. Art monitors can collect and clean the glue containers.

EVALUATING PROCEDURES

Learning Outcomes
1. Why can you call your artwork a mosaic?
2. Do you see unity or balance in your artwork?
3. Tell about your favorite mosaic. Talk about color, balance, unity, shapes, and texture.

Evaluation
Use these questions to evaluate students' progress:
1. Did students show understanding of the vocabulary during oral discussions?
2. Did the students follow the steps in *Making Art*?
3. Did students criticize artworks by applying art concepts presented?

Encourage the students to evaluate their own work.

Students can ask themselves the following questions:

1. Did I follow each step in *Making Art*?
2. What parts of my work do I like?
3. What parts of my work can I improve upon?

LEARNING ENRICHMENT

Art Across the Curriculum

Health/Nutrition: Have interested students create mosaics out of a variety of foods such as cereals, beans, peas, seeds, rice, etc. Encourage the students to plan their mosaics, trying to include a food from each of the food groups.

Language Arts: Some students may want to write poems about their mosaics. Encourage them to use many adjectives to describe colors, textures, and shapes.

Lesson 33

| Animals Can Be Smooth | pages 74-75 |

LEARNING OBJECTIVES

Understanding Art
Students will recognize the art style of ancient Chinese artists.

Creating Art
Students will carve plaster sculptures.

Appreciating Art
Students will identify properties of different media used for carvings and explain why each works best for a certain purpose.

Vocabulary
sculpture, base

LESSON PREPARATIONS

Suggested Art Materials
Each student will need: plaster block, pencil, paper, carving tools (dull paring knife, plastic knife, nail file, nail, nut pick, etc.), fine sandpaper, glue, brush

Additional Teaching Materials
small milk cartons, cardboard cartons with 2" sides, small dishes for water, buckets, pictures of animals, carbon paper (optional), tape (optional), tiny balloons (optional)

Planning Ahead
• Prepare the plaster blocks in advance, or have the students prepare them. Mix the plaster (see the *How to Do It* section) and pour it into small milk cartons. Allow it to dry, and tear the carton away to reveal the block.

• This activity may take several class periods to complete. It is important not to rush the students, as the carving is a slow process. The ideal way to teach this lesson is to have the students work on it several times, but not for extended periods.

Safety Precautions
The students should place their blocks in cardboard boxes with low sides when carving. This confines the plaster dust to a limited area. It is recommended that students also wear simple masks while carving if the dust seems to be plentiful. Don't let the plaster get near your sink. If it washes down the drain, it will turn into a cement-like substance that cannot be removed.

GUIDED TEACHING

Lesson Focus
Have the students look at a plaster block and try to imagine an animal within it. What parts of the block would fall away to reveal the animal?

Focus on Looking and Thinking
• As a class, look at and discuss the photographs of Chinese sculptures. Point out how strong and solid the animals appear. Discuss how each artist has simplified and smoothed the animal. Ask the students to imagine feeling the sculptures.

• Look at magazine pictures of real animals, and ask the students to determine how these animals could be simplified. The students should begin recognizing the essence of an animal as something which sculpture can portray. (For example, the panda looks like he would roll if he walked.)

• Point out that horns and tiny legs are possible in bronze and jade sculptures, but not in plaster sculptures. They would only chip off.

• Discussion questions:
 1. Think about an animal. What is the main thing you notice and remember about this kind of animal? How could you show this one thing in a sculpture?
 2. Would you like the panda as well if you could see all of the hairs on his body?

3. What kind of animal could you show well in a plaster sculpture?

Focus on Making Art
• Try to make the students understand that they are to show the essence of an animal, not try to create a replica of it.

• Encourage the students to feel their sculptures as they work. This activity should be a rich tactile experience.

• Remind the students that fine details are not possible in a plaster sculpture.

• Make sure the students turn the sculptures as they work. They also need to remember to keep the base solid during most of the carving process so that the piece does not become top-heavy and fall over.

• Thin the glue with water for the students to use on the sculptures. Let them know that the glue will protect the sculpture and make it stronger.

• Cleanup: Use buckets full of water for all your cleanup. Do *not* use the sink. Have art monitors collect all the supplies and store them properly.

EVALUATING PROCEDURES

Learning Outcomes
1. What types of sculpture can you create out of hard materials? Which types of sculptures can you create out of soft materials?

2. How successful were you in bringing the form you desired out of the plaster block?

3. What would you do differently if you carved another sculpture?

Evaluation
Use these questions to evaluate students' progress:
1. Did students show understanding of the vocabulary during oral discussions?

2. Did the students follow the steps in *Making Art*?

3. Did students criticize artworks by applying art concepts presented?

Encourage the students to evaluate their own work. Students can ask themselves the following questions:
1. Did I follow each step in *Making Art*?

2. What parts of my work do I like?

3. What parts of my work can I improve upon?

LEARNING ENRICHMENT

Lesson Variations
• Students can use carbon paper taped to the plaster

blocks to transfer the animal designs. Just make sure the designs are drawn on paper sized to match the block.

• Do another type of plaster activity. Suspend tiny inflated balloons in empty milk cartons. Fill the cartons with plaster. When the plaster is thoroughly hard, tear away the cartons to reveal sculptures with tunnels and caves. The students can smooth and round the edges of the forms.

Aesthetic Perception
Encourage the students for several days to notice all the smooth, solid forms in their environment. Often we fail to notice the simple designs. The students should be aware of these.

Lesson 34

Canadian Indian Art pages 76-77

LEARNING OBJECTIVES

Understanding Art
Students will state that art can be made from what is available. Learners will identify the Micmac art of quilling.

Creating Art
Students will draw simple designs to use as a basis for quilling.

Appreciating Art
Students will describe the art of quilling as a unique form.

Vocabulary
quilling

LESSON PREPARATIONS

Suggested Art Materials
Each student will need: 8″ cardboard circle, toothpicks, coloring substance (berry colors), paper towels, pencil, glue

Additional Teaching Materials
paper to cover work areas, map of the world, pictures of porcupines

Planning Ahead
• Cut the cardboard circles prior to the lesson.

• Set up a toothpick coloring station.

Helpful Hints

You have several options for what to use to color the toothpicks. Food coloring works well, but only when pure. Dilution takes the color out of it. Thus, it becomes impractical for large classes. Dyes, poster paints, and thin tempera paint are other options.

GUIDED TEACHING

Lesson Focus

Display pictures of porcupines. Ask the students to describe what they see. Can they imagine any way that porcupines could contribute to the world of art?

Focus on Looking and Thinking

• Have a student find Canada on the map. Point out the exact spot where it is believed the Micmac tribe lived.

• Talk about colors in nature. Have the students name specific plants from which they think actual dyes could come.

• Discussion questions:
1. Why do you think the Micmac Indians made art from porcupine quills?
2. Why do you think the Micmacs used simple designs?
3. What do you like about the chair cover?
4. What other types of art have you learned about this year that are made from everyday objects?

Focus on Making Art

• If the students dye the toothpicks first, then they can create their designs while the toothpicks dry.

• Make sure the students are placing the toothpicks very closely together.

• Cleanup: Have an art monitor clean up the coloring station. Ask the students to check the floor for toothpicks. Collect, clean, and store the glue containers. Throw away the paper covering the work areas.

EVALUATING PROCEDURES

Learning Outcomes

1. What do you know about the Micmac Indians?
2. Was your design large and simple enough to cover with toothpicks?
3. Which of your classmates' designs are most attractive? Why?

Evaluation

Use these questions to evaluate students' progress:
1. Did students show understanding of the vocabulary during oral discussions?
2. Did the students follow the steps in *Making Art*?
3. Did students criticize artworks by applying art concepts presented?

Encourage the students to evaluate their own work. Students can ask themselves the following questions:
1. Did I follow each step in *Making Art*?
2. What parts of my work do I like?
3. What parts of my work can I improve upon?

LEARNING ENRICHMENT

Lesson Variations

Some students may want to learn more about making natural dyes. Have them research dyes and try to make natural dyes from available materials. Carrot tops and beets make excellent dyes. Then have them make another quilling design using the dyes they have made.

Art Across the Curriculum

Science: Let interested students learn more about the porcupine. They can make clay and toothpick models of porcupines and write reports about the animal.

Lesson 35

American Indian Art **pages 78-79**

LEARNING OBJECTIVES

Understanding Art

Students will state that art changes and progresses over time. Learners will explain that art often represents what is important to a people.

Creating Art

Students will create art in response to Indian examples.

Appreciating Art

Students will describe the messages in and the historical significance of Indian art.

Vocabulary

clay coil pottery

LESSON PREPARATIONS

Suggested Art Materials
Each student will need: 6" x 22" grey construction paper, crayons (yellow, gold, red, black, white, and red-brown), black marker, ruler

Additional Teaching Materials
paper to cover work areas, examples of Indian symbols, circular forms, iron (optional), clay (optional)

GUIDED TEACHING

Lesson Focus
Ask the students to name all the symbols they can. Make sure each thing named is indeed a symbol.

Focus on Looking and Thinking
• Have available examples of Indian designs for the students to observe. Let the students discuss the significance of the symbols.

• Give some background on our lack of knowledge about Mimbres art. Explain that many of the Mimbres sites have been looted so that the pottery is not seen in its original resting places. The anthropologists and the Hopi Indians have guessed about the meanings. Obviously, the animals appearing on the pottery were important in the lives of the Mimbres. Rabbits form a large part of the diet of the Pueblo dwellers today, and no doubt did at the time of the Mimbres, too. Yet, others of the animals were in short supply. Ask the students their opinions about the symbolism.

• Discuss the realism and/or lack of realism in the symbols on the pottery shown in the text.

• Discuss the colors used to decorate the pottery. The pottery of the Mimbres and Hopi Indians use the same colors. Why?

• Discussion questions:
 1. What do you like about Indian art?
 2. How can you tell when an artwork is Indian art?
 3. What three colors would you choose for a design using Indian symbols?

Focus on Making Art
• As a good follow-through for the previous lesson, encourage the students to use circles in their designs. They can use plates or other circular forms to draw the circles. Then they can create designs that are appropriate for circles. Suggest five styles that the Indians often use:
 1. Quadrants—divide circle into fourths; each portion has a rotated version of the same design.

 2. Circular layout—concentric circles with a different pattern in each band.

 3. Parallel lines—perhaps five bands of design running horizontally across the circle.

 4. Mirror image—divide circle in half; one side shows exact opposite of design in other half (symmetry).

 5. Central figure with a wide band of pattern repeated around edge of circle.

• Students should use rulers to create the borders and to construct straight lines.

• Supervise the students to make sure they use marker on all their lines. Also help them to select three appropriate colors from the crayons given.

• Point out that the students should use heavy pressure on the crayons to make the colors really stand out.

• Cleanup: Have the students put the crayons and rulers away. Discard the paper covering the work areas.

EVALUATING PROCEDURES

Learning Outcomes
1. Why do you think historians study the symbols on Indian pottery?
2. Does your artwork contain symbols or just a design?
3. Do the symbols you chose represent or stand for something that is important to you?

Evaluation
Use these questions to evaluate students' progress:
1. Did students show understanding of the vocabulary during oral discussions?
2. Did the students follow the steps in *Making Art?*
3. Did students criticize artworks by applying art concepts presented?

Encourage the students to evaluate their own work. Students can ask themselves the following questions:
1. Did I follow each step in *Making Art?*
2. What parts of my work do I like?
3. What parts of my work can I improve upon?

LEARNING ENRICHMENT

Lesson Variations
• You may have the students complete this activity on 18" circles of butcher paper in yellow, brown, red, or white. This will reemphasize the idea that some

designs will work really well on a circle (as they learned in the quilling activity). When the designs are complete, have the students repeatedly crumple and iron the paper to achieve an aged effect.

• Have students actually create clay coil pottery and decorate it appropriately.

Art Across the Curriculum

Social Studies: Ask interested students to do more research on the Mimbres Indians. They can share what they learn by writing a paper or an imaginative short story.

Planning for Tomorrow's Lesson

Ask the students to bring in all kinds of calendars to use in Lesson 36.

Lesson 36

Art That Tells Time pages 80-81

LEARNING OBJECTIVES

Understanding Art
Students will state that art is often used to record important events.

Creating Art
Students will use simple lines and shapes to create winter counts.

Appreciating Art
Students will explain the significance of Indian art to the culture.

Vocabulary
winter count

LESSON PREPARATIONS

Suggested Art Materials
Each student will need: brown construction paper, thin coffee, thick brush, thick black marker

Additional Teaching Materials
paper to cover work areas, large cans, a variety of calendars

Planning Ahead
Set up a coffee painting station covered with paper, where students can find large cans of thin coffee and large brushes.

GUIDED TEACHING

Lesson Focus
Ask the students to name all the ways they know of to tell time.

Focus on Looking and Thinking
• Talk about the Cheyenne buffalo hide. Inform the students that the Cheyenne once lived around Lake Superior, where they fished and hunted. In the late 1700s, they moved to the Great Plains. Here they hunted buffalo and lived in tepees. See if the students can identify any of these facts by studying the winter count.

• Direct the students' attention to the calendar collection that you and the students have brought to class. Let the students discuss the similarities and differences among the calendars.

• Ask the students what the calendar on page 81 shows. Do they feel the picture is appropriate for the month of December? Comment on the little pictures occurring on individual days.

• Discussion questions:
 1. How many different types of artwork can be found in the class collection of calendars?
 2. Do you think it was difficult for the leaders of the Indian tribe to choose the most important thing that had happened since last year?
 3. Would it be difficult for you to decide on a most important event? What about for the whole class to decide?
 4. Have you ever seen a drawing on an animal skin before? Where? What other things from nature have you seen with drawings on them?
 5. Why do you think the winter count was and is so important?

Focus on Making Art
• Direct the students to *carefully* tear the edges of the brown paper and to *carefully* crumple it. Otherwise, the paper may rip.

• Emphasize that the designs should be simple, like the Indian examples.

• Cleanup: Have an art monitor clean the painting station. Ask the students to cap the markers and throw away all the torn scraps of paper.

EVALUATING PROCEDURES

Learning Outcomes
1. Why did the Indians begin making winter counts?

2. Do the lines and shapes of your winter count tell a story?

3. What did you like best about this art activity?

Evaluation
Use these questions to evaluate students' progress:
1. Did students show understanding of the vocabulary during oral discussions?

2. Did the students follow the steps in *Making Art*?

3. Did students criticize artworks by applying art concepts presented?

Encourage the students to evaluate their own work. Students can ask themselves the following questions:
1. Did I follow each step in *Making Art*?

2. What parts of my work do I like?

3. What parts of my work can I improve upon?

LEARNING ENRICHMENT

Art Across the Curriculum
Mathematics/Social Studies: Let interested students learn more about the origin of the calendar. They might want to make other types of calendars similar to those used by other civilizations. Inventing a new calendar format would be a challenge for gifted students.

Language Arts: Encourage the students to also write about the great events shown on their winter counts.

Seasonal Art
Have the students extend this activity to create a 12-month calendar with an illustration for each month. These make excellent Christmas gifts.

Lesson 37

Art to Wear pages 82-83

LEARNING OBJECTIVES

Understanding Art
Students will describe roles of masks throughout history.

Creating Art
Students will create and decorate masks.

Appreciating Art
Students will demonstrate the ability of an artist to be original even when working with standard forms.

Vocabulary
mask, decorate

LESSON PREPARATIONS

Suggested Art Materials
Each student will need: 3″ x 10″ strip of tagboard; scissors; a variety of paints, crayons, markers; a variety of scraps (construction paper, ribbons, feathers, trims, etc.); glue

Additional Teaching Materials
newspaper, hole punch, yarn, map or globe, a variety of masks

Planning Ahead
Set up stations where students can choose their materials—a color station, a trim station, a glue station, etc. You may choose to have your students actually work at the stations, too.

Helpful Hints
Manipulating scissors to punch holes is an important skill. Depending on the abilities of your students, however, they may need to have adult supervision during this process. Alternatively, you can pre-cut the holes with a hole punch. The students can then shape the eyes however they want.

GUIDED TEACHING

Lesson Focus
Ask the students to recall favorite Halloween costumes. What was the most important part of the costume? Why?

Focus on Looking and Thinking
• Have available a variety of masks for students to try on, compare and contrast.

• Ask volunteers to locate Peru, Mexico, and Alaska on a map or globe. Give the students some background information on the Haida people. These Indians lived by fishing, hunting, and collecting plants. They had a rigid social structure, with a small upper-class segment whose wealth came in the form of slaves and fishing rights. The Haida are known for other crafts besides mask-making: canoe building, house building, wood carving, carvings from black slate.

• Discussion questions:
 1. Why do you think so many people in so many places, so long ago, made masks?

2. How many different materials can you name from which masks are made?

3. Can you find symbols on the masks in this lesson?

Focus on Making Art

• Show the students how the masks will fit over their faces.

• Have the students look at all the shapes of the eyes in the mask collection and in the lesson.

• Remind the students that moveable parts will add interest to the masks.

• You can use two 10″ pieces of yarn to tie a mask on. Punch holes at the two ends of the mask, pull the yarn through, and tie the pieces together in back.

• Cleanup: Have the students put all the useable scraps in the appropriate boxes at the stations. Throw away scraps too small to use. Clean and cap the glue containers, and store the scissors in a safe place.

EVALUATING PROCEDURES

Learning Objectives

1. Why do you think masks have been so important?

2. Were you able to use the materials available to create an interesting mask?

3. Which mask is the most original? Why?

Evaluation

Use these questions to evaluate students' progress:
1. Did students show understanding of the vocabulary during oral discussions?

2. Did the students follow the steps in Making Art?

3. Did students criticize artworks by applying art concepts presented?

Encourage the students to evaluate their own work. Students can ask themselves the following questions:
1. Did I follow each step in Making Art?

2. What parts of my work do I like?

3. What parts of my work can I improve upon?

LEARNING ENRICHMENT

Creative Dramatics

Let interested students create a skit or play in which the characters wear masks. (You will be surprised how many students will volunteer, since they can hide behind masks.) Encourage the students to write the play, practice it, and then share it with the class.

Creative Expression

Some students may want to share their masks by doing an impromptu dialogue for a small group or for the whole class. Encourage the students to speak to the group as if they were the masks, alive and able to talk.

Lesson 38

Colorful Cloth pages 84-85

LEARNING OBJECTIVES

Understanding Art

Students will recognize the process of tie-dying. Learners will explain why art styles can spread from country to country.

Creating Art

Students will tie-dye pieces of fabric, planning the types of designs beforehand.

Appreciating Art

Students will identify the variations found in a single type of art.

Vocabulary

tie-dye, anthropologist

LESSON PREPARATIONS

Suggested Art Materials

Each student will need: permanent black marker, 18″ x 18″ cotton fabric, small objects (marbles, nails, pebbles), waxed twine, scissors, plastic bag, rubber-bands

Additional Teaching Materials

soda ash fixer or washing soda (*not* baking soda), plastic dishpans, gallon containers, wooden spoons, cold-water dyes, 3 or 4 pairs plastic gloves, *uni*odized salt, measuring cups and spoons, papers for work areas, mild laundry soap, paper towels, food coloring (optional), waxed paper (optional)

Planning Ahead

Do not be overwhelmed by the list of materials for this lesson. These materials are readily available, and the lesson itself is not complicated if you set it up in stations. Following are the various stations you'll need, with complete instructions for setting them up.

• Dye station. Prepare the dyes the night before. Mix a solution of dye, salt, and water in a gallon jug, using a different jug for each primary color. Three to five teaspoons of dye dissolved in a cup of hot water will make a dye of strong intensity. Dissolve one cup of salt in two cups of hot water and add it to the jug. Fill the jug with cool water and mix.

• Soda-soak station. Use ½ cup of soda ash fixer (also known as ordinary washing soda) per gallon of water. You'll need to soak everyone's fabric before it is added to a dyebath, so you'll need about four gallons in large dishpans at this station.

• Tying station. The string must be waxed because otherwise the fiber-reactive dye will also penetrate and bond with the string, going right through and dying the fabric under the string. Melt beeswax in a tin can set in a pan of water. Dip the string or twine in wax and remove. You'll need lots of string and also a large supply of rubber bands at this station.

• Washing station. You'll need mild laundry soap and lots of clear water.

Helpful Hints
Nine yards of sheeting or unbleached muslin will yield 36 squares of 18" x 18" fabric. Make sure the cloth is clean and ironed.

GUIDED TEACHING

Lesson Focus
Have the students examine their clothes for designs of circles and lines. What other types of designs can they find?

Focus on Looking and Thinking
• Let the students locate China, Indonesia, and Africa on the map. Discuss how far apart these countries are. Do the students have theories about why tie-dye has been found in all these countries?

• Try to find plenty of examples of tie-dye for the students to see. You can use these examples to explain the various types of designs one can create with the tie-dye technique.

• Discussion questions:
 1. Why can't scientists figure out exactly where tie-dye originated?
 2. Why are there so many designs possible in tie-dying?
 3. How would you answer the question at the bottom of page 84?

Focus on Making Art
• You might want to demonstrate for your students

how to create different types of designs. Accordion pleats create lines. Big circular shapes can be formed by sticking a finger into the fabric, forming a tent. Fasten a rubberband around the base of the finger, slide the finger out, and then tie string around the rubberband. Concentric circles can be made by tying strings down the tent. Smaller circles can be made by tying marbles and stones into the fabric. Tiny, wonderful circles are formed by tying the heads of galvanized nails into the fabric.

• By diagramming on the board, you can show how to create balance with the circles or by combining circles and lines.

• The dyebath should be gently stirred with a wooden spoon while the fabrics are in it.

• Don't hang the fabrics to dry, or else the dye will collect at the bottom. Lay them on stacks of newspaper instead.

• The students may need help in cutting the strings off; it is easy to cut the cloth. Make sure the gloves are still worn.

• Cleanup: Discard the strings and rubber bands. Rinse out the soda soak containers. The unused dye can be saved. Store the scissors in a safe place. Hang the almost-dry fabrics in a sunny window.

EVALUATING PROCEDURES

Learning Outcomes
1. What causes parts of the tie-dye to be white?
2. Is your design balanced? Does it have circles and lines?
3. What would you like to add to your colorful cloth?

Evaluation
Use these questions to evaluate students' progress:
1. Did students show understanding of the vocabulary during oral discussions?
2. Did the students follow the steps in *Making Art*?
3. Did students criticize artworks by applying art concepts presented?

Encourage the students to evaluate their own work. Students can ask themselves the following questions:
1. Did I follow each step in *Making Art*?
2. What parts of my work do I like?
3. What parts of my work can I improve upon?

LEARNING ENRICHMENT

Lesson Variations
• Tie-dye is a good way for your students to experi-

ment with color mixing. They can dye the cloth in one color, let it dry, and then dye it in another color, changing the placement of objects.

• Students can fold and dye paper. Fold paper towels into quarters, quarters again, and then diagonally. Dip each corner into water and then each corner into a different hue of food coloring. Spread the towels out on waxed paper to dry.

Creative Movement
Have the students research the beautiful art form of scarf dancing. Then have them create a scarf dance based on the use of their colorful, tie-dyed cloths.

Lesson 39

Layers and Layers of Crayon
pages 86-87

LEARNING OBJECTIVES

Understanding Art
Students will identify how the media used influence the way a product looks.

Creating Art
Students will use crayons in a new way to create crayon etchings. Students will create simple but symbolic designs.

Appreciating Art
Students will recognize that ancient Aboriginal art reflects a way of life.

Vocabulary
Aboriginal bark painting, media

LESSON PREPARATIONS

Suggested Art Materials
Each student will need: 8½" x 11" white paper, crayons (red, brown, black, yellow, orange), paper towel, scissors

Additional Teaching Materials
paper to cover work areas, map or globe, 2-3 pieces flat bark, encyclopedias

GUIDED TEACHING

Lesson Focus
Show the students where Australia is located by

using a map or globe. Ask them to close their eyes and try to imagine what Australia is like.

Focus on Looking and Thinking
• Review with the students the ancient art forms they have learned about so far. What does Aboriginal art hold in common with these other forms?

• Let the students feel actual pieces of bark so they can better imagine the accomplishment of the Aborigines in creating such beautiful artworks from such limited materials.

• Most encyclopedias show examples of Aboriginal bark paintings. Find examples of bark paintings that are made up of lines and shapes. These will supplement the realistic bark painting shown in the text.

• Discussion questions:
 1. How many types of media can you name?
 2. What do you notice about the shapes used in the Aboriginal bark paintings?
 3. What do you notice about the lines used in the Aboriginal bark paintings?
 4. Do you like the symbolism used in the student artwork?
 5. Why do you think the Aborigines used bark as a surface on which to paint?

Focus on Making Art
• As the students apply the first layer of crayon, urge them to make the surface quite waxy.

• Emphasize the need to be aware of the pressure applied when adding the other four layers.

• Inform the students that rubbing the surface of the picture with a paper towel smoothes it and makes it glossy by ridding it of the extra residue.

• Encourage the students to repeat shapes in their designs to create unity. They may need to plan their etchings on separate paper first.

• Cleanup: Have the students throw away the papers covering the work areas, being careful to keep all crayon wax on the paper. Collect and store the scissors in a safe place.

EVALUATING PROCEDURES

Learning Outcomes
1. How is your artwork different from the Aboriginal example in the book?
2. Do your colors show through on the etching? Is your etching design simple enough?
3. What do you like best about your artwork?

Evaluation
Use these questions to evaluate students' progress:

1. Did students show understanding of the vocabulary during oral discussions?

2. Did the students follow the steps in *Making Art*?

3. Did students criticize artworks by applying art concepts presented?

Encourage the students to evaluate their own work. Students can ask themselves the following questions:

1. Did I follow each step in *Making Art*?

2. What parts of my work do I like?

3. What parts of my work can I improve upon?

LEARNING ENRICHMENT

Lesson Variations

This activity creates remarkably dissimilar results when different color schemes are used. The students might enjoy doing a modern etching that uses bright, psychedelic colors and wild designs.

Art Across the Curriculum

Language Arts: Let interested students write stories or poems about the designs they etched. Encourage them to use their imaginations to tell about the symbolism or meanings of the designs.

Social Studies: Students can learn much more about the Aborigines and about Australia through research. Encourage them to read as much as they can about the country and its people. They can illustrate, write, or tape record their findings.

Lesson 40

Art That's Life-Sized pages 88-89

LEARNING OBJECTIVES

Understanding Art

Students will state that art can be any size. Learners will recognize a silhouette.

Creating Art

Students will create life-sized self-portraits.

Appreciating Art

Students will identify buildings, murals, and other large art forms as valid works of art.

Vocabulary

mural, mosaic, sculpture, silhouette, detail, self-portrait

LESSON PREPARATIONS

Suggested Art Materials

Each student will need: butcher paper, floodlight or filmstrip projector light, a variety of markers, crayons, scissors

Additional Teaching Materials

examples of Christo's work, stapler (optional), scrap paper (optional)

GUIDED TEACHING

Lesson Focus

Have two volunteers come to the front of the room. One volunteer will be the detective. He or she will point out all the details that should be included in an artwork depicting the other student. Urge the students to point out all the details they can find.

Focus on Looking and Thinking

• After the students have observed the artworks in this lesson, tell them about a famous artist who does really big art. His name is Christo, and he wraps buildings, islands, and other huge things with pieces of colorful fabric. Once the objects are wrapped, he takes pictures of them and then unwraps them. If possible, show an example of his work. (His most famous recent work was an entire island wrapped in bright pink fabric.)

• Urge the students to find all the details they can in the artworks shown in the lesson. Point out that art is found in tiny things as well as in big things. Art can be of any size.

• Discussion questions:
 1. What is the largest work of art you've ever seen?

 2. Why do you think some artists like to create such huge works of art?

 3. What other large pieces of art have you studied this year?

Focus on Making Art

• An adult may be needed to assist students with placement of shadows on the paper.

• Encourage the students to experiment with their poses before beginning. If no lights are available, have the students lie down on paper. The partners can trace around the bodies.

• Point out that the students should go slowly when drawing the silhouettes. However, they should not worry about perfection since the shapes will be cut out.

• Remind the students that they should be detail detectives. Have them put as many details as possible on their shapes.

• Cleanup: Have the students throw away any scraps and put the crayons away. Collect the scissors and markers and store them properly.

EVALUATING PROCEDURES

Learning Outcomes
1. What is a silhouette?
2. Did you miss any details when making your life-sized portrait?
3. How big do you think most art should be? Why?

Evaluation
Use these questions to evaluate students' progress:
1. Did students show understanding of the vocabulary during oral discussions?
2. Did the students follow the steps in *Making Art*?
3. Did students criticize artworks by applying art concepts presented?

Encourage the students to evaluate their own work. Students can ask themselves the following questions:
1. Did I follow each step in *Making Art*?
2. What parts of my work do I like?
3. What parts of my work can I improve upon?

LEARNING ENRICHMENT

Art Across the Curriculum
Language Arts: Have the students write name poems to accompany their self-portraits. Using the letters of their first names, written vertically, the students should think of words or sentences (beginning with the letters) that are appropriate to their personalities.

Lesson Variations
You can have the students cut out two identical silhouettes, staple them together, and stuff them to give them form. These silhouettes could then be placed in the students' seats for the next parents' night.

Enhancing Self-Concept
Follow up on the concept that each of the students is an artwork. Have them tell you how the human body is artistically valid, and how an individual's details fit into the artwork.

Lesson 41

Chinese Paper Art pages 90-91

LEARNING OBJECTIVES

Understanding Art
Students will recognize papier-mâché.

Creating Art
Students will create papier-mâché dragons.

Appreciating Art
Students will explain the importance of symbols to a culture.

Vocabulary
papier-mâché, Oriental art

LESSON PREPARATIONS

Suggested Art Materials
Each student will need: 2 or more large paper bags, masking tape, liquid starch, paper towels, newspaper, wire coat hanger, a variety of brushes and paints, white glue

Additional Teaching Materials
egg cartons, a variety of dragons, cardboard scraps, gesso (optional), shellac (optional)

Planning Ahead
• Plan on using 4-6 separate art sessions to complete this activity.

• Set up two stations, a papering station and a painting station.

• Cut or tear the newspaper and paper towel strips prior to the lesson.

• The wire coat hangers should be uncoiled at the tops so the students can easily shape them.

Helpful Hints
You can add drops of food coloring to each day's starch supply. This will help the students identify whether or not they have covered the entire previous layer.

GUIDED TEACHING

Lesson Focus
Have the students imagine a dragon walking into the classroom right now. How would it look? Let them describe what they imagine.

Focus on Looking and Thinking

• Spend some time discussing the Hsueh Shao-Tang dragon. Ask the students what they think about an artwork made from torn stamps.

• Give the students some brief background material on the people of China. China has four times as many people as the United States. Most Chinese work on small farms. They work for long hours and receive very little pay. Even though the Chinese have few luxuries, they seem content. They love to celebrate. The Chinese New Year is their biggest holiday. On this day (which varies yearly), children receive money wrapped in red paper. Red represents happiness and good luck for the Chinese. The celebration lasts a total of 15 days and includes dancing, kite flying, and many other fun things.

• The students will enjoy hearing some fun information about the legend of dragons. The ancient Chinese believed the dragon protected them and brought them good fortune. They thought the dragon controlled the land. By humping its back, it could make hills. By bringing rain, it could produce good crops. In general, ancient Chinese artists portrayed the dragon as long and writhing, with two sets of legs and no wings. A scale ran the length of its back. Its eyes were bulging, and it had horns. The brightest colors were used on dragons. History has shown that only the emperor and his children could have clothing or bowls that showed dragons with 5 claws on each foot. Everyone else had dragons portrayed with 3 or 4 claws.

• Point out the differences and similarities among the examples of dragons you have collected. Stress that the dragon can look different each time because it is *imaginary*.

• Discussion questions:
 1. What is the shape you notice in most dragons? (square jaw)
 2. Why do you think this imaginary animal is an important Chinese symbol?
 3. Do Americans have important symbols? What are they? What would you like them to be?

Focus on Making Art

• Familiarize the students with the stations you have set up for this project.

• Allow the students to experiment with their coat hanger shapes until they like the way they look. Suggest to the students that they can show movement in their wire forms (tail lashing out to side, backbone humping, etc.)

• As the students wad the paper, encourage them to wrap the wads with masking tape so they won't pop open.

• The students will need to use at least three layers of papier-mâché to obtain a fairly solid form. Allow *each* layer to dry before the next layer is added. Bits of paper that pop up when dry can be glued down.

• The paper towel coat can use smaller pieces that look more like scales.

• Egg cartons work well for jaws and nostrils. To add details like these, the students can use the paper strips just like bandages.

• Gesso can be applied after the last coat. It will produce a hard, white sealing coat and a perfect surface for tempera paints.

• Let the students' imaginations run wild with the painting stage. Remind them that red is a symbolic Chinese color. Also encourage them to use *bright* colors.

• You or other adults can cover the completed dragons with a coat of shellac. This will strengthen them and make the paint permanent.

• Cleanup: Ask art monitors to clean the work stations. Have the students clean their own areas, throwing away all scraps and returning supplies to appropriate places. Clean and store the brushes and paint containers.

EVALUATING PROCEDURES

Learning Outcomes
1. For what kinds of art projects does papier-mâché work well?
2. Does your dragon look like a symbol of China?
3. What do you like best about your dragon? What could you have done better?

Evaluation
Use these questions to evaluate students' progress:
1. Did students show understanding of the vocabulary during oral discussions?
2. Did the students follow the steps in *Making Art*?
3. Did students criticize artworks by applying art concepts presented?

Encourage the students to evaluate their own work. Students can ask themselves the following questions:
1. Did I follow each step in *Making Art*?
2. What parts of my work do I like?
3. What parts of my work can I improve upon?

LEARNING ENRICHMENT

Art Across the Curriculum
Social Studies: Encourage interested students to

learn more about the Chinese New Year. They might even choose to plan a related event for the class to participate in. Other students can find out more about the symbols of other countries. They can illustrate their findings to share with the class.

Lesson Variations

• Some students may want to create dioramas that include the dragons as the main points of attention.

• Students can use printing to decorate the dragons. First, a colored base of paint should be applied. Then potato or carrot prints can be made over the paint to appear as scale-like shapes.

Planning for Tomorrow's Lesson

Ask the students to bring in objects and pictures which they feel are symbolic of America.

Lesson 42

Your American Story pages 92-93

LEARNING OBJECTIVES

Understanding Art
Students will recognize American symbols.

Creating Art
Students will create self-portraits with symbolic backgrounds.

Appreciating Art
Students will identify art as a vehicle for symbolism.

Vocabulary
self-portrait, foreground, background, oval, symbol

LESSON PREPARATIONS

Suggested Art Materials
Each student will need: drawing paper, crayons

Additional Teaching Materials
a variety of American symbols, a variety of photographs showing all kinds of people at work, mirror (optional), other drawing media (optional)

Planning Ahead
Display all the collected symbols of America on a table. The students can refer to these while completing their artworks.

GUIDED TEACHING

Lesson Focus
Define *patriotic* for the students. Ask them how they as artists can create patriotic artworks.

Focus on Looking and Thinking

• Let the students talk about what they want to be when they grow up.

• Let the students observe and handle the pictures and objects that have symbols of America.

• Talk about the American Colonial Limners. These were the earliest artists in America. They were self-taught and looked for work by wandering from place to place. They painted signs; carriages; decorations on houses, shops, and barns; and portraits. Although not particularly skilled at portraiture, the Limners are a valuable part of American art history. During the winter months, the Limners would prepare canvases that included stock backgrounds, figures posed in stock ways, and various costumes. When the weather warmed, the Limners would take the canvases and travel in search of colonists who wanted portraits done. The customers simply selected the poses and costumes they liked, and the Limners filled in the faces.

• Discussion questions:
 1. Are there any symbols here that you would not have considered American?
 2. What American symbols are your favorites?
 3. Can you explain the difference between background and foreground?
 4. What messages do you read in the pictures for this lesson?

Focus on Making Art

• Discuss the oval shape. Draw an oval on the chalkboard if necessary. Point out that most of our faces are oval.

• Encourage the students to think about how to best show their desired careers. Point out that the student whose self-portrait is included in the lesson wants to be an artist.

• Remind the students that colors can be symbolic, too.

• You might suggest that the students use mirrors to find details to include in their self-portraits.

• The students' artworks might show up better if they outline the major shapes with black markers.

• Cleanup: Have the students put away the crayons.

EVALUATING PROCEDURES

Learning Outcomes
1. How can an artist give a message in an artwork?

2. Does your self-portrait look like you? Does your background tell what you will do in America?

3. What does your artwork tell about yourself?

Evaluation

Use these questions to evaluate students' progress:
1. Did students show understanding of the vocabulary during oral discussions?
2. Did the students follow the steps in *Making Art*?
3. Did students criticize artworks by applying art concepts presented?

Encourage the students to evaluate their own work. Students can ask themselves the following questions:
1. Did I follow each step in *Making Art*?
2. What parts of my work do I like?
3. What parts of my work can I improve upon?

LEARNING ENRICHMENT

Lesson Variations

• Some students may want to create another self-portrait, this time using chalk, paint, or charcoal.

• Have the students do self-portraits that show them at 70 years of age. They can make the backgrounds show where they'll be at that time and what they'll be doing.

Art Heritage

Ask interested students to research famous drawings and paintings that symbolize America or tell about its great events. Encourage the students to find out about the artists of such works and write a short report on each.

Lesson 43

Art to Live In pages 94-95

LEARNING OBJECTIVES

Understanding Art

Students will list the many parts of an architect's job. Learners will recognize three-dimensional forms in buildings.

Creating Art

Students will draw architects' blueprints.

Appreciating Art

Students will identify architects as artists. Learners will describe the roles of environment and purpose in the designing of buildings.

Vocabulary

architect, blueprint, three-dimensional forms

LESSON PREPARATIONS

Suggested Art Materials

Each student will need: pencil, newsprint, 12″ x 22″ white construction paper, blue or black chalk

Additional Teaching Materials

an actual blueprint, a variety of pictures of buildings, fixative

GUIDED TEACHING

Lesson Focus

Display an actual blueprint. Ask the students if they know what it is. Discuss with them the things a blueprint shows.

Focus on Looking and Thinking

• Ask the students to name the forms shown in the picture on page 94. See if they can also locate three-dimensional forms in the photographs on page 95.

• Inform the students that St. Basil Cathedral is located in Moscow, Russia. Explain that it is one of the most famous buildings in the world. Identify the Pompidou Center as a very modern building in Paris. Explain that it houses a museum and many other cultural attractions.

• Discussion questions:
 1. Do you think architects are important to our communities? Why?
 2. What kind of feeling do you get by looking at St. Basil Cathedral? How does the Pompidou Center make you feel? Which do you like better? Why?
 3. Why do you think an architect must study the environment of a building site before planning a building?

Focus on Making Art

• It is important that the students consider all of the questions listed in step one before beginning. Sketching their ideas is an important part of this activity. Encourage them to sketch in the background as well.

• Make sure the students complete the major outlines of the buildings before adding details.

• Point out that many of the details may be functional as well as decorative.

• Reinforce the idea that the students are working as architects.

• Cleanup: Store the chalk. The students may need to wash their hands. If possible, spray the blueprints with fixative or hair spray in a well-ventilated area.

EVALUATING PROCEDURES

Learning Outcomes
1. Would an architect plan a different type of building for a lot in the forest by a lake than for a lot in the center of the city near a highway? Why?
2. Can someone looking at your blueprint see what the building would look like if it were built? Could he or she recognize three-dimensional forms?
3. Why do you think architects are so important in our world?

Evaluation
Use these questions to evaluate students' progress:
1. Did students show understanding of the vocabulary during oral discussions?
2. Did the students follow the steps in *Making Art*?
3. Did students criticize artworks by applying art concepts presented?

Encourage the students to evaluate their own work. Students can ask themselves the following questions:
1. Did I follow each step in *Making Art*?
2. What parts of my work do I like?
3. What parts of my work can I improve upon?

LEARNING ENRICHMENT

Lesson Variations
• Some students might want to make blueprints that resemble those made years ago. They can use blue construction paper and white chalk to achieve the same effect.

• Let interested students collect found objects to use to create models from the blueprints. (This would work well as an at-home project.)

Careers in Art
Have several students write a letter to a local architect, enclosing several of their blueprints for his or her examination. Make sure the students tell the architect what they have learned. They might like to invite the architect to visit the class and tell more about the career of architecture.

Lesson 44

Art That Shows Ideas and Feelings pages 96-97

LEARNING OBJECTIVES

Understanding Art
Students will state the purpose of nonobjective art.

Creating Art
Students will create nonobjective paintings.

Appreciating Art
Students will describe the link between feelings and art.

Vocabulary
nonobjective art

LESSON PREPARATIONS

Suggested Art Materials
Each student will need: 36″ x 36″ butcher paper, paint (many colors), a large brush for each color of paint chosen, reuseable palette

Additional Teaching Materials
newspaper, drawing paper, crayons, sponge brushes (optional)

Helpful Hints
Cover one or more large tables with newspaper. Put the paints, brushes, and paper on the tables. Have the students go to these painting stations as you direct them. Let the students know that they are responsible for making sure their work areas are neat and prepared for the next artist.

GUIDED TEACHING

Lesson Focus
Have the students respond with color names to your suggested moods: calm, angry, sleepy, excited, happy, silly, etc.

Focus on Looking and Thinking
• Discuss with the students the different ideas and feelings portrayed by the two paintings in the lesson.

• Have the students do the following warm-up activity using crayons:

1. Use a color that makes you feel calm to draw calm lines or shapes.
2. Use a color that makes you feel angry to draw angry lines or shapes.
3. Find a color that makes you feel special to draw your own kinds of lines or shapes.
4. Choose a color that reminds you of computers, and draw lines or shapes that a computer might draw.

• Discussion questions:
1. What is the purpose of nonobjective art?
2. Do you think you feel about these paintings the way the artists wanted you to feel?
3. Why do you think artists create nonobjective art?

Focus on Making Art

• Stress the fact that the students should choose *three* colors.

• If possible, let the students experiment with large brushes *and* sponge brushes. They can choose the types of brushes that work well for what they intend.

• These paintings will require a large area in which to dry. You might consider having only a few students paint each day.

• Cleanup: Have the students throw away the top sheets of their palettes. The work areas should already be clean, if the students have been preparing them for the next group of painters.

EVALUATING PROCEDURES

Learning Outcomes
1. Is your artwork a nonobjective painting? Why or why not?
2. What idea or feeling does your artwork show?
3. Why did you paint this particular painting today? Would it have been different yesterday?

Evaluation
Use these questions to evaluate students' progress:
1. Did students show understanding of the vocabulary during oral discussions?
2. Did the students follow the steps in *Making Art*?
3. Did students criticize artworks by applying art concepts presented?

Encourage the students to evaluate their own work. Students can ask themselves the following questions:
1. Did I follow each step in *Making Art*?

2. What parts of my work do I like?
3. What parts of my work can I improve upon?

LEARNING ENRICHMENT

Art History
Explain to the students that *abstract art* is the broad term for artworks that portray real-life scenes or objects in non-realistic ways. Try to make them understand that nonobjective art does *not* start with a real-life vision. Then have the students choose a favorite realistic painting and recreate it in an abstract form.

Art Across the Curriculum
Language Arts: Let interested students keep diaries of their ideas and feelings for a week or longer. They might want to illustrate each page with nonobjective art that reveals their moods.

Lesson 45

Art That Moves pages 98-99

LEARNING OBJECTIVES

Understanding Art
Students will list the basic steps behind television production. Learners will recall the importance of having a center of interest in an artwork.

Creating Art
Students will work with the class to create a television show from a story. Learners will use colors, placement, and background/ foreground to create effective illustrations.

Appreciating Art
Students will describe the link between oral and visual communication.

Vocabulary
film, storyboard

LESSON PREPARATIONS

Suggested Art Materials
Each student will need: drawing paper (manila is a good weight), felt markers, glue or paste

Additional Teaching Materials

butcher paper. These materials will be needed to make the television screen: copier-paper box with lid (11½″ x 17½″ x 10″), extra cardboard from another box, utility knife, white glue, old broom handle or 1″ dowel to form 2 dowels 16″ long, saw, hammer, finishing nails, spray enamel, double-sticky tape or stapler

Planning Ahead

Follow these steps to make the television set:

1. Lay copier-paper box on its side, lid perpendicular to the floor. (The screen will be wider than it is tall.) Cut the lid to form a frame around the screen, 1½″ in at top and bottom, 2″ in from sides.

2. Cut 4 holes, 2 in the top and 2 in the bottom on the long sides of the box. To determine where to cut the holes, cut the butcher paper to size, fasten one end to the dowel, roll the paper on the dowel, and measure the radius from the center of the dowel to the outer edge of the paper roll. Add 1″, and that measurement will be the distance the center of the holes should be from the edges of the box.

3. The television box must sit up off the table to enable the dowels to extend through the box. Cut an extra box to form a platform. Fasten the television box to the platform with white glue.

4. Spray the box with enamel (undercoat and finish coat).

GUIDED TEACHING

Lesson Focus

Have the students name their favorite television shows and tell what they like best about them.

Focus on Looking and Thinking

• Show the students the television box, and explain what it is.

• Stress to the students that all stories and television shows have a sequence or an order in which things happen. Have the students help you put the steps discussed on page 98 into sequential order on a chart. (Story → Select characters and other details → Filming)

• Discussion questions:

1. What kind of setting does your favorite television show use? How does it fit the story?

2. What kinds of stories do your favorite television shows have?

3. What other decisions do you think television producers must make before filming?

Focus on Making Art

• Suggested stories to read aloud are *Come Back, Amelia Bedelia* and the Curious George stories. These have a lot of action and many different scenes.

• If it is difficult to find enough scenes in the story you have chosen, use closeups for some of the action.

• As the students begin their illustrations, stress the art concepts that are important in this lesson. Contrast between light and dark areas in the individual pictures will allow objects to pop out from the background and be seen across the room. In each illustration there should be a strong center of interest. Point out that the center of interest could be brighter and more detailed than the background. Also encourage the students to fill the space of their papers. Remind them that tiny drawings will not be seen from the back of the room.

• When the pictures are complete, retell the stories and have the students bring their pictures to you as they recognize their own scenes. Number the pictures on the backs to correspond to the order of the story. Then have the students come one at a time to adhere their drawings to the butcher paper.

• To "load the film" follow these steps:

1. Tape the butcher paper to the dowels with double-sticky tape, or staple it.

2. Wind up the scroll and insert it in the box.

3. Nail the finishing nails to the dowels. Tack the nails just outside the box so that the dowels can't move up or down while the show is rolling.

• Cleanup: Have the students cap the markers and store them in their proper place. Clean the glue or paste containers and store them safely.

EVALUATING PROCEDURES

Learning Outcomes

1. What are the basic steps in making a television show?

2. Could the picture you created be seen easily from the back of the room?

3. Will this television show keep the interest of viewers? Why?

Evaluation

Use these questions to evaluate students' progress:

1. Did students show understanding of the vocabulary during oral discussions?

2. Did the students follow the steps in *Making Art*?

3. Did students criticize artworks by applying art concepts presented?

Encourage the students to evaluate their own work. Students can ask themselves the following questions:

1. Did I follow each step in *Making Art*?

2. What parts of my work do I like?

3. What parts of my work can I improve upon?

LEARNING ENRICHMENT

Lesson Variation
Have the students add a sound track to their television show. It could include music as well as words.

Art Across the Curriculum
Language Arts: Let interested students write their own stories to make into television shows. These could be original stories or sequels to the story you used for this activity.

Careers in Art
Some students may be interested in finding out more about television and the many jobs it includes. They can research these ideas, possibly even visiting a local television station for exact information.

EXPLORING ART

African Art

This Exploring Art activity is intended to pique the students' interest in the important style of African art. The activity also sets the students to work as designers. Identify the visuals on page 100 as a decorative umbrella top and a spoon. Encourage the students to discuss the appeal of each object. To further extend this activity:

• This Exploring Art activity affords an opportunity for in-depth discovery of a specific art style. Let interested students research this type of African art and give a complete group report about their findings.

• Have the students create fanciful designs for large-scale utilitarian items. Things like cars, trains, and houses can be fun ideas with which to work.

REVIEW

Knowing About Art

These answers are suggested responses only.

1. The cave painting of an animal was created first. The quality of materials and the modernistic approach of the Frankenthaler painting identify it as much more recent.

2. The cave painting was created from charcoal and paints made from natural substances. The Frankenthaler piece was created with a synthetic, modern type of paint (acrylic).

3. *Small's Paradise* is about ideas and feelings. The cave painting tells a story.

4. The cave painting is of the style of the earliest art. It is a simple line drawing probably meant to record an important event. The Frankenthaler painting is a nonobjective artwork. It is not meant to portray anything real, but to display a mood, idea, or feeling.

5. Students' answers will vary.

Unit 4

ART FOR EVERY DAY

As the students begin unit four, they are familiar with the elements and principles of art. They are competent with many different media. They should be able to apply art concepts and vocabulary to make aesthetic judgments about art. The students are aware of the ongoing historical significance of art. What is left for the students to achieve?

Unit four concentrates on imagination and on the students as artists who are capable of creating art that fits into their world. They create unusual artworks as well as those that can be used every day. They create familiar objects and identify them as art. They work together to create a mural and to put on an art show. Most importantly, they determine which of their artworks they like the best and which types of art projects are their favorites.

The visuals in the unit opener emphasize the ability of the artist to create art from almost anything. Claes Oldenburg imaginatively sees common screws as a bridge. Children decorate a plain wall with a wonderful mural. Your students use their imaginations to see potential media in common items.

Continue to emphasize the imagination throughout this unit. Lead the students to identify all their artworks as valid additions to the environment. Urge the students to consider all possibilities when planning each artwork. The results will reflect the extra thought.

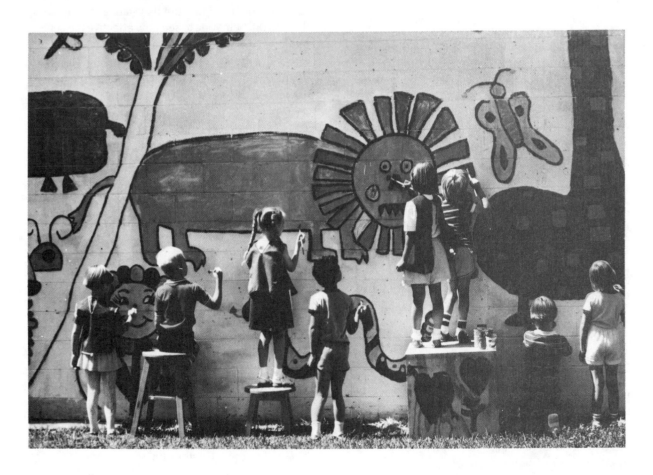

This photograph is from page 102 of the student book.

Lesson 46

Art from Scraps pages 104-105

LEARNING OBJECTIVES

Understanding Art
Students will find the artistic center of interest in artworks.

Creating Art
Students will create multi-media collages with centers of interest.

Appreciating Art
Students will see inherent artistic qualities in many everyday materials.

Vocabulary
collage, center of interest

LESSON PREPARATIONS

Suggested Art Materials
Each student will need: 12″ x 12″ cardboard, a variety of objects from nature, man-made scraps, glue, paints of all colors, brushes of all sizes, crayons, scissors

Additional Teaching Materials
a variety of realistic and abstract art prints, spray paints (optional)

Planning Ahead
Set up a collection table a week before starting this project. Have the students bring in any scraps or interesting objects they can find.

Helpful Hints
You may want to set up a painting station for those students who want to paint all or parts of their multi-media art.

GUIDED TEACHING

Lesson Focus
Have the students recall all the different art materials they have used this year. Ask them to think of the two art materials that they think would look strangest if combined in an artwork.

Focus on Looking and Thinking
• After the students identify the centers of interest in the collages shown in the lesson, have them identify the center of interest in each of the variety of art prints you have available. Make sure you use examples of many different styles of art. Point out that the center of interest may be made apparent by the use of color, size, shape, texture, or subject.

• Discussion questions:
 1. What is a center of interest?
 2. Do you like to use a variety of media to create art? Why or why not?
 3. Can an everyday object seem to be an artwork? Why?
 4. How do you get ideas for your artworks?

Focus on Making Art
• You might want to have the students talk about the various scraps they have brought to class. Encourage the students to view the scraps in terms of artistic usefulness.

• Remind the students that a center of interest can be achieved in many ways. They might want to use color, shape, texture, or a unique object to create the center of interest. Point out that standing away from the artwork helps one to see how effective the center of interest is.

• Encourage the students to try many different arrangements before they decide to glue the pieces down.

• Cleanup: Have the students return all useable scraps to the table. Clean and store the glue containers properly. Have art monitors clean the painting station. Throw away all scraps too small to use.

EVALUATING PROCEDURES

Learning Outcomes
1. How many different things does your artwork include?
2. Can someone else find the center of interest in your artwork?
3. Do you see interesting shapes in most everyday materials? Can you give an example?

Evaluation
Use these questions to evaluate students' progress:
1. Did students show understanding of the vocabulary during oral discussions?
2. Did the students follow the steps in *Making Art*?
3. Did students criticize artworks by applying art concepts presented?

Encourage the students to evaluate their own work.

Students can ask themselves the following questions:
1. Did I follow each step in *Making Art*?
2. What parts of my work do I like?
3. What parts of my work can I improve upon?

LEARNING ENRICHMENT

Lesson Variation
Have the students create other multi-media collages. Then spray paint them a single color. See if the students have still created centers of interest. Caution: Only adults should use the spray paints, and only in a well-ventilated area.

Art Across the Curriculum
Language Arts: Have interested students write about their collages. They should use as many adjectives as possible to tell about all the different parts of the artworks.

Planning for Tomorrow's Lesson
Have the students each bring in a shoe box and pictures of gardens.

Lesson 47

Garden in a Box pages 106-107

LEARNING OBJECTIVES

Understanding Art
Students will describe the interesting effect created by layers of tissue paper.

Creating Art
Students will create garden dioramas.

Appreciating Art
Students will comment upon the beauty of colors in nature.

Vocabulary
diorama, overlap

LESSON PREPARATIONS

Suggested Art Materials
Each student will need: shoe box, liquid starch in a small container, brush, variety of colors of tissue paper

Additional Teaching Materials
pictures of gardens of all kinds, flowers, fruits, and vegetables

Planning Ahead
Create a bulletin board entitled, "Gardens Galore." As the students bring in their pictures of gardens, tack them on the board.

GUIDED TEACHING

Lesson Focus
Have each student choose a favorite garden from the displayed pictures and write a paragraph telling why that garden was chosen.

Focus on Looking and Thinking
• Help the students pronounce *diorama*. If possible, show them some examples of dioramas.

• Let the students study any fruits, vegetables, and flowers that you have brought. Ask them to arrange these items in ways that best show off the colors.

• Discussion questions:
1. What do you notice most in the garden pictured on page 106? Do you see repeated shapes and colors?
2. Study all the pictures of gardens in the book and on the bulletin board. Look at the shapes and colors. Which do you like? Why?
3. Do you see different shades and tints of colors in the pictures? Point them out.

Focus on Making Art
• Encourage the students to tear the tissue paper into shapes that are repeated. Also suggest that they repeat colors. Mention that this will help create unity.

• Point out that the students can paint the eight sections of their boxes with starch to create whatever shapes or types of rows they want.

• Focus the students' attention on the whole space of the box that they must cover (all four sides inside, plus bottom). Start them thinking about the space as representative of background.

• Cleanup: Large scraps of tissue paper should be saved. Have the students throw away all the others. Ask the students to thoroughly clean the brushes and put them in a safe place to dry. Store the starch. Save the boxes for the next lesson.

EVALUATING PROCEDURES

Learning Outcomes
1. What happens when you overlap tissue paper?

2. Did you overlap the tissue paper to create a pleasing effect?

3. What did you discover about the colors in nature?

Evaluation
Use these questions to evaluate students' progress:
1. Did students show understanding of the vocabulary during oral discussions?
2. Did the students follow the steps in *Making Art*?
3. Did students criticize artworks by applying art concepts presented?

Encourage the students to evaluate their own work. Students can ask themselves the following questions:
1. Did I follow each step in *Making Art*?
2. What parts of my work do I like?
3. What parts of my work can I improve upon?

LEARNING ENRICHMENT

Art Across the Curriculum
Science: Have interested students learn more about individual plants. They can read about how certain vegetables, fruits, and flowers are grown. Encourage them to write reports about their findings.

Language Arts: Let interested students read *I Like Fruit* by Ethel Goldman (Minneapolis: Lerner Publications, 1969). This is an excellent research book that uses tissue paper to teach about fruits and vegetables. Readers can find other interesting art projects to do concerning these areas.

Planning for Tomorrow's Lesson
• Keep the garden pictures displayed for use in Lesson 48.

• Ask the students to begin thinking of items they can add as sculptures to their dioramas.

Lesson 48

What Belongs in a Garden?　　pages 108-109

LEARNING OBJECTIVES

Understanding Art
Students will explain what additive sculpture is. Learners will recognize that most sculptures have a central axis to which small parts are added.

Creating Art
Students will create simple additive sculptures, sized correctly for their diorama settings.

Appreciating Art
Students will describe the properties of clay.

Vocabulary
additive sculpture

LESSON PREPARATIONS

Suggested Art Materials
Each student will need: a piece of plastic, non-hardening clay about the size of your fist (several colors to choose from)

Additional Teaching Materials
paper towels, pictures of gardens (used in Lesson 47)

GUIDED TEACHING

Lesson Focus
Ask the students to imagine that they are tiny enough to walk through the gardens they have created. What would they see?

Focus on Looking and Thinking
• Have a brainstorming session during which the students name all the things to be found in a garden. Write their ideas on the board. Remind the students to think about figures, animals, and objects. The list will give them a large bank of ideas from which to choose.

• Discussion questions:
1. What is additive sculpture?
2. Explain how the Lebanese bearded figure and *The Gondolier* represent additive sculpture.
3. What makes clay a good medium for creating sculptures?

Focus on Making Art
• The students should place the clay on paper towels while working with it.

• Encourage the students to use ideas from the class list. If they choose to create sculptures of people, let them model for one another.

• Remind the students to study the pictures on page 108 to see how to join the clay pieces together.

• Point out to the students that their sculptures must be flat on the bottoms so they will stand up in the gardens.

• Encourage the students to make their two pieces proportionate to each other.

• Cleanup: The students may need to wash their hands. Have them throw away the paper towels. Collect all the leftover clay.

EVALUATING PROCEDURES

Learning Outcomes

1. Explain why your sculptures are additive sculptures.

2. Do your additive sculptures make your garden seem more real?

3. Do you enjoy working with clay? Why or why not?

Evaluation

Use these questions to evaluate students' progress:

1. Did students show understanding of the vocabulary during oral discussions?

2. Did the students follow the steps in *Making Art*?

3. Did students criticize artworks by applying art concepts presented?

Encourage the students to evaluate their own work. Students can ask themselves the following questions:

1. Did I follow each step in *Making Art*?

2. What parts of my work do I like?

3. What parts of my work can I improve upon?

LEARNING ENRICHMENT

Art Across the Curriculum

Social Studies: Some students may want to create other dioramas. This time, they could portray parks which they feel would be valuable contributions to the community.

Lesson Variation

Have interested students create additive sculptures portraying fellow classmates. They should attempt to show several different poses.

Lesson 49

Pictures Help Poems pages 110-111

LEARNING OBJECTIVES

Understanding Art

Students will identify the purpose of illustrations.

Creating Art

Students will create imaginative artworks triggered by a poem.

Appreciating Art

Students will determine the link between oral and visual communication.

Vocabulary

illustrations, illustrator

LESSON PREPARATIONS

Suggested Art Materials

Each student will need: 8½" x 11" white drawing paper, crayons, paints, paintbrushes, markers, colored pencils, chalk, etc.

Additional Teaching Materials

paper to cover work areas

Planning Ahead

Set up a supply station where students can go to choose their art materials. You might also want to set up a painting station for those students who choose this medium.

GUIDED TEACHING

Lesson Focus

Tell the students the story about the people of Columbus' time and how they believed the world was flat. Ask the students to imagine the world being flat. If they reached the end of the world, what would they see?

Focus on Looking and Thinking

• Read "Landscape" aloud to the students. Then have volunteers read it aloud, too. Let the students discuss the appropriateness of the photographs in this lesson.

• Ask the students to close their eyes and visualize the edge of the world as you once again read the poem aloud, slowly and softly.

• Discussion questions:

1. Why do you think stories and poems are illustrated? Why aren't all poems and stories illustrated?

2. What is the difference between listening to a story on the radio and seeing it on television?

3. Why might illustrations be more effective than photographs?

Focus on Making Art

• Let the students choose their materials from the station you have set up. Point out that some materials might work best for serene scenes (pastel chalks and crayons), while others might work best for action scenes (bold colors of markers or tempera paints).

• Encourage the students to be as imaginative as possible.

• Cleanup: Have the students return the materials to the station. Art monitors can clean the paint area and store the art materials correctly.

EVALUATING PROCEDURES

Learning Outcomes

1. What is the purpose of an illustration?
2. Does your illustration go well with Eve Merriam's poem?
3. Did the materials you used work for your idea?

Evaluation

Use these questions to evaluate students' progress:
1. Did students show understanding of the vocabulary during oral discussions?
2. Did the students follow the steps in *Making Art*?
3. Did students criticize artworks by applying art concepts presented?

Encourage the students to evaluate their own work. Students can ask themselves the following questions:
1. Did I follow each step in *Making Art*?
2. What parts of my work do I like?
3. What parts of my work can I improve upon?

LEARNING ENRICHMENT

Lesson Variations

Let interested students write their own poems and illustrate them. Each of these students can then illustrate another's poem without seeing the original illustration. It is interesting to see if they got the same ideas from the poems.

Art Across the Curriculum

Language Arts: The students might enjoy writing a class poetry book that has illustrations. Encourage them to use a variety of poetry forms and many different media for illustrations.

Lesson 50

What Does a Desert Look Like? pages 112-113

LEARNING OBJECTIVES

Understanding Art

Students will explain what a mural is. Learners will define the term *horizon*.

Creating Art

Students will work as a class to create a mural background.

Appreciating Art

Students will describe art as a way of showing what has been learned.

Vocabulary

mural, background, horizon, blend

LESSON PREPARATIONS

Suggested Art Materials

Each student will need: pencil, a variety of paint colors, reuseable palette, a variety of paintbrushes

Additional Teaching Materials

butcher paper sized for a mural, paint containers, pictures and photographs of the deserts of the world, salt (optional), flour (optional), diorama materials (optional)

Planning Ahead

You may want to set up a desert resource table and/or bulletin board. Include resource books, pictures, and photographs of the desert.

Helpful Hints

Lay out the mural paper before your students arrive. Place the paint containers all along the mural paper. The students can share the paints and mix new colors on their individual palettes.

GUIDED TEACHING

Lesson Focus

Ask the students where they think the hottest spot in the world is. Ask them what it must look like.

Focus on Looking and Thinking

• Discuss all the desert visuals you have collected, including those in the text. (Lesson 51 also contains pictures of deserts.) See if the students can correctly name the different parts of the deserts.

• Ask the students to locate the horizon in each of the pictures.

• Discussion questions:
 1. What makes up the backgrounds of the desert pictures?
 2. What do you like about the desert?
 3. How is the desert similar to your environment? How is it different?
 4. Which of the deserts in the pictures would you like to see?

Focus on Making Art

• Stress the fact that the students will be working *together* on this project. They will need to discuss their ideas with one another.

• Encourage the students to first sketch their ideas lightly with pencil.

• The students can mix colors to make the background have depth. Remind the students how to mix tints and shades.

• Cleanup: Have art monitors clean the paintbrushes and store the paints correctly. The students should tear off the top sheets of their palettes and throw them away. Leave the mural where it can safely dry.

EVALUATING PROCEDURES

Learning Outcomes
1. Point out the horizon and the different parts of the desert on the mural.
2. Do the different parts of the mural blend well together?
3. Did you like working with a group to create an artwork? Why or why not?

Evaluation

Use these questions to evaluate students' progress:
1. Did students show understanding of the vocabulary during oral discussions?
2. Did the students follow the steps in *Making Art*?
3. Did students criticize artworks by applying art concepts presented?

Encourage the students to evaluate their own work. Students can ask themselves the following questions:
1. Did I follow each step in *Making Art*?

2. What parts of my work do I like?
3. What parts of my work can I improve upon?

LEARNING ENRICHMENT

Art Across the Curriculum
Social Studies: Some students might want to continue the study of the desert. They can create salt and flour maps or dioramas to show what they learn. Make sure they label all the parts of the desert.

Aesthetic Perception
Let interested students study and critique the paintings of Georgia O'Keeffe. They can compare her works showing the desert to those by other artists. They will see how certain landscapes inspire artists in different ways. Encourage them to write about any artists who interest them.

Lesson 51

| What Belongs in a Desert? | pages 114-115 |

LEARNING OBJECTIVES

Understanding Art
Students will explain the principle of foreground.

Creating Art
Students will individually contribute to the foreground of the desert mural.

Appreciating Art
Students will identify art as a vehicle for communication.

Vocabulary
foreground, background

LESSON PREPARATIONS

Suggested Art Materials
Each student will need: white construction paper, pencil, crayons, scissors, glue

Additional Teaching Materials
desert resource table (used in Lesson 51), map or globe

GUIDED TEACHING

Lesson Focus
Have the students imagine themselves as small enough to enter the mural. What details do they see?

Focus on Looking and Thinking
• Have the students find Egypt and the Nile on a map or globe.

• Discuss in some detail the visuals included in this lesson.

• Brainstorm with the students about all the things found in the desert. Make a list of the suggestions on the board. This will give the students a large bank of ideas from which to choose.

• Discussion questions:
 1. What is foreground? What foreground objects do you see in the pictures of deserts?
 2. Have you ever been to a desert in America? How do you think the desert in Egypt might be different?
 3. How do you suppose the Nile River changes the Sahara?
 4. Why do you think the people who live in the Sahara live in tents and wear long robes?

Focus on Making Art
• Have the students work *together* to complete steps one and two. They will want to include a variety of objects and make them similarly sized.

• Point out that the mural will be viewed from a distance. The drawings should be outlined and colored heavily.

• Encourage the students to consider overlapping some parts of the foreground as they arrange the pictures. They should move the pieces around to find the best arrangement before gluing.

• Have the class think of a good place to hang the mural. One idea is an international airport, near the Egyptian airlines.

• Cleanup: Have the students throw away all the scraps and put away the crayons. Ask art monitors to properly clean and store the glue containers.

EVALUATING PROCEDURES

Learning Outcomes
1. Does the mural look three-dimensional? Why?
2. Does your picture fit well into the background of the mural? Does it go well with the other students' pictures?

3. What does your mural say to someone looking at it?

Evaluation
Use these questions to evaluate students' progress:
1. Did students show understanding of the vocabulary during oral discussions?
2. Did the students follow the steps in *Making Art*?
3. Did students criticize artworks by applying art concepts presented?

Encourage the students to evaluate their own work. Students can ask themselves the following questions:
1. Did I follow each step in *Making Art*?
2. What parts of my work do I like?
3. What parts of my work can I improve upon?

LEARNING ENRICHMENT

Art Across the Curriculum
History: Interested students can study the civilization of ancient Egypt. Ask them to write reports about the building of the Sphinx and the Pyramids.

Social Studies: The students might enjoy creating a mural of their community. They could create the background first, and then individually contribute pictures of the places where they live to the foreground. Encourage the use of different media such as chalk or black paper silhouettes.

Science: Some students might want to study the plants of the desert. They can find out facts about the plants and then work as technical illustrators to draw pictures of them.

Lesson 52

Lines That Move **pages 116-117**

LEARNING OBJECTIVES

Understanding Art
Students will describe the process of animation.

Creating Art
Students will create flip books that show action.

Appreciating Art
Students will recognize the detailed work required to show movement in art.

Vocabulary
animation, animator

LESSON PREPARATIONS

Suggested Art Materials
Each student will need: five 3" x 5" index cards, black marker with thin tip

Additional Teaching Materials
·newsprint, pencils, stapler, pictures of cartoon characters

GUIDED TEACHING

Lesson Focus
Ask the students to name their favorite cartoon characters and to tell what actions those characters are involved in (running, flying, jumping, driving, diving, etc.).

Focus on Looking and Thinking
• Ask a volunteer to do a simple movement in slow motion. Say, "Freeze!" four or five times during the course of the movement. This will help the students to visualize what is meant by breaking simple movements into parts.

• Discussion questions:
1. What is animation?
2. If Batman and Robin were on television, what do you think their next movement would be?
3. What do you like about the cartoon on page 117? How does the artist show movement?

Focus on Making Art
• You may want to pass out newsprint and pencils for the students to use for idea sketches.

• Point out that the less complicated the movement is the easier it will be to animate.

• Focus the students' attention on the placement of the figures on the cards and on making the figures the same size on each card.

• Encourage the students to initially use black markers, not pencils, to draw the pictures on the cards. If the students cannot erase, a lot of frustration and wasted time will be eliminated.

• Remind the students to only make *very* small changes in each drawing.

• The flip books will be easier to manipulate if you staple the cards together on one side.

• Cleanup: Have the students cap the markers and store them.

EVALUATING PROCEDURES

Learning Outcomes
1. What does an animator do?

2. Does your flip book show movement?
3. Whose flip book do you think shows the most movement? Why do you think that is so?

Evaluation
Use these questions to evaluate students' progress:
1. Did students show understanding of the vocabulary during oral discussions?
2. Did the students follow the steps in *Making Art*?
3. Did students criticize artworks by applying art concepts presented?

Encourage the students to evaluate their own work. Students can ask themselves the following questions:
1. Did I follow each step in *Making Art*?
2. What parts of my work do I like?
3. What parts of my work can I improve upon?

LEARNING ENRICHMENT

Careers in Art
Some students might want to find out more about animation as a career. They can write to famous animators or do research in the library.

Creative Movement
Let interested students put together a "Live Animation Festival." They will use slow motion to show the actions of characters they make up.

Lesson 53

The Art of Advertising pages 118-119

LEARNING OBJECTIVES

Understanding Art
Students will identify the role of art and graphic designers in advertising.

Creating Art
Students will create simple graphic designs or trademarks.

Appreciating Art
Students will describe the appeal of simple graphic designs.

Vocabulary
advertisement, graphic designer, trademark

LESSON PREPARATIONS

Suggested Art Materials
Each student will need: white drawing paper, pencil, crayons

Additional Teaching Materials
magazines, scissors, glue, construction paper, bookbinding materials

GUIDED TEACHING

Lesson Focus
Ask the students to list all the places where advertising occurs (cereal boxes, billboards, television, mass transit systems, etc.). Encourage them to be thorough in this activity.

Focus on Looking and Thinking
• Have old magazines available for the students to look through. Ask them to each cut out five appealing trademarks or simple advertisement designs. Have the students share their favorite designs and tell why they like them. Glue these designs into a class scrapbook for the students to refer to.

• Emphasize that a trademark is really a miniature advertisement. Lead the students to see that the Wild Waters trademark tells us quite a few things about the water attraction.

• Discussion questions:
 1. What does an advertisement try to do?
 2. Do you think you would like to be a graphic designer? Why or why not?
 3. What does the Wild Waters trademark make you think about?
 4. Why is the graphic design on page 118 appropriate for a fitness center?

Focus on Making Art
• The students can study the class design scrapbook for ideas.

• Encourage the students to keep the designs very simple so they can be seen from far away. Point out that simple designs also tend to stay in people's minds.

• Explain that the colors chosen should stand out. They need to be eye-catching. Tell the students to make their coloring waxy and heavy.

• When the designs are complete, display them for discussion purposes. Foster the sharing of positive comments.

• Cleanup: Have the students put away the crayons and pencils.

EVALUATING PROCEDURES

Learning Outcomes
1. What do you think graphic designers consider before beginning a project?
2. Does your design make someone want to go to the place you are advertising? How do you know?
3. Have you ever liked an advertisement so much that you bought what it advertised? What made you like that particular advertisement?

Evaluation
Use these questions to evaluate students' progress:
1. Did students show understanding of the vocabulary during oral discussions?
2. Did the students follow the steps in *Making Art*?
3. Did students criticize artworks by applying art concepts presented?

Encourage the students to evaluate their own work. Students can ask themselves the following questions:
1. Did I follow each step in *Making Art*?
2. What parts of my work do I like?
3. What parts of my work can I improve upon?

LEARNING ENRICHMENT

Lesson Variation
Some students may be interested in designing a class trademark. Others might like designing personal logos. Let the students use their personal trademarks on some assignments in place of their names.

Creative Dramatics
Encourage the students to create a television commercial and act it out. It should begin by showing an enlarged trademark. Then the students act out the commercial. The trademark appears again to end the commercial.

Lesson 54

Frame It! **pages 120-121**

LEARNING OBJECTIVES

Understanding Art
Students will explain the stenciling process.

Creating Art

Students will mount artworks. Learners will create stencil designs and use them to stencil frames.

Appreciating Art

Students will identify the finishing touches an artist achieves by mounting and framing artworks.

Vocabulary

stencil, mount

LESSON PREPARATIONS

Suggested Art Materials

Each student will need: a favorite piece of artwork, tagboard cut 3" larger on all sides than the student's artwork, stiff paper (5" x 8" index card, old file folder cut to measure, actual stencil paper, etc.), crayons, glue

Additional Teaching Materials

sample stencil, paints (optional), paper plates (optional)

GUIDED TEACHING

Lesson Focus

Have the students get out their viewfinders. Ask them to each isolate a portion of the Lee Krasner painting in Lesson 44 and think about the portion as its own painting. Lead the students to discover that the viewfinder is like a frame; it makes an artwork look finished.

Focus on Looking and Thinking

• Demonstrate for your students how a stencil works. See if they can suggest other media besides crayons that would work well.

• Use the stencil to demonstrate positive and negative shapes. Do a stencil design using the piece with the cut-out shape. Then do another design using the piece which has been cut out. Ask the students which parts of each design are most important (the colored parts on the first, and the blank parts on the second). Point out that both designs use the same shape, but in different ways.

• See if the students can think of other uses for stencils (car details, wall borders, lettering, floor designs, etc.).

• Discussion questions:
1. Which stencil on page 120 do you like best? Why?
2. Why do you think artists frame artworks?
3. How do stencils work?

4. What do you think you should consider when selecting a frame for an artwork?

Focus on Making Art

• If possible, have adults use spray glue to mount the students' artworks on the tagboard. (Make sure this is done only in a well-ventilated area.)

• Encourage the students to think about the artworks to be framed when designing the stencils. For example, it is effective to repeat a shape from the artwork in the design around the frame, as shown by the student example on page 121.

• Focus the students' attention on spacing the stencils evenly and on using only one color. Point out that the color chosen can actually help the artwork by bringing out an important color.

• Cleanup: Have the students discard any scraps and correctly store the crayons and glue.

EVALUATING PROCEDURES

Learning Outcomes

1. Do you like the way the stenciled frame makes your artwork look?
2. Do your stencil designs fit nicely in the border? Are they spaced evenly? Did you use a good color?
3. Which frames do you like best?

Evaluation

Use these questions to evaluate students' progress:
1. Did students show understanding of the vocabulary during oral discussions?
2. Did the students follow the steps in *Making Art*?
3. Did students criticize artworks by applying art concepts presented?

Encourage the students to evaluate their own work. Students can ask themselves the following questions:
1. Did I follow each step in *Making Art*?
2. What parts of my work do I like?
3. What parts of my work can I improve upon?

LEARNING ENRICHMENT

Lesson Variation

Students can also create gift wrapping or book covers by using paint to stencil designs on heavy paper.

Art Across the Curriculum

Health/Nutrition: Have the students cut out food

stencils. Distribute paper plates on which the students can stencil balanced meals.

Lesson 55

Patterns for Fabrics pages 122-123

LEARNING OBJECTIVES

Understanding Art
Students will explain the process of block printing.

Creating Art
Students will create blocks to use for printing. Learners will use the blocks effectively to create patterns on fabric.

Appreciating Art
Students will identify printed fabrics and woven fabrics as art forms.

Vocabulary
weave, block, block printing

LESSON PREPARATIONS

Suggested Art Materials
Each student will need: styrofoam cup, scissors, 4″ x 4″ piece of thick cardboard, 10″ x 14″ piece of cloth (sheeting, burlap, or trigger cloth works well), paint of many colors, glue, sponge

Planning Ahead
Immediately before class, soak the sponges with bright colors of tempera paint. Set up a station where students can use the paint while printing.

GUIDED TEACHING

Lesson Focus
Ask the students to write about the clothes they are wearing in terms of color, line, shape, texture, and pattern.

Focus on Looking and Thinking
• Discuss the design on the cloth on page 122. Lead the students to see that the block would contain only the parts that are white.

• Stress that the cloth on page 122 is functional as well as pretty. It is a pillowcase.

• Ask the students to critique the student art on page

123. See if a volunteer can draw on the board the design each block would have.

• Discussion questions:
1. What is block printing?
2. How often do you notice the patterns on the fabrics that your friends wear? Is anyone in your class wearing a block print today?
3. Why do you think fabric design is called art?

Focus on Making Art
• As the students begin planning their designs, remind them that a simple design will probably print clearest.

• The students will need to carefully flatten the designs cut from the styrofoam cups.

• As the students arrange the designs on the cardboard, focus their attention on the positive and negative shapes involved. Encourage them to move the shapes around on the cardboard until they are sure the designs look best.

• Let the students know that the glue used to glue the pieces to the cardboard must dry before the blocks are used.

• The students may want to make their initial prints on scrap paper to ensure that the prints look as intended.

• Encourage the students to overlap the prints and to use definite patterns of color and placement.

• Cleanup: Have the students throw away all the scraps. Ask an art monitor to clean the painting station.

EVALUATING PROCEDURES

Learning Outcomes
1. When would block printing be best for creating designs on fabrics?
2. Does your design have a pattern? Did you use the whole space wisely?
3. What would you do differently if you were to block print again?

Evaluation
Use these questions to evaluate students' progress:
1. Did students show understanding of the vocabulary during oral discussions?
2. Did the students follow the steps in *Making Art*?
3. Did students criticize artworks by applying art concepts presented?

Encourage the students to evaluate their own work. Students can ask themselves the following questions:

1. Did I follow each step in *Making Art?*
2. What parts of my work do I like?
3. What parts of my work can I improve upon?

LEARNING ENRICHMENT

Art Across the Curriculum
History: Have interested students study the making of fabric throughout time. They can trace the development of the loom, the way the plans for a weaving factory were secretly brought to America from England, and the extent of modern development. Ask them to share their findings with the class.

Art Heritage
Ask several students to find out about ethnic fabric designs. They could create block printings that use the designs and colors typifying the different cultures.

Lesson 56

Spatter It! pages 124-125

LEARNING OBJECTIVES

Understanding Art
Students will define Abstract Expressionism. Learners will recognize Jackson Pollock as an important and inventive American painter.

Creating Art
Students will create spatter paintings and realistic paintings, using the same medium.

Appreciating Art
Students will determine the roles of ingenuity and originality in the creation of art.

Vocabulary
Abstract Expressionism, original

LESSON PREPARATIONS

Suggested Art Materials
Each student will need: a variety of colors of paint, toothbrushes (one for each color), 12″ x 22″ white paper, wire screen

Additional Teaching Materials
paper to cover work areas, masking tape, jar lids or small embroidery hoops

Planning Ahead
Set up a spatter painting center where two or more students can work at a time.

Helpful Hints
The screens used in this lesson must stand up off the paper, not lay flat on it. Wooden hoops and jar lids with the centers removed work well to prop the screens up. The students then make the spattering motion off the edge of the screen. A flick of the wrist sprays the paint off the toothbrush, while keeping it in a confined area.

GUIDED TEACHING

Lesson Focus
Ask the students to name all the ways they have applied a design to a surface during the year. Ask them to name other ways they can think of to apply paint to paper.

Focus on Looking and Thinking
• Let the students measure a 7′ x 9′ rectangle on the floor. Mark this area off with masking tape to show what a huge canvas the Pollock work encompasses. Discuss with the students that many works of art are even bigger than this. See if they can name some they have learned about this year.

• Discussion questions:
 1. What is Abstract Expressionism?
 2. Who was Jackson Pollock?
 3. Why is Jackson Pollock still important to us today?
 4. Do you think everyone liked Jackson Pollock's work when he first started painting in the 1940s? Why or why not?

Focus on Making Art
• Have the students consider the feelings they want their paintings to convey. They should choose colors that portray these feelings.

• Show the students how to achieve interesting effects by moving the screen around to overlap the colors.

• Point out that the students' completed spatter paintings could be useful. They could save them to use for gift wrapping.

• Encourage the students to discuss among themselves which style of painting with the toothbrush was most enjoyable. Point out they should center the discussion on artistic pleasure rather than "fun."

• Cleanup: Have the students carefully wash the toothbrushes, screens, and paint containers. Ask them to throw away the paper covering the work areas.

EVALUATING PROCEDURES

Learning Outcomes

1. Why do you think Jackson Pollock was called a very original painter?

2. Did you achieve interesting effects with your spatter painting?

3. What other painting techniques would you like to try with a toothbrush?

Evaluation

Use these questions to evaluate students' progress:

1. Did students show understanding of the vocabulary during oral discussions?

2. Did the students follow the steps in *Making Art*?

3. Did students criticize artworks by applying art concepts presented?

Encourage the students to evaluate their own work. Students can ask themselves the following questions:

1. Did I follow each step in *Making Art*?

2. What parts of my work do I like?

3. What parts of my work can I improve upon?

LEARNING ENRICHMENT

Lesson Variations

Some students may want to try another of Pollock's techniques, such as dripping, pouring, or throwing paint on a canvas.

Seasonal Art

Encourage the students to create gift wrapping that is appropriate to seasons by using the spatter technique with different colors (red and green for Christmas, pink and red for Valentine's Day, green for St. Patrick's Day, black and orange for Halloween, etc.).

Lesson 57

Weaving, Looms, and Table Mats
pages 126-127

LEARNING OBJECTIVES

Understanding Art

Students will explain the role of looms in weaving.

Creating Art

Students will create cardboard looms. Learners will weave pieces of cloth on the looms.

Appreciating Art

Students will differentiate handwoven cloth from machine-woven cloth.

Vocabulary

loom, weaving

LESSON PREPARATIONS

Suggested Art Materials

Each student will need: 8″ x 10″ heavy cardboard, 10″ lengths of yarn in many colors, ruler, pencil, scissors, string, masking tape

Additional Teaching Materials

map or globe, pieces of woven fabric, magnifying glasses

GUIDED TEACHING

Lesson Focus

Ask the students to try to imagine making by hand the clothes they are wearing. How would they do it? With needle and thread? Lead the students to recall what they have already learned about weaving.

Focus on Looking and Thinking

• Ask the students to examine the small pieces of fabric you have on hand. They may want to use magnifying glasses to unravel the fabrics and see how they are made.

• Discussion questions:

1. Why do you think a loom is necessary for weaving?

2. Why do you think handwoven cloth is so special?

3. What do you like about the student artworks on page 127?

Focus on Making Art

• The students should mark off the ends of cardboard that are 8″ (the short ends). Point out that the marks on one side must align with the marks on the other side.

• Some children may need assistance in cutting the cardboard.

• Demonstrate how to wind the string. Show the

students that on each wind, the string goes into a new notch. Point out to the students that the string will move diagonally across the back of the cardboard.

• Have the students tape the string ends down in back when all of the notches have been filled.

• Encourage the students to select the colors carefully. Remind them that they are creating table mats. They might select colors that will go well with the family dishes or dining area.

• Stress that the pieces of yarn must be pushed closely together.

• Cleanup: Ask the students to throw away all scraps and to store the pencils, rulers, and scissors where they belong.

EVALUATING PROCEDURES

Learning Outcomes
1. How important was the loom to your weaving?
2. Do the pieces of yarn in your weaving follow a pattern? Do they fill the whole loom?
3. What is special about your table mat?

Evaluation
Use these questions to evaluate students' progress:
1. Did students show understanding of the vocabulary during oral discussions?
2. Did the students follow the steps in *Making Art*?
3. Did students criticize artworks by applying art concepts presented?

Encourage the students to evaluate their own work. Students can ask themselves the following questions:
1. Did I follow each step in *Making Art*?
2. What parts of my work do I like?
3. What parts of my work can I improve upon?

LEARNING ENRICHMENT

Lesson Variation
Some students might want to create whole sets of table mats. This would be a good activity for stressing variety. The students could make the table mats look like a set without making them all identical.

Art in the Environment
Encourage interested students to learn more about various fabrics. Ask them to find out about the variety of things we use unique fabrics for today.

Lesson 58

| Clowns Make | pages 128-129 |
| You Laugh | |

LEARNING OBJECTIVES

Understanding Art
Students will recognize shapes and demonstrate how to cut them out.

Creating Art
Students will each cut out and join together the many parts of a clown puppet.

Appreciating Art
Students will identify artistic possibilities in different shapes, colors, and textures.

Vocabulary
shape, color, texture

LESSON PREPARATIONS

Suggested Art Materials
Each student will need: popsicle stick, four 1″ x 12″ paper strips (bright colors), a variety of colors of construction paper, glue, scissors, pencil, crayons, markers, string, fabric scraps, any other fun materials you can think of

Additional Teaching Materials
pictures of clowns, paper to cover work areas

Planning Ahead
Set up a supply station for students to visit as they need materials.

GUIDED TEACHING

Lesson Focus
Have the students make funny faces. Ask them how they could draw funny faces. What lines, colors, and shapes would they need to use?

Focus on Looking and Thinking
• Discuss the clowns on page 128. Point out the bright, happy colors the clowns are wearing. Talk about what makes the clowns look funny. Discuss the big feet, the accordion pleats, and the make-up.

• Discuss the student clowns on page 129. Ask the students to find different colors, shapes, and textures in them.

- Discussion questions:
 1. What kind of clown do you find funny?
 2. What have you noticed about the clothes and shoes that clowns wear?
 3. How do you think it would feel to be a clown?
 4. Why can we say that a clown is an art form?

Focus on Making Art

- Acquaint the students with all the materials at their disposal.

- The students may need special materials collected from home to create the clowns just the way they want to. You may want them to sketch their ideas next to the list of materials they need.

- Point out to the students that they should make the clown bodies first and then add the details.

- Encourage the students to have plans for the overall color schemes of the clowns.

- Focus the students' attention on making a flat shape three-dimensional by folding and bending paper.

- Ask the students to use their imaginations to think of ways to add texture to their clowns.

- Cleanup: Have the students pick up and throw away all scraps too small to use. Store reuseable materials in their proper places.

EVALUATING PROCEDURES

Learning Outcomes

1. How can you create humor in art?
2. Did you use a variety of shapes, textures, and colors to create your clown? Is your clown's face full of expression?
3. How do you feel when you look at the clowns?

Evaluation

Use these questions to evaluate students' progress:
1. Did students show understanding of the vocabulary during oral discussions?
2. Did the students follow the steps in *Making Art*?
3. Did students criticize artworks by applying art concepts presented?

Encourage the students to evaluate their own work. Students can ask themselves the following questions:
1. Did I follow each step in *Making Art*?
2. What parts of my work do I like?
3. What parts of my work can I improve upon?

LEARNING ENRICHMENT

Lesson Variation

Have a day when students experiment with becoming clowns by using clown make-up. You might consider having an actual clown come and create the clown puppets' faces on your students.

Creative Dramatics

Let interested students create a clown puppet play. They can write the script, rehearse, and present the play for the class.

Lesson 59

What Kind of Artist Are You? pages 130-131

LEARNING OBJECTIVES

Understanding Art

Students will define some artistic themes as universal.

Creating Art

Students will create cats by using the media of their choice.

Appreciating Art

Students will classify different art materials as best suited for different purposes. Learners will consciously decide which art techniques they prefer as artists.

Vocabulary

media

LESSON PREPARATIONS

Suggested Art Materials

Each student will need: white drawing paper, pencil. Other art materials to be specified by student.

Additional Teaching Materials

examples of cats in art, photos of cats

Planning Ahead

A few days prior to the students' beginning the *Making Art* portion of this lesson, have the students plan their artworks. They should each compose a list of needed materials and give it to you. This will allow you time to collect the materials.

GUIDED TEACHING

Lesson Focus
Ask the students to move creatively, as they believe a cat moves. They should take into account the shape, attitude, and actions of a cat.

Focus on Looking and Thinking
• Ask the students to read this section carefully and study all the pictures of cats you have available. Encourage them to discuss the size, shape, color, face, etc., of each cat.

• Discussion questions:
1. Why do you think cats have been favorite subjects of artists and writers throughout time?
2. Why do you think the ancient Egyptians worshiped cats?
3. What do you like about the cats created by student artists?
4. Why do you think Paul Klee often drew cats like the one on page 131?

Focus on Making Art
• Encourage the students to review those lessons that used the techniques they plan to use.

• Suggest that the students make complete plans or detailed sketches of their ideas, showing where different media will be used.

• Cleanup: The students should clean up their own work areas. Stress that caring for art materials is also part of an artist's job.

EVALUATING PROCEDURES

Learning Outcomes
1. Why did you choose to create the type of artwork that you did?
2. Did you create a cat that has a definite personality?
3. Are you pleased with the results of your creation? Why?

Evaluation
Use these questions to evaluate students' progress:
1. Did students show understanding of the vocabulary during oral discussions?
2. Did the students follow the steps in *Making Art*?
3. Did students criticize artworks by applying art concepts presented?

Encourage the students to evaluate their own work. Students can ask themselves the following questions:

1. Did I follow each step in *Making Art*?
2. What parts of my work do I like?
3. What parts of my work can I improve upon?

LEARNING ENRICHMENT

Art Across the Curriculum
Language Arts: Let interested students write about their cats. The class could create an anthology of poems and short stories about cats.

Science: Some students may want to learn more facts about cats. They could study the history of cats or learn about becoming a veterinarian.

Lesson 60

Putting on an Art Show	pages 132-133

LEARNING OBJECTIVES

Understanding Art
Students will explain the important role of art museums in the preservation and displaying of art.

Creating Art
Students will work together to put on an art show.

Appreciating Art
Students will describe the importance of making art visible to the public. Learners will select favorite artworks to display.

Vocabulary
art museum, art gallery, exhibition, mount, frame

LESSON PREPARATIONS

Suggested Art Materials
Each student will need: favorite artwork, tagboard for mounting and framing, glue, stenciling materials (optional)

Additional Teaching Materials
white sheets, pins, index cards, spotlights, pens, map or globe, graph paper

Planning Ahead
It would be a good idea to form the students into committees (planning, labeling, lighting, cleanup, etc.)

GUIDED TEACHING

Lesson Focus

Discuss with the students why all artworks should not be privately owned.

Focus on Looking and Thinking

• Ask volunteers to locate the cities where the museums in the text are found. They can use maps or a globe.

• Discussion questions:
1. Why do you think lighting is important in an art museum?
2. Why do the people who work to set up the exhibitions have to think about where people will walk (traffic patterns)?
3. Why do you think it is important to keep a museum the same temperature, not too hot and not too cold?
4. Why do people who work in museums treat the artworks very carefully? Why are some artworks locked in cases?
5. Why do you think people like to go to art museums?

Focus on Making Art

• Suggest to the students that a complete art show includes all different media.

• Encourage the students to draw plans to decide how to group the artworks. They can use graph paper and refer to the Unit I Exploring Art activity (it describes using a grid).

• The committee in charge of the Grand Opening might want to ask room mothers and fathers for assistance. It would be fun to actually send out invitations and to serve food.

• Cleanup: Take down the art show and return the artworks to the students.

EVALUATING PROCEDURES

Learning Outcomes

1. Why do you think it is important to share your artwork with other people?
2. Did visitors seem to enjoy your art show? What comments did they make?
3. What would you suggest doing differently to make the next art show better?

Evaluation

Use these questions to evaluate students' progress:
1. Did students show understanding of the vocabulary during oral discussions?
2. Did the students follow the steps in *Making Art*?
3. Did students criticize artworks by applying art concepts presented?

Encourage the students to evaluate their own work. Students can ask themselves the following questions:
1. Did I follow each step in *Making Art*?
2. What parts of my work do I like?
3. What parts of my work can I improve upon?

LEARNING ENRICHMENT

Lesson Variation

Invite other classes to participate in the art show, even making it school-wide. Follow the same guidelines as given in this lesson, and it will be a success.

Careers in Art

Some students might enjoy learning about the people behind the scenes at museums. Encourage them to write to and visit local galleries and museums to interview exhibition designers, curators, and registrars.

Unit 4

EXPLORING ART

A Summer Diary

An important part of this activity is its reinforcement of essential, confidence-building values. The students are once again assured that they can communicate through art as well as through words. Additionally, the students are referred to as illustrators. This encourages them to see themselves as artists.

The *Bookbinding* section of this manual includes specific instructions on creating several types of books. Refer to this portion as you teach the activity. To further extend this activity:

• Encourage the students to design unique, eye-catching covers for their diaries. Remind them to include title pages as well.

• Read aloud from famous diaries such as those by Anne Frank, Nina Kosterina, Kenichi Horie, and Susan Magoffin. Ask the students how they might illustrate certain entries. Lead them to an understanding of the nature of diary entries (they are a means of recording daily events).

REVIEW

Valuing Art

These answers are suggested responses only.

1. line—beards of musicians, design on clothing of middle musician, notes and staff on music, guitar strings; shape—triangles, circles, rectangles, squares; texture—smooth surface of table, roughness of beards, indentations of clarinet keys; color—brightness of white, yellow, and orange in contrast with brown, black, and shades of blue; space—perspective where walls meet floor; blank, colorless background; distorted forms; value—varying values of white and blue

2. Students' answers will vary, but they should identify the three musicians, their clothes, and their instruments. The dog is facing left. Its tail can be seen between the legs of the middle musician. Its front legs extend left of the musician on the left.

3. Students' answers will vary.

4. Students' answers will vary.

5. Students' answers will vary.

How To Do It

DRAWING

One type of drawing is the sketch, a quick, undetailed drawing that indicates only the main features of a person, object, or scene. A sketch is often used as a reference for a later drawing or other work.

Drawings may be done with light or heavy lines and shading, depending on the artist or the choice of subject. While many drawings are done in great detail, other drawings are made with a few simple lines.

Drawing instruments include pencils, pen and ink, chalk, charcoal, crayons, oil pastels, broad and narrow felt-tipped colored markers, as well as brushes loaded with paint. Drawing instruments such as rulers, protractors, and compasses are useful for drawing exact shapes and dimensions.

DRAWING TOOLS AND TECHNIQUES

Pencils

Many different effects can be created with a pencil, depending on how it is held and how much pressure is exerted. Pencil lead varies from 6B (which makes the darkest, softest mark) to 9H (which makes the lightest, hardest mark). Note that very soft lead breaks and smears easily.

Several pencils of different degrees of hardness can be used in one drawing if desired.

Pencils used in the primary grades are large, with a broad lead surface that makes a strong drawing point.

Details are made by medium-range, harder pencil leads, such as regular number 2 or 2½ pencils.

Shading, or making light and dark tones to produce shadows and a feeling of solidness and depth, is best done with the flat side of a fairly soft-leaded pencil.

Colored Pencils are most effectively used by first making light strokes, then building up to develop darker areas.

Pen or Brush and Ink

Ink used with a pen or brush is useful for creating line drawings, silhouettes, and calligraphy.

Ink is available in permanent (or waterproof) and non-waterproof varieties and colors. Permanent inks come in the deepest and longest-lasting colors.

 Safety Precautions: Both non-waterproof and permanent inks stain badly. It is a good idea to wear old clothing or a bibbed apron when working with these inks. A large man's shirt worn backwards is helpful.

When diluted with water, ink is useful for making washes. To get a lighter value, add more water to the ink. Inks can be put down with steel, reed, or bamboo pens, brushes, pen nibs, or even twigs.

Pen Nibs are small metal points that attach to a holder. They range in shape from very flat and broad to extremely narrow to make different kinds of lines. Nibs are often used in calligraphy.

Helpful Hints: Scrape the tip of a pen nib against the lip of the ink bottle to remove excess ink. Pushing the pen away will cause it to dig into the paper and splatter ink. Ink flows more evenly if drawing is done on a sloped surface.

Chalk

This material is soft, powdery, and smears easily. Chalk can be softened and light and dark tones blended by smudging with a finger or soft cloth. The final drawing should be sprayed with a fixative to preserve it.

 Safety Precautions: Some students may be allergic to chalk dust. Before assigning a lesson in which chalk is used as a medium, check to see if any students have allergies, and make appropriate provisions for them.

Charcoal

This material is made from charred twigs or vine and is available in natural sticks, pencils, and compressed sticks. Its effects range from soft and dark to hard and light. Edges can be softened and light and dark tones blended by smudging with a finger or soft cloth.

Because it is dry and easily smeared, the final charcoal drawing should be sprayed with a fixative to preserve it.

Crayons

Made of hard wax, this medium is available in a great variety of colors. When applied with a heavy pressure, crayons produce rich, vivid colors.

Preliminary sketches are better made with white chalk or a light-colored crayon because pencil lines will often show through the crayon color. Newspaper padding under the drawing paper insures an even application of color.

Oil Pastels

Softer than wax crayons and similar to chalk, oil pastels produce bright, glowing color effects. They smudge more easily than crayons. As with crayons, drawing can be done with the points or with the unwrapped sides. (*Note:* Pressing hard creates rich, vibrant color; less pressure produces a softer color. Oil pastels break easily once the wrapping is removed.)

Colors can be mixed by adding one over another, or by placing dots of different colors side by side and smudging them.

Neither crayons nor oil pastels mix with water, so a watercolor wash over a drawing creates a crayon or oil pastel resist.

Colored Markers

These non-permanent felt or plastic-tipped instruments are clean and easy to use, and they are available in a wide range of colors and sizes. They are useful for sketching outdoors, making contour drawings, and for just about every art assignment imaginable.

Markers dry out easily, so be sure to keep caps on the tips when the markers are not in use.

Mechanical Drawing Instruments

Ruler. Hold the ruler firmly in place and measure a line of the desired length. Then put dots to mark the beginning and ending of the line and connect them by drawing a line against the ruler's edge.

Protractor. This instrument is in the form of a half-circle used to draw and measure angles.

Pencil Compass. This instrument is useful for making circles. First, be sure the pencil is securely attached to the holder on one leg; it should be the exact length of the pointed leg.

Press the metal point into the paper, with the two legs apart. Hold the pencil at the top and turn the pencil leg around the pointed leg. This creates a circle.

Vary the size of the circle by spreading or closing in the legs of the compass. The measurement from the center of a circle to the outside edge is called the radius.

PAINTING

Two of the most popular and readily available paints are tempera and watercolor.

PAINTING TOOLS AND TECHNIQUES

Tempera

This paint works best when it has the consistency of thick cream. It is available in powder or liquid, with the liquid form being the most common. Tempera is opaque—the paper beneath cannot be seen through the paint.

Powder. Available in cans or boxes, tempera powder should be mixed in small amounts. Water and powder are mixed to the desired consistency until there is sufficient paint. Only mix as much as is needed; dried tempera paint should not be used again.

Liquid. Available in a jar, or plastic container, tempera liquid is in a ready-to-use condition. Shake well each time the paint is to be used.

Keep the lid on when paint is not being used, and keep paint cleaned out of the cap to prevent sticking. Stuck bottle caps will usually loosen in warm water.

Some manufacturers supply pouring spouts, which are very helpful. If used, however, put a galvanized nail in the spout opening to keep it from getting stopped up.

Watercolor

Watercolor paints sometimes come in tubes, but more often come in a container or box with small, solid cakes. The solid paint needs to soften; have the students put a couple drops of water in each color as soon as they receive their paint boxes.

Watercolor paints are to be used with plenty of water. Because they are transparent, it is possible to see through the paints to the paper underneath. This gives watercolor paintings a distinctive shimmering effect.

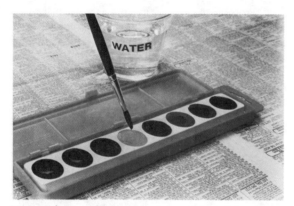

Watercolors—Add a couple drops of water in each pan to soften the paints.

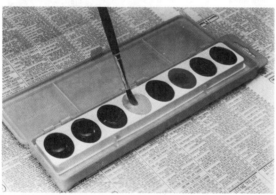

Loading the brush.

Brushes

Choose well-made brushes with metal ferrules that are tightly bonded to the wooden handles so that the bristles will not come off. Poorly made brushes are frustrating to students, since the bristles often come off onto their paintings.

Dozens of sizes and varieties of brushes are available, from nylon bristle brushes to fairly expensive sable brushes. Students should have access to a wide variety of brushes: round and flat, thick and thin, square-ended and oval-tipped. Other kinds of painting tools may be kept on hand for the students to experiment with: toothbrushes, eye-makeup brushes, various kinds of sponges and sponge applicators, cotton swabs, bristly cleaning brushes, and the like. With these unusual painting tools, the students can create interesting, varied effects.

Color-Mixing Tips

Be sure to keep the water in the container clean, and rinse the brush before dipping it into a new color. Even the youngest students should learn from the start the proper way to go about changing colors when painting.

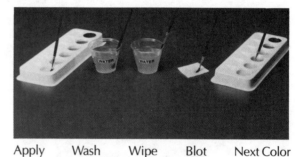

Apply Wash Wipe Blot Next Color

Mixing trays, or paint palettes, can be made from many free or inexpensive materials: pie pans, muffin tins, plastic trays from frozen foods, paper plates, and the like. Egg cartons make especially good mixing trays, as they provide plenty of room for color mixing and can be closed, labeled with the student's name, and stored for later use. (Note: When storing tempera paint in a mixing tray for later use, always add a little water to keep the paint from drying out overnight. A water spray bottle for indoor plants is very effective for this purpose.)

Water containers can be made from empty bottles, old cups, plastic margarine containers, and other containers. Empty milk cartons that the students have saved from their lunches can also be effectively used and may be the most economical alternative.

For Tempera Paint:

1. With tempera paint, always begin mixing with light colors, and add darker colors. For example, when mixing tints it is best to start with white and gradually add small amounts of color to make the desired hue. When mixing shades, start with a color and gradually add small amounts of black to form the desired shade.

2. Don't try to lighten tempera paint that has become too dark. Adding more paint will only make the color muddier.

3. To make gray, add small amounts of black tempera to white.

Pouring spouts on commercial paints and a cardboard container (which once held bottles of soda) form a unit which is easily carried and distributed to students.

A Styrofoam egg carton provides places to mix paint. If needed, the lid can be closed and the paints stored overnight (the students can write their names on the lids in pencil). When finished, all cartons can be discarded in a large plastic bag for easy disposal.

For Watercolor Paint:
1. To make watercolors lighter, add water.
2. To deepen watercolors, use less water.
3. There is no white in watercolor since it is opaque. The paper is allowed to show through where white is needed.
4. To make gray, just thin down black paint with water. All grays look better with a dab of another color added.

For Both Tempera and Watercolor:
1. To make green, add small amounts of blue to yellow.
2. To make orange, add small amounts of red to yellow.
3. To make violet, add small amounts of blue to red.
4. To make brown, try putting these colors together (each combination will make a variation of brown):
 a. red and green
 b. red, yellow, and black
 c. red and black

Cleaning and Storage of Brushes
Brushes must be thoroughly cleaned of paint after each class session's use, or the bristles will cake and can seldom be restored to normal. Store brushes with bristles upright in a container. Students are never too young to understand the importance of proper care of their art tools, so teach proper brush care and advise the students never to stand the brushes bristles-down in any container, not even while they are painting.

PRINTMAKING

PRINTMAKING TOOLS AND TECHNIQUES

Since early printmaking was done with wood blocks or metal plates, the terms "block" and "plate" are used for the objects that are developed to make prints, no matter what their material.

It's possible to make blocks from a wide variety of materials, such as Styrofoam meat trays, glue lines on cardboard, or cut/torn pieces of paper or tagboard pasted to another sheet of paper or cardboard.

Other materials recommended for making prints include man-made objects, such as keys or paper clips, and natural objects, such as leaves, roots, or wood.

Almost any variation in an otherwise flat surface will be enough to create a relief print. There are other techniques of printmaking, but most are too complex for the classroom setting in an elementary school.

How to Print:
1. Roll printing ink on a flat surface (such as a metal or plastic tray, a pan, or a cookie sheet).
2. Roll the brayer over the ink to spread it so the brayer can pick up an even coat of ink.
3. Roll the ink-coated brayer over the block until the whole surface is evenly covered with ink. Roll first in one direction, then in another at right angles.

4. Place the paper on top of the inked block. Press it down gently with the palm of the hand. Rub the back of the paper with the fingertips or the back of a spoon. Be sure to cover all areas, including the edges.

5. Pull the paper away from the block. This is called "pulling the print." The print is ready to dry.

Print block fully coated with paint.

Prepare the print block.

Put paper on *top* of inked block. Rub gently with your fingertips over the entire back of the paper.

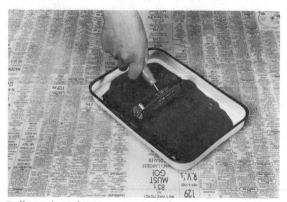

Roll out the ink in a pan using a brayer.

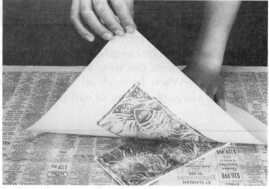

Pull the print.

Roll the ink evenly over the block.

Inks
In elementary school, printing ink should be water-based since it dries quickly and cleans up easily. However, it needs thinning to keep it from becoming tacky.

Printmaking Paper
Recommended paper for printing includes newsprint, construction paper, butcher paper, and tissue paper. Avoid using paper with a hard, slick finish because it absorbs ink and paint poorly.

Helpful Hints: Set up three printing centers in a classroom. (You may want to use a different color of ink at each center.) Put two students in charge of each center, keeping it neat and well-stocked with paper and ink. They will also be in charge of clean-up.

As students are ready to print, they go to a center and roll the ink on their blocks with the brayer. They take their inked blocks and papers to their desks and do the actual printing there. This will prevent long lines at the centers.

Cleanup
Drop a folded piece of newspaper in the pan filled with ink. Roll the brayer on the newspaper. This will remove a great deal of the ink from both the pan and the brayer. Unfold the newspaper and refold it with the dirty side inside. Crumple and throw away the newspaper. Repeat.

Once most of the ink is out of the pan, it is easy to rinse both it and the brayer at the sink.

SCULPTURE

Sculpture refers to three-dimensional art. It is usually made by carving, modeling, casting, or construction. Sculptures can be created by adding to or taking away from a block of material.

Materials appropriate for subtractive sculpture in school include clay, chalk, soap, wax, soft salt blocks, artificial sandstone, and plaster of paris.

Materials recommended for adding on to a piece of sculpture include clay, papier-mâché, wood, and almost anything else that can be joined together. Specific carving techniques appear in the discussion of each medium.

CLAY

Clay comes from the ground and usually has a gray or reddish color. It is mixed with other materials so that it is flexible and yet able to hold a shape.

Oil-Based Clay (also called Plasticine)

This clay is mixed with an oil, usually linseed, and cannot be fired or glazed. It softens when it is molded with warm hands. As it becomes old and loses oil, it becomes difficult to mold and will eventually break apart. Oil-based clay is available in many colors.

Water-Based or Wet Clay

This ceramic clay comes in a variety of textures and can be fired so that it is permanent. It should be kept in a plastic sack or covered with a damp cloth to keep it moist until it is used. If a piece begins to dry out, it may be kept damp with a fine spray of water.

Clay Methods

Clay can be molded and formed using the pinch, slab, and coil methods, or a combination of these.

With the pinch method, a chunk of clay is molded into a ball. Holding the ball in one hand, press the thumb in and carefully squeeze the clay between thumb and forefinger. Begin at the bottom and gradually work upward and out. Continually turn the ball of clay as it is pinched.

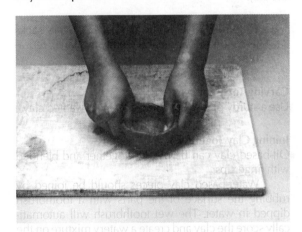

To make a slab, use a rolling pin to roll a chunk of clay into a flat slab about an inch thick. Shapes can be cut from the slab and joined together to form containers or sculpture.

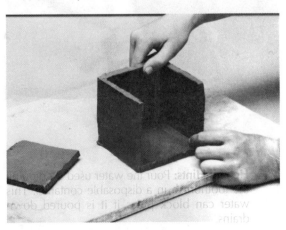

To create a coil, use the palm of the hand to roll a chunk of clay against a hard surface until it forms a "rope" of clay of even thickness. Coils can be attached to each other, and built into a shape.

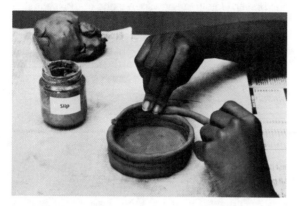

Textures can be created by pressing combs, coins, bolts, burlap, buckles, keys, chains, utensils, sticks, shells, straws, toothpicks, pencils, buttons, bottle caps, old jewelry, and other interesting objects into the clay.

Helpful Hints: Use brown paper grocery sacks as a work surface that is readily available, reusable, and easy to store.

Carving Techniques
Use a sturdy plastic knife to cut away unwanted clay.

Joining Clay Together
Oil-based clay can be pressed together and blended with fingertips.

Water-based clay pieces should be joined by rubbing the surface of the parts with a toothbrush dipped in water. The wet toothbrush will automatically score the clay and create a watery mixture on the parts to be joined.

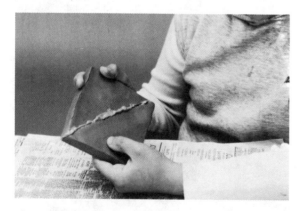

Helpful Hints: Pour the water used for dipping the toothbrush in a disposable container. This water can block pipes if it is poured down drains.

PAPIER-MÂCHÉ
This art material is made from mixing paper pulp or strips with paste or glue. It can be molded into various three-dimensional shapes when it is wet, and painted when it is dry.

Preparing Pulp
Shred pieces of soft paper, such as newsprint, paper towels, newspaper, or facial tissue, into small bits or thin strips. Soak several hours in water. Then drain, squeeze out the extra water, and mix the pulp with prepared wheat paste to the consistency of soft clay. Let the mixture stand for an hour before beginning to work with it.

Preparing Strip
Tear newspaper or newsprint into long, thin strips about 1/2" wide. Dip the strips into a wheat paste or starch and white glue mixture, and then put down a layer of wet strips over the shape to be covered. Continue putting strips on the form until there are five or six layers. This thickness is strong enough to support most papier-mâché projects.

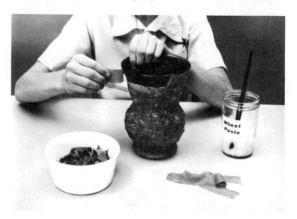

Foundations

Good forms that can be used as foundations for papier-mâché include the following: rolled newspapers secured with string or tape, blown-up balloons, plastic bottles, paper sacks stuffed with newspapers and tied with string, and wire or wooden armatures used as skeletal forms.

PLASTER OF PARIS

This white powder comes in large paper sacks and must be kept dry before use. It quickly turns solid when it is mixed with water and feels warm to the touch as it dries. Let the plaster dry two or three hours before working with it.

Plaster of paris is relatively soft and easy to carve and can be colored while drying or after it has hardened. The finished piece should be coated with an art spray or polymer gloss to preserve and protect it.

How To Mix Plaster

1. Put as much water in a bowl or bucket as the directions indicate.

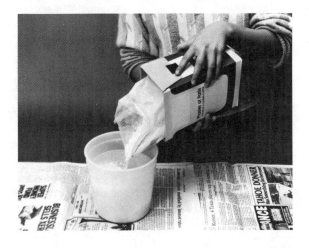

2. Quickly sprinkle plaster into the water until it begins to show through the surface of the water.
3. Mix the plaster and water together by hand or with a wooden spoon.

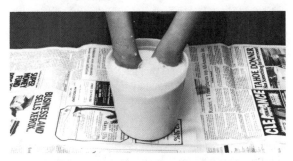

4. When the plaster is like thick cream, it is ready to pour.

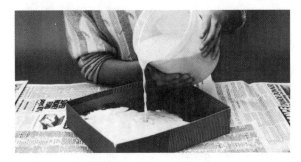

Carving Techniques

1. Pour the plaster into a mold, such as a disposable pie pan or a small milk carton.
2. Use a nail, nut pick, or old table knife to carve lines and descriptive details into the hardened plaster.

Safety Precautions: Always put plaster that is to be thrown away in a special newspaper-lined wastebasket, never down a drain.

BASIC MATERIALS AND PROCEDURES

TYPES OF PAPER

Butcher Paper
Available in wide rolls and several colors, this paper is useful for murals and other large art projects, as well as projects which require a hard-surfaced paper.

Construction Paper
Available in different colors, this fairly stiff paper is useful for tempera painting, collage, and paper sculpture. It will fade easily.

Drawing and Painting Paper
This fairly thick, slightly rough paper is useful for drawing and painting projects at the elementary level.

Newsprint Paper
This thin, blank paper is used for printing newspapers. Inexpensive and easily torn, it is good for sketching, printmaking, and making papier-mâché.

Tissue Paper
Very thin and strong and available in many bright colors, tissue is especially good for making collages and projects which require transparent color.

TECHNIQUES FOR USING PAPER

Folding
Bend the paper so that one edge is exactly on top of the other, and hold the two edges together. Smooth the paper until it creases at the center, then press the crease in between finger and thumb.

Tearing
Paper may be torn apart by hand, causing the edges to look ragged or fuzzy, or it may be folded, creased, and then torn along the creased fold, which gives a neater tear.

Cutting
If cutting from a large sheet, cut what is needed from the edge, not the center.

Scoring
With a hard or pointed instrument, such as a scissors' blade tip, press into but not through a piece of paper or cardboard. The paper will then easily bend or fold on that line.

 Safety Precautions: This technique is recommended only for upper-grade students.

Piercing
Middle-grade and upper-grade elementary students can learn to cut out parts in the center of a piece of paper by using pointed scissors to pierce and then cut into paper, removing unwanted center parts. This technique is especially useful for cutting out eyeholes in paper masks, cutting asymmetrical stencils or cutouts with negative spaces (such as number and letter shapes), and making frames or mats out of paper, without spoiling the rest of the paper.

Safety Precautions: Since pointed scissors are needed for this technique, students should only attempt this under teacher guidance. If the areas to be pierced are small, caution the students to be careful and not to put their fingers underneath the paper where the scissors will come through. Depending on the grade level, you may want to carry out the piercing technique yourself and let the students continue to cut away unwanted parts. This technique is not recommended for the primary grades.

GLUE, STARCH, AND PASTE

White Glue
This creamy liquid comes in plastic squeeze bottles and in larger containers. It is useful for sticking cardboard, wood, cloth, Styrofoam, and pottery. It will cause wrinkling when used with paper, especially if too much is used.

Starch
Recommended for making tissue paper collages, it should be mixed to a thin, watery consistency.

School or Library Paste
A thick, soft, and white mixture that usually comes in jars. It is good for sticking paper and cardboard, but if applied unevenly, the lumps will dry out so that the paper comes loose.

How to Stick Things Together
Spread out some newspaper. Place the artwork to be glued face downward. Spread the glue or paste outward from the center. Use a piece of cardboard or a finger. Be sure the edges and corners are all covered.

Lift the paper up and carefully lay it in the desired place. Smooth the paper flat with clean hands. Place a sheet of paper over the top and smooth down on top of that, using the palm of the hand.

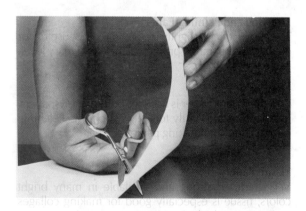

Helpful Hints: Always use the least amount of glue possible. Too much will spoil the appearance of the artwork.

FRAMING ARTWORK

Frames almost always improve the appearance of artwork and make attractive displays.

Mounting

The simplest kind of frame is a mount. It is made by putting a small dab of paste at each corner of an artwork. The artwork is then placed on the center of a sheet of construction paper or cardboard that is 2″ to 3″ larger than the work on all sides. The border may be slightly narrower at the top and slightly wider at the bottom, for a well-balanced appearance.

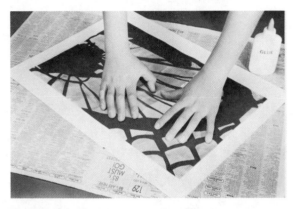

Matting (For Teachers)

A mat is a frame with a cut-out center. A picture is taped in place behind it, with the mat forming a border. Students can make mats out of black or colored construction paper. Professional-style mats made out of matboard should only be made by the teacher. You may wish to do this if you are preparing drawings or paintings for an art show.

To make a mat, take a piece of fairly thick cardboard, or matboard, that extends 2″ or 3″ beyond the picture on all sides. Measure the picture to be matted. Then, on the back of the matboard, mark the position where the art is to be placed.

The mat will look balanced if the bottom margin is a little larger than the other sides. Then measure 1/4″ in and mark it all around the frame. This will make the picture overlap the cut-out window on all sides.

Use an X-acto knife to cut along your inside measurements. Cut very carefully when a corner is reached so the matbord is not cut beyond the mark. When all four sides have been cut, the center will come out. Fasten a picture to the back with tape, and the mat is complete.

Safety Precautions: Work slowly and use caution when using an X-acto knife. Keep the blade pointed away from your body, and be sure to retract the blade or return the knife to its container when not in use.

Bookbinding Methods

Knowing how to bind books is a useful and enriching skill for teachers and students alike. Students experience pride and gain confidence as they see their work treated with the same care and consideration as a published book. The opportunities for turning your classroom into a "publishing house" are limited only by your imagination, for there are a host of activities that suggest themselves for bookbinding projects. You may, for example, wish to have your students create durable sketchbooks of blank paper for extracurricular as well as in-class sketching activities. You may suggest that your students make blank books that can be used as scrapbooks to contain student writings, photographs, and paper collectibles. As the students study subjects of interest to them, experience exciting moments in their home or school lives, or begin to write and illustrate their own original poems and stories, they may wish to record and save their knowledge, experience, and creativity in self-made books. Alternatively, an entire class can get together to make a "book by committee," in which students compile the contents, lay out the format, and design the cover for a book featuring creative works by the entire class.

In the pages that follow, you will be introduced to some basic approaches to bookbinding in the classroom. Other methods exist, and may be found in various books on the subject. While most of the directions given here use specific measurements so that you can make sample products with ease and familiarize yourself with the basic methods of bookbinding, the directions are adaptable to your choice of other sizes and shapes.

TAGBOARD BIND

1. To make a 24-page book, fold six sheets of 8½" x 11" paper in half, making 5½" x 8½" page size.
2. Fold a 9" x 11½" piece of colored tagboard in half.
3. Place the folded 5½" x 8½" pages inside the cover. Open the pages at the center fold and use a pencil and ruler to mark the very center of the fold with a dot. Then make two dots on either side of the center dot, 1½" apart, to make a total of five evenly spaced dots along the center fold. See diagram A.

4. Insert a needle through the pages and the tagboard cover at each of the five dots, making holes for the insertion of thread. Thread a large needle with a yard of thread, doubled but not knotted.
5. To stitch the book, insert the needle through the center hole, starting from the inside of the book and working to the outside. Leave about three or four inches of thread at the center hole, then follow diagram B to complete the stitching. When the binding has been sewn, pull the thread tight and tie a knot inside the book at the center hole. Snip excess thread.

A

B

1. For a 24-page book, fold six sheets of 6¼" x 8½" paper in half, making pages of 6¼" x 4¼" size.

2. For the endpapers, fold two pieces of 6¼" x 8½" paper in half. For best results, the endpapers should be of a contrasting color to the pages of the book. If you use a patterned paper for the covers of the book, use plain paper for the endpapers, and vice versa.

3. Place the folded endpapers over the folded pages, making what is called a *section* or *signature*, as shown in diagram A. The center pages will protrude slightly on the open side. (See diagram B.) To correct this, place the signature on a magazine and use a straight edge and X-acto knife to trim the uneven pages, as shown in diagram C.

B

C

A

4. To make the bookboards—the hard cover of the book that will be covered by paper—cut two pieces of mat or illustration board, each 6¾" x 4¼". If you intend to leave your bookboards uncovered—as you may wish to do if you are using colored mat board—you can attach the signature directly to the bookboards. In this case, skip steps 5-8, and proceed directly to step 9.

5. To make papers to cover the bookboards, cut two pieces of 9" x 5¼" paper. Some papers that may be used for covering bookboards include patterned wrapping paper, drawing paper, construction paper, plain butcher paper, etc.

6. Place one of the bookboards on newspaper and use the edge of a strip of thick cardboard (about 1½" x 2" wide) as a scraper to spread paste evenly over the entire surface of the bookboard. Then place the bookboard, paste-covered side down, on one of the covering papers, as shown in diagram D. Press firmly to eliminate air bubbles.

D

7. Snip the two corners of the covering paper, leaving about 1/16" of space between the diagonal cut and the corner of the bookboard, following diagram E. Spread some of the paste on the three side edges of the bookboard and fold the covering paper onto the backside of the bookboard (diagram F) to complete the mitered joint.

E

F

8. Repeat this process for the other bookboard.

9. Cut a piece of 1½" wide fabric or plastic tape into a 9" length. Place the tape on the table, sticky side up. Place the front sides of the bookboards on the tape, leaving an *alley* about 1/2" wide between them, as shown in diagram G. Fold the ends of the tape over, following diagram H.

G

H

10. Once again, use the cardboard scraper and spread paste smoothly and evenly over the *inside* of one of the bookboards, applying the paste in a 1/4″ band around the three edges. Hold the stitched signature of the book upright in the alley, between the front and back covers. Lower one of the endpapers down onto the past-covered book-board, being careful to place it evenly. Wipe off any paste that may be left around the edges. Cut a piece of waxed paper and place it over the endpaper before closing the book, so that any paste that may remain around the edges will not soil the body of the book. Repeat this process for the endpaper on the other side of the book.

I

11. Place your finished book under a heavy weight to prevent warpage while it dries.

FABRIC-COVERED BOOKBOARDS: DRY-MOUNT BINDING

An alternative method of covering bookboards, especially successful if fabric or wallpaper is to be used rather than paper, is the dry-mount method. Although this method is fast and effective, special materials—including an iron and dry-mount paper—are necessary in order to bind books using this method. As you follow these directions, you may wish to make your book to the same dimensions as were used in the preceding instructions for Paper-Covered Bookboards—Single Section Bind.

1. Decide how many pages to include in your book, and make them by folding half that number of pages in half, adding two extra pages front and back to make endpapers. These extra pages may be a different color from the rest of the pages in the signature.

A

2. To make the section or signature, use a large needle and white thread to stitch down the center fold of the paper. A sewing machine can also be used for this.

B

3. Cut a piece of fabric or wallpaper so that it is a little more than 1″ larger all the way around than the size of the open book pages. Lay the cloth or wallpaper on a flat surface.

C

4. Cut two equal-size pieces of cardboard, mat-board, or chipboard, making each piece slightly larger than the size of a folded book page. These will be your bookboards.

D

F

E

G

5. Cut a piece of *dry-mount paper* (available in photo supply stores or through art or educational supply order catalogs) to the same size as the fabric or wallpaper. Place the fabric, right side down, on a flat surface. Then place the dry-mount on top of the fabric. Carefully lay the bookboards on top of the dry-mount paper, as shown in diagram D. Leave a small space, about the width of a pencil, between the two bookboards, making a gutter or alley where the spine of the book will be.

6. Using a warm iron, press the dry mount and fabric to the bookboard, as shown in diagram E. First, fold over the fabric at each corner of the book and press it down. Be careful to press only the fabric with the iron, not the dry mount itself, since the dry-mount paper acts like glue when it is heated, sealing the fabric to the bookboard. After folding over the corners of the fabric, fold over each 1″ long overlap of fabric and heat-seal it to the bookboard with your iron.

7. Now cut a second piece of dry-mount paper the same size as the open book page. Place this dry mount in the center of the open bookboard. Lay the signature on the dry mount so that the stitched center fits in the alley, the space between the bookboards.

8. Carefully press the first page of the signature—the endpaper—to the bookboard, heat-sealing it with your iron. Then do the same for the last page. Apply heat to the paper for only a few seconds. You may want to use a press cloth over your endpapers to avoid burning or scorching the paper. Finally, close the book, pressing the front and back covers with a warm iron so that the fabric or wallpaper is thoroughly bonded to the bookboards.

first page H last page

NOTEBOOK RING BIND

1. Cut two squares of mat or illustration board in 6″ x 6″ size to make bookboards.
2. Cut two pieces of covering paper for the bookboards, each 8″ x 8″. Suitable covering paper can be made from patterned wrapping paper, drawing paper, lightweight wallpaper, etc.
3. Use the edge of a thick piece of cardboard to spread an even coat of paste over one of the

bookboards. Place the bookboard in the center of one of the pieces of covering paper. Then miter the four corners of the bookboard as described in "Paper-Covered Bookboards—Single Section Bind," snipping the corners and pasting the four sides onto the inside of the bookboards.

4. Cut two endpapers, 5½″ x 5½″. Spread paste evenly over the inside of the bookboards, leaving a 1/4″ unpasted border on all sides. Then attach the endpapers.

5. On the front cover, measure and mark with a pencil where you will place the two notebook rings. They should be 1″ from the top and bottom and about 1/3″ in from the edge. Use a leather punch to make the two holes. (The best way to do this is by holding the punch in place on the marked dot and gently twisting the bookboard back and forth while applying a small amount of pressure with the punch.) After the front cover

has been punched, mark matching spots for the holes on the back cover and punch holes in the same manner.

6. Weight the covered bookboards down while they are drying to prevent warpage.

7. Cut the desired number of pages for the book, making each page 5½″ x 5½″. Secure the bookboards and pages with two 1″ notebook rings.

ZIGZAG OR ACCORDION BIND

1. To make the bookboards, cut two squares of mat or illustration board to a 6″ x 6″ size.

2. Cut two pieces of covering paper (lightweight wallpaper, patterned wrapping paper, drawing paper, etc.) in an 8″ x 8″ size. Cover both front and back bookboard covers as described under "Notebook Ring Bind," mitering the four corners. Do *not* paste down any endpapers.

3. Cut a strip of butcher paper 5½″ x 44″ and fold it in an accordion manner, being careful to keep the edges straight and even and the folds crisp.

4. To make ties on the sides (see diagram A) of the bookboards, use a 1/2″ wide chisel and tap a vertical slit about 1/3″ from the edge in the middle of the right and left sides. Insert a 12″ length of ribbon or middy tape through the slit from the front, pasting about 1″ of it down flat on the inside of the bookboard. This part will be covered by the zigzag-folded strip later.

5. Spread paste over the inside front cover, leaving 1/4″ border on all sides. Place the end flap of the zigzag-folded strip down on it. This strip takes the place of an endpaper. Spread paste over the inside of the back bookboard cover and place the other end of the zigzag strip down on it.

6. Close the book and weight it down while it dries to prevent warpage.

ALBUM BIND

1. Cut two pieces of mat or illustration board to 7¼″ x 8″ size for the bookboards. Then cut two strips

of board in a 1″ x 7¼″ size for the album ends.

2. Cover the front and back bookboards as

described previously. Use endpapers that are 9¼" x 9". Then paste down the endpapers (7¾" x 6¾"), as shown in diagram A. Weight the covers while they are drying to prevent warpage.

A

3. Cut a piece of 1½"-wide tape to a length of 9¼". Lay it on the table, sticky side up. Place one of the 1" x 7¼" board strips you cut earlier on the left side of the tape and the front of one of the covered bookboards on the other side, leaving a gutter or alley of tape between them about 1/3" wide. (See diagram B.) Fold the flaps of tape over to secure the bookboard and board strip. (See diagram C.) Then cut another piece of tape in a 6¼" length and cover the alley, as shown in diagram D. Repeat this process to make the other bookcover.

B

C

D

4. Use additional tape to cover the front side of the 1" wide strip to make a neat finish. Then use a leather punch to make two holes in each of the end strips. (See diagram E.) Cut the desired number of pages (9" x 6¾") and use a paper punch to make holes in them. Secure the pages between the back and front covers with two Chicago screws. (Chicago screws are available in office supply stores.)

E

Chicago screw

Supplies Chart* – Grade 3

Supplies/Lesson Number	1	2	3	4	5	6	7	8	9	10	11	12	13	14	15	16	17	18	19	20	21	22	23	24	25	26
Balloon																										
Box																										
Brown paper																										
Brushes												•	•		•			•	•	•						•
Butcher paper														•												
Buttons																										
Cardboard			•																			•	•			
Chalk							•											•								
Charcoal																										
Clay				•					•																	
Cloth																										
Coffee																										
Colored construction paper															•			•				•				•
Colored markers								•						•												
Crayons					•			•			•							•			•			•		
Dyebath																										
Fabric scraps						•																				
Feathers																										
Food coloring																										
Glitter																										
Gloves																										
Glue			•			•	•																•			
Index cards												•														
Knife																										
Lace																										
Lights																										
Magazines with pictures																			•							
Miscellaneous objects				•	•			•	•																	
Mounting and framing materials																										
Natural objects																										
Paint								•	•			•	•			•		•	•	•					•	•
Paper bag																										
Paste														•												•
Pens																	•		•					•		
Petroleum jelly																										
Pins																										
Pipe cleaners																							•			
Plaster block																										
Plastic bag																										
Popsicle sticks																										
Ribbon																		•								
Rollers																										
Ruler																								•		
Sandpaper																										
Scissors	•		•			•	•							•	•			•		•	•	•		•		•
Sheets (white)																										
Soda soak for tie-dye																										
Stapler														•												
Starch										•																
String																		•								
Styrofoam cup																										
Tagboard																										
Tape							•					•										•	•	•		
Tissue paper										•																
Toothbrush																										
Toothpicks																										
Waxed paper										•																
Wire coat hanger																					•					
Wire screen																										
Wrapping paper																										
Yarn			•																							

*The following items are needed in nearly every lesson, and so are not included on the chart: pencil and eraser, white drawing or sketching paper, newspaper, water, water containers, and paper towels.

Supplies/Lesson Number	27	28	29	30	31	32	33	34	35	36	37	38	39	40	41	42	43	44	45	46	47	48	49	50	51
Balloon			•																						
Box																			•		•				
Brown paper										•															
Brushes							•			•					•			•			•			•	
Butcher paper									•									•	•						
Buttons		•		•																					
Cardboard								•																	
Chalk					•												•								
Charcoal					•																				
Clay																						•			
Cloth												•													
Coffee										•															
Colored construction paper		•			•						•						•								•
Colored markers				•						•	•			•					•				•		
Crayons	•			•				•			•		•	•		•				•			•		•
Dyebath												•													
Fabric scraps				•																					
Feathers											•														
Food coloring								•																	
Glitter											•														
Gloves												•													
Glue		•			•	•	•				•									•					
Index cards																									
Knife							•																		
Lace				•																					
Lights														•											
Magazines with pictures																									
Miscellaneous objects											•	•													
Mounting and framing materials																									
Natural objects																			•						
Paint		•	•	•							•				•			•	•				•	•	
Paper bag		•													•										
Paste				•															•						•
Pens																									
Petroleum jelly				•																					
Pins																									
Pipe cleaners																									
Plaster block							•																		
Plastic bag												•													
Popsicle sticks																									
Ribbon				•							•														
Rollers																				•					
Ruler																									
Sandpaper							•																		
Scissors		•	•			•					•	•	•												•
Sheets (white)																									
Soda soak for tie-dye												•													
Stapler		•																							
Starch															•						•				
String		•										•													
Styrofoam cup																									
Tagboard											•														
Tape		•		•											•										
Tissue paper																					•				
Toothbrush																									
Toothpicks								•																	
Waxed paper																									
Wire coat hanger															•										
Wire screen																									
Wrapping paper														•											
Yarn		•																							

Supplies Chart – Grade 3

Supplies/Lesson Number	52	53	54	55	56	57	58	59	60
Balloon							F	F	
Box							R	R	
Brown paper							E	E	
Brushes							E	E	
Butcher paper									
Buttons							C	C	
Cardboard				•		•	H	H	
Chalk							O	O	
Charcoal							I	I	
Clay							C	C	
Cloth				•			E	E	
Coffee									
Colored construction paper									
Colored markers	•								
Crayons		•	•						
Dyebath									
Fabric scraps									
Feathers									
Food coloring									
Glitter									
Gloves									
Glue									
Index cards	•								•
Knife									
Lace									
Lights									
Magazines with pictures									
Miscellaneous objects									
Mounting and framing materials									•
Natural objects									
Paint				•	•				
Paper bag									
Paste									
Pens									•
Petroleum jelly									
Pins									•
Pipe cleaners									
Plaster block									
Plastic bag									
Popsicle sticks							•		
Ribbon									
Rollers									
Ruler						•			
Sandpaper									
Scissors				•		•			
Sheets (white)									•
Soda soak for tie-dye									
Stapler									
Starch									
String						•			
Styrofoam cup									
Tagboard									
Tape						•			
Tissue paper									
Toothbrush					•				
Toothpicks									
Waxed paper									
Wire coat hanger									
Wire screen					•				
Wrapping paper									
Yarn						•			

Bibliography

Art Education—General

Arts & Activities. Magazine. San Diego, CA.

Arts for the Gifted and Talented. Sacramento, CA: California State Department of Education, 1981.

Brittain, W. Lambert. *Creativity, Art, and the Young Child*. New York: Macmillan, 1979.

Brommer, Gerald, and Gatto, Joseph. *Careers in Art: An Illustrated Guide*. Worcester, MA: Davis, 1985.

Carson, Janet. *Tell Me About Your Picture*. Englewood Cliffs, NJ: Prentice-Hall, 1984.

Chapman, Laura H. *Approaches to Art in Education*. New York: Harcourt Brace Jovanovich, 1978.

Chenfeld, Mimi B. *Creative Activities for Young Children*. San Diego, CA: Harcourt Brace Jovanovich, 1983.

Cherry, Clare. *Creative Art for the Developing Child: A Teacher's Handbook for Early Childhood Education*. Belmont, CA: Pitman Learning, 1972.

Clements, Claire R., and Clements, Robert D. *Art and Mainstreaming: Art Instruction for Exceptional Children in Regular School Classes*. Springfield, IL: Charles Thomas, 1984.

Di Leo, Joseph H. *Children's Drawings as Diagnostic Aids*. New York: Brunner-Mazel, 1980.

Eddy, Junius. *The Music Came from Deep Inside: The Story of Artists and Severely Handicapped Children*. New York: McGraw-Hill, 1982.

Eisner, Elliot W. *Educating Artistic Vision*. New York: Macmillan, 1972.

Face to Face: Children, Art and Education. Cleveland, OH: Council on Human Relations, 1984.

Feldman, Edmund Burke. *Becoming Human Through Art*. Englewood Cliffs, NJ: Prentice-Hall, 1970.

Gardner, Howard. *Artful Scribbles*. New York: Basic Books, 1980.

Gaitskell, Charles D.; Hurwitz, Al; and Day, Michael. *Children and Their Art, Methods for the Elementary School*. 4th Ed. New York: Harcourt Brace Jovanovich, 1982.

Garritson, Jane. *Child Arts: Integrating Curriculum Through the Arts*. Menlo Park, CA: Addison Wesley, 1979.

Hardiman, George W., and Zernich, Theodore. *Art Activities for Children*. Englewood Cliffs, NJ: Prentice-Hall, 1981.

Herberholz, Barbara, and Hanson, Lee. *Early Childhood Art*. Dubuque, IA: William C. Brown, 1985.

Herberholz, Donald, and Alexander, Kay. *Developing Artistic and Perceptual Awareness*. 5th Ed. Dubuque, IA: William C. Brown, 1985.

Holden, Donald. *Art Career Guide*. New York: Watson-Guptill, 1983.

Hubbard, Guy. *Art for Elementary Classrooms*. Englewood Cliffs, NJ: Prentice-Hall, 1982.

Hubbard, Guy, and Zimmerman, Enid. *Artstrands, a Program of Individualized Art Instruction*. Prospect Heights, IL: Waveland Press, 1982.

Hurwitz, Al. *The Gifted and Talented in Art, a Guide to Program Planning*. Worcester, MA: Davis, 1983.

Hurwitz, Al, and Madeja, Stanley S. *The Joyous Vision: Source Book*. Englewood Cliffs, NJ: Prentice-Hall, 1977.

James, Philip. *Teaching Art to Special Students*. Portland, ME: J. Weston Walch, n.d.

Linderman, Marlene. *Art in the Elementary School: Drawing, Painting, and Creating for the Classroom*. 3rd Ed. Dubuque, IA: William C. Brown, 1984.

Luca, Mark, and Allen, Bonnie. *Teaching Gifted Children Art in Grades One Through Three*. Sacramento, CA: California State Department of Education, 1974.

Mattil, Edward L., and Marzan, Betty. *Meaning in Children's Art*. Englewood Cliffs, NJ: Prentice-Hall, 1981.

Nash, Ann Bachtel. *National Directory of Programs Addressing the Gifted and Talented*. Pasadena, CA: Tams, 1984.

Plummer, Gordon, S. *Children's Art Judgment*. Dubuque, IA: William C. Brown, 1974.

School Arts. Magazine. Worcester, MA: Davis.

Silberstein-Storfer, and Jones, Mablen. *Doing Art Together*. New York: Simon & Schuster, 1982.

Smith, Nancy R. *Experience and Art: Teaching Children to Paint*. New York: Teachers College Press, 1983.

Timmons, Virginia G. *Art Materials, Techniques, Ideas: A Resource Book for Teachers*. Worcester, MA: Davis, 1974.

Uhlin, Donald. *Art for Exceptional Children*. Dubuque, IA: William C. Brown, 1984.

Visual and Performing Arts Framework for California Public Schools: K-12. Sacramento, CA: California State Department of Education, 1982.

Wachowiak, Frank. *Emphasis Art*. 4th Ed. New York: Thomas Y. Crowell, 1984.

Wilson, Marjorie, and Wilson, Brent. *Teaching Children to Draw: A Guide for Teachers and Parents*. Englewood Cliffs, NJ: Prentice-Hall, 1982.

Perception and Visual Thinking

Adkins, Jan. *Inside: Seeing Beneath the Surface.* New York: Walker & Company, 1984.

Bager, Bertel. *Nature as Designer.* New York: Van Nostrand Reinhold, 1976.

Berner, Jeff. *The Photographic Experience.* Garden City, NY: Anchor Books, Doubleday, 1975.

Borten, Helen. *Do You See What I See?.* New York: Abelard-Schuman, 1959.

Harris, Ned. *Form and Texture: A Photographic Portfolio.* New York: Van Nostrand Reinhold, 1974.

Hoban, Tana. *Look Again.* New York: Macmillan, 1971.

Johnson, Mary Frisbee. *Visual Workouts: A Collection of Art-Making Problems.* Englewood Cliffs, NJ: Prentice-Hall, 1983.

Lacey, Jeanette F. *Young Art, Nature and Seeing.* New York: Van Nostrand Reinhold, [1973?]

Laliberte, Norman, and Mogelon, Alex. *The Reinhold Book of Art Ideas.* New York: Van Nostrand Reinhold, 1976.

Leff, Herbert L. *Playful Perception.* Burlington, VT: Waterfront Books, 1985.

McKim, Robert H. *Thinking Visually, a Strategy Manual for Problem Solving.* Belmont, CA: Lifetime Learning Pub., Division of Wadsworth, 1980.

Meilach, Dona Z.; Hinz, Jan; and Hinz, Bill. *How to Create Your Own Designs.* Garden City, NY: Doubleday, 1975.

Morman, Jean Mary. *Wonder Under Your Feet, Making the World of Art Your Own.* New York: Harper & Row, 1973.

Raudsepp, Eugene. *More Creative Growth Games.* New York: A Perigee Book, 1980.

Raudsepp, Eugene, and Hough, George P., Jr. *Creative Growth Games.* New York: Harcourt Brace Jovanovich, 1977.

Samuels, Mike, and Samuels, Nancy. *Seeing with the Mind's Eye.* A Random House-Bookworks Book, 1975.

Taylor, Benjamin Debrie. *Design Lessons from Nature.* New York: Watson-Guptill, 1974.

Von Oech, Roger. *A Whack on the Side of the Head.* Menlo Park, CA: Creative Thinking, 1983.

Two-Dimensional Art: Drawing, Painting, and Printmaking

Allen, Janet. *Drawing, a Complete Teach-Yourself Handbook.* New York: Van Nostrand Reinhold, 1980.

Amery, Heather, and Civardi, Anne. *The Funcraft Book of Print and Paint.* Scholastic Book Services, Usborne Publishing Ltd., 1976.

Andrew, Laye. *Creative Rubbings.* New York: Watson-Guptill, 1972.

Borgeson, Bet. *The Colored Pencil.* Lakewood, NJ: Watson-Guptill, 1983.

Borgman, Harry. *Drawing in Pencil.* Lakewood, NJ: Watson-Guptill, n.d.

_____ . *The Pen and Pencil Technique Book.* New York: Watson-Guptill, 1984.

Brockett, Anna. *Draw Patterns.* New York: A Pentalic Book, Taplinger, 1980.

Brommer, Gerald F. *Drawing, Ideas, Materials and Techniques.* Rev. Ed. Worcester, MA: Davis, 1978.

_____ . *Landscapes.* Worcester, MA: Davis, 1977.

_____ . *Relief Printmaking.* Worcester, MA: Davis, 1970.

Brown, David. *Draw Birds.* New York: A Pentalic Book, Taplinger, 1979.

Carhartt, Mary. *Watercolor: See For Yourself Series.* New York: Grumbacher, 1984.

Clifton, Jack. *The Eye of the Artist.* New York: North Light Pub., Watson-Guptill, 1973.

Dean, Wayne. *The Incredible, Spreadable, Magic Drawing Book.* San Diego, CA: Wayne Dean Editions, 1983.

de Fiore, Gaspare. *The Drawing Course: Learning to See and Draw* and *Drawing with Color and Imagination.* Lakewood, NJ: Watson-Guptill, n.d.

de Reyna, Rudy. *How to Draw What You See.* Lakewood, NJ: Watson-Guptill, 1972.

DuBery, Fred, and Willats, John. *Perspective and Other Drawing Systems.* New York: Van Nostrand Reinhold, 1983.

Edwards, Betty. *Drawing on the Right Side of the Brain.* Los Angeles: J. P. Tarcher, 1979.

Gordon, Stephen F. *The Contemporary Face: New Techniques and Media.* New York: Van Nostrand Reinhold, 1972.

Hanks, Kurt, and Belliston, Larry. *Draw! A Visual Approach to Thinking, Learning and Communicating.* Los Altos, CA: William Kaufmann, 1977.

_____ . *Rapid Viz, a New Method for the Rapid Visualization of Ideas*. Los Altos, CA: William Kaufmann, 1980.

Hart, Tony. *The Young Letterer.* New York: Frederick Warne, 1965.

Hayes, Colin. *The Technique of Watercolor Painting.* New York: Reinhold, 1967.

Hurwitz, Al. *Drawing for the Schools.* Baltimore, MD: Maryland Institute, College of Art, 1983.

James, Jane H. *Perspective Drawing, a Directed Study.* Englewood Cliffs, NJ: Prentice-Hall, 1981.

Kampman, Lothar. *Creating with Poster Paints.* New York: Van Nostrand Reinhold, 1967.

_____ . *Creating with Printing Materials.* New York: Van Nostrand Reinhold, 1969.

Laliberte, Norman, and Mogelon, Alex. *Drawing with Ink, History and Techniques* and *Drawing with Pencils, History and Techniques.* New York: Van Nostrand Reinhold, 1970.

Malins, Frederick. *Drawing Ideas of the Masters.* Tucson, AZ: H.P. Books, 1981.

Meglin, Nick. *On-the-Spot Drawing.* New York: Watson-Guptill, 1976.

Mueller, Mary Korstad. *Murals, Creating an Environment.* Worcester, MA: Davis, 1979.

O'Connor, Charles A. *Perspective Drawing and Applications.* Englewood Cliffs, NJ: Prentice-Hall, 1984.

Paterson, Robert. *Abstract Concepts of Drawing.* New York: Van Nostrand Reinhold, 1983.

Petrie, Ferdinand, and Shaw, John. *The Watercolorist Guide to Painting Trees.* New York: Watson-Guptill, 1984.

Porter, Albert W. *Expressive Watercolor Techniques.* Worcester, MA: Davis, 1982.

Rein, Charles. *Painting What You (Want To) See.* Lakewood, NJ: Watson-Guptill, n.d.

Rottger, Ernst, and Klante, Dieter. *Creative Drawing, Point and Line.* New York: Reinhold, 1963.

Rubbra, Benedict. *Draw Portraits.* New York: A Pentalic Book, Taplinger, 1979.

Schachner, Ervin. *Printmaking, Step by Step.* New York: Golden Press, 1970.

Selleck, Jack. *Faces.* Worcester, MA: Davis, 1977.

Seymour, Mary. *Draw Flowers and Plants.* New York: A Pentalic Book, Taplinger, 1979.

Simpson, Jan. *Drawing: Seeing and Observation.* New York: Van Nostrand Reinhold, 1982.

Spencer, Roy. *Draw the Human Body.* New York: A Pentalic Book, Taplinger, 1980.

Striker, Susan, and Kimmel, Edward. *The Anti-Coloring Book,* series of 12. New York: Holt, Rinehart & Winston, n.d.

Stern, Arthur. *How to See Color and Paint It.* New York: Watson-Guptill, 1984.

Suffudy, Mary, ed. *Sketching Techniques.* Lakewood, NJ: Watson-Guptill, n.d.

Tritten, Gottfried. *Art Techniques for Children.* New York: Reinhold, 1965.

_____ . *Teaching Color and Form.* New York: Van Nostrand Reinhold, 1981.

Warner, Malcolm. *Portrait Painting.* New York: Mayflower Books, Phaidon Press, 1979.

Watson, Dori. *The Techniques of Painting.* New York: Galahad Books, 1970.

Weiss, Harvey. *Paper, Ink and Roller.* New York: Young Scott Books, 1958.

_____ . *Pencil, Pen and Brush.* New York: Scholastic Book Services, 1965.

Winter, Roger. *Introduction to Drawing.* Englewood Cliffs, NJ: Prentice-Hall, 1983.

Three-Dimensional Art and Crafts

Aaron, Elisabeth. *Quilling, The Colonial Art of Paper Scrollwork.* New York: Larousse & Company, 1976.

Accorsi, William. *Toy Sculpture.* New York: Reinhold, 1968.

Baylor, Byrd. *When Clay Sings.* New York: Atheneum, 1972.

Berensohn, Paulus. *Finding One's Way with Clay.* New York: Simon & Schuster, 1972.

Betts, Victoria. *Exploring Papier Mâché.* Rev. Ed. Worcester, MA: Davis, 1966.

Birks, Tony. *Basic Pottery.* New York: Sterling, 1984.

Blair, Margot C., and Ryan, Cathleen. *Banners and Flags, How to Sew a Celebration.* New York: Harcourt Brace Jovanovich, 1977.

Braeman, Shirley W. *Fold, Tie, Dip and Dye.* Minneapolis: Lerner, 1976.

Castino, Ruth. *Spinning and Dyeing the Natural Way.* New York: Van Nostrand Reinhold, 1974.

Ceramics Techniques and Projects. Ed. Sunset Books and Magazine. Menlo Park, CA: Lane Books, 1974.

Three-Dimensional Art and Crafts *continued*

Cobeck, John. *Pottery: Techniques of Decoration.* New York: Van Nostrand Reinhold, 1983.

Cooper, Patricia, and Buferd, Norma B. *The Quilters, Women and Domestic Art, an Oral History.* Garden City, NY: Anchor Press, Doubleday, 1978.

Create-A-Kite. Ed. Consumer Guide. Fireside Book, Simon & Schuster, 1977.

Curtis, Annabelle, and Hindley, Judy. *The Funcraft Book of Paper Fun.* Scholastic Book Services, Usborne Publishing, Ltd., 1976.

Dieringer, Beverly, and Morton, Marjorie. *The Paper Bead Book.* New York: David McKay, 1977.

Dumpleton, John. *Make Your Own Booklet.* New York: A Pentalic Book, Taplinger, 1980.

Eisner, Vivienne, and Shisler, William. *Crafting with Newspapers.* Little Craft Book Series. New York: Sterling, 1976.

Enthoven, Jacqueline. *Stitchery for Children, a Manual for Teachers, Parents and Children.* New York: Van Nostrand Reinhold, 1968.

Ericksen, Aase, and Wintermute, Marjorie. *Students, Structure, Spaces: Activities in the Built Environment.* Menlo Park, CA: Addison-Wesley, 1983.

Flacklam, Margery, and Phibbs, Patricia. *Corn-Husk Crafts.* Little Craft Book Series. New York: Sterling, 1973.

Gardner, Pat, and Gleason, Kay. *Dough Creations, Food to Folk Art.* Radnor, PA: Chilton, 1977.

Grainger, Stuart E. *Creative Papercraft.* New York: Sterling, 1980.

Hall, Carolyn Vosburg. *Soft Sculpture.* Worcester, MA: Davis, 1981.

Harelson, Randy. *The Kids' Diary of 365 Amazing Days.* New York: Workman, 1979.

Hilliard, Clifford. *Ceramics, a Beginner's Handbook.* Portland, ME: J. Weston Walch, 1984.

Hofsted, Jolyon. *Step-by-Step Ceramics.* New York: Golden Press, 1967.

Hutton, Helen. *Mosaic Making Techniques.* New York: Charles Scribner's Sons, 1977.

Isenstein, Harald. *Creative Claywork.* New York: Sterling, 1975.

Johnson, Pauline. *Creating with Paper.* Seattle: University of Washington Press, 1958.

Katzenberg, Gloria. *Art and Stitchery, New Directions.* New York: Charles Scribner's Sons, 1974.

Kulasiewicz, Carol. *Printmaking Made Easy.* Portland, ME: J. Weston Walch, 1985.

Laliberte, Norman, and McIlhany, Sterling. *Banners and Hangings, Design and Construction.* New York: Van Nostrand Reinhold, 1966.

Laury, Jean Ray. *Appliqué Stitchery.* Van Nostrand Reinhold, 1966.

_____ . *Doll Making, a Creative Approach.* New York: Van Nostrand Reinhold, 1970.

Lorrimar, Betty. *Creative Papier-Mâché.* Cincinnati, OH: Watson-Guptill, 1971.

Marin, Lise. *Lots of Fun to Cook.* Cleveland, OH: Collins World, 1974.

Meilach, Dona Z. *Creating Art with Bread Dough.* New York: Crown, 1976.

_____ . *A Modern Approach to Basketry with Fibers and Grasses.* New York: Crown, 1974.

Meilach, Dona Z., and Snow, Lee Erlin. *Creative Stitchery.* Chicago: Reilly & Lee, 1970.

Mergeler, Karen. *Too Good to Eat!* Santa Ana, CA: Folk Art Publications, 1972.

Neuville, Christiane. *Fun with Clay.* New York: Franklin Watts, 1974.

Newman, Lee S., and Newman, Jay H. *Kite Craft.* New York: Crown, 1975.

Newman, Thelma R. *Quilting, Patchwork, Appliqué and Trapunto.* New York: Crown, 1975.

Newman, Thelma R.; Newman, Jay; and Newman, Lee. *Paper as Art and Craft.* New York: Crown, 1973.

Philpott, Violet, and McNeil, Mary Jean. *The Fun Craft Book of Puppets.* Scholastic Book Services, Usborne Publishing, 1976.

Priolo, Joan, and Priolo, Anthony. *Ceramics by Slab.* Little Craft Book Series. New York: Sterling, 1973.

Post, Henry, and McTwigan, Michael. *Clay Play Learning Games for Children.* Englewood Cliffs, NJ: Prentice-Hall, 1973.

Proctor, Richard M. *The Principles of Pattern for Craftsmen and Designers.* New York: Van Nostrand Reinhold, 1969.

Puppets, Art and Entertainment. *Washington, DC: Puppeteers of America, 1980.*

Rainey, Sarita R. *Wall Hangings: Designing with Fabric and Thread.* Worcester, MA: Davis, 1974.

_____ . *Weaving Without a Loom.* Worcester, MA: Davis, 1968.

Russell, Elfleda. *Off-Loom Weaving, a Basic Manual.* Boston: Little, Brown, 1975.

Schmitt-Menzel, Isolde. *Having Fun with Clay.* New York: Watson-Guptill, 1969.

Solberg, Ramona. *Inventive Jewelry-Making.* New York: Van Nostrand Reinhold, 1972.

Stephan, Barbara. *Creating with Tissue Paper.* New York: Crown, 1973.

_____ . *Decorations for Holidays and Celebrations.* New York: Crown, 1978.

Stribling, Mary Lou. *Art from Found Materials, Discarded and Natural.* New York: Crown, 1971.

Three-Dimensional Art and Crafts *continued*

Tacker, Harold, and Tacker, Sylvia. *Band Weaving.* New York: Van Nostrand Reinhold, 1974.

Temko, Florence. *Paper Folded Cut Sculpted.* New York: Collier Books, Macmillan, 1974.

Tipton, Barbara. *Great Ideas for Potters.* Columbus, OH: Professional Publications, 1983.

Topal, Cathey Weisman. *Children, Clay and Sculpture.* Worcester, MA: Davis, 1983.

Trotzig, Liv, and Axelsson, Astrid. *Weaving Bands.* New York: Van Nostrand Reinhold, 1974.

Tyrrell, Susan. *Kites, The Gentle Art of High Flying.* Garden City, NY: Dolphin Books, Doubleday, 1978.

Wankelman, Willard F.; Wigg, Philip; and Wigg, Marietta. *A Handbook of Arts and Crafts for Elementary and Junior High School Teachers.* Dubuque, IA: William C. Brown, 1982.

Weiss, Harvey. *Hammer and Saw.* New York: Thomas Y. Crowell, 1981.

Williamson, Ethie. *Baker's Clay Cutouts, Sculptures, and Projects with Flour, Salt and Water.* New York: Van Nostrand Reinhold, 1976.

Wilson, Jean. *Weaving is Creative, Weaving is Fun,* and *Weaving is for Anyone.* New York: Van Nostrand Reinhold, 1972.

Wiseman, Ann. *Bread Sculpture, The Edible Art.* San Francisco: 101 Productions, 1975.

Wong, Wucius. *Principles of Three-Dimensional Design.* New York: Van Nostrand Reinhold, 1977.

Art Heritage

Adams, Hugh. *Modern Painting.* New York: Mayflower Books, Phaidon Press, 1979.

Anfam, David A., et. al. *Techniques of the Great Masters of Art.* Secaucus, NJ: Chartwell Books, 1985.

Archer, B. J. *Follies: Architecture for the Late 20th Century Landscape.* New York: Rizzoli International, 1983.

Art and Man Magazine. Englewood Cliffs, NY: National Gallery of Art, Scholastic.

Batterberry, Ariane Ruskin, and Batterberry, Michael. *The Pantheon Story of American Art for Young People.* New York: Pantheon, 1976.

Brommer, Gerald F. *Discovering Art History.* Worcester, MA: Davis, 1981.

Chase, Alice Elizabeth. *Famous Artists of the Past.* New York: Platt & Munk, 1964.

_____ . *Famous Paintings, an Introduction to Art.* New York: Platt & Munk, 1964.

Chastel, Andre. *The Flowering of the Italian Renaissance.* New York: Odyssey, 1965.

Churchill, E. Richard, and Churchill, Linda R. *Great Artists Activity Reader.* Portland, ME: J. Weston Walch, 1978.

Colby, C. B. *Early American Crafts: Tools, Shops, and Products.* New York: Coward-McCann, 1967.

Cornell, Sara. *Art: A History of Changing Style.* Englewood Cliffs, NJ: Prentice-Hall, 1983.

Davidson, Marshall B. *A History of Art from 25,000 B.C. to the Present.* New York: The Random House Library of Knowledge, 1984.

Dawe, Frederick. *Understanding the Masters* (Series: *Gauguin, Michelangelo, Rembrandt, van Gogh*). New York: A&W Visual Library, 1976.

Donaldson, Gerald. *Books.* New York: Van Nostrand Reinhold, 1981.

Downer, Marion. *Long Ago in Florence.* New York: Lothrop, Lee & Shepard, 1968.

_____ . *Roofs Over America.* New York: Lothrop, Lee & Shepard, 1967.

Ford, John. *Tutankhamen's Treasures.* Secaucus, NJ: Chartwell Books, 1978.

Fowler, Carol. *Contributions of Women: Art.* Minneapolis: Dillon, 1976.

Fry, Nicholas. *Treasures of World Art.* New York: Hamlyn, 1975.

Gardner, Helen. *Art Through the Ages.* 7th Ed. New York: Harcourt Brace Jovanovich, 1980.

Gombrich, E. H. *The Story of Art.* 13th Ed. New York: Phaidon, 1978.

Gordon, Philip. *Artists of the American West.* Secaucus, NJ: Castle Books, Div. of Book Sales, 1980.

Grant, Neil. *Cathedrals.* New York: Franklin Watts, 1972.

The Great Artists, A Library of Their Lives, Times and Paintings (Series: *van Gogh, Rembrandt, Homer, Renoir, Michelangelo, Picasso, Da Vinci, Toulouse-Lautrec, El Greco, Degas, Titian, Modigliani, Rubens, Whistler, Raphael, Gauguin, Gainsborough, Cézanne, Vermeer, Goya, Monet, Velázquez, Bonnard, Manet*). New York: Funk & Wagnalls, 1978.

Hiller, Carl E. *Babylon to Brasilia, the Challenge of City Planning.* Boston: Little, Brown, 1972.

———————. *From Tepees to Towers.* Boston: Little, Brown, 1967.

Hillyer, V. M., and Huey, E. G. *Young People's Story of Our Heritage, 15,000 B.C.-1800 A.D.* New York: Meredith Press, 1966.

———————. *Young People's Story of Our Heritage, Fine Art, the Last 200 Years.* New York: Meredith Press, 1966.

———————. *Young People's Story of Our Heritage, Sculpture.* New York: Meredith Press, 1966.

Jackson, Florence. *The Black Man in America— 1932-1954.* New York: Franklin Watts, 1975.

Janson, H. W., with Cauman, Samuel. *History of Art for Young People.* New York: A Harry N. Abrams Book for American Book Co., 1981.

Janson, H. W., and Janson, Dora J. *The Story of Painting from Cave Painting to Modern Times.* New York: Harry N. Abrams, 1977.

Leacroft, Helen, and Leacroft, Richard. *The Buildings of Ancient Greece.* Reading, MA: Addison-Wesley, 1966.

———————. *The Buildings of Ancient Man.* Reading, MA: Addison-Wesley, 1973.

Levy, Virginia K. *Let's Go to the Art Museum.* Pompano Beach, FL: Veejay Publications, n.d.

Lynton, Norbert. *A History of Art—An Introduction to Painting and Sculpture.* Warwick Press, 1982.

———————. *The Story of Modern Art.* Englewood Cliffs, NJ: Prentice-Hall, 1980.

May, Robin. *History of the American West.* New York: Exeter Books, 1984.

Miralles, Jose M. *Famous Artists and Composers.* Bryn Mawr, PA: Mainline Book Co., n.d.

Newton, Douglas. *Masterpieces of Primitive Art, The Nelson A. Rockefeller Collection.* New York: Alfred A. Knopf, 1978.

Peppin, Anthea. *The Usborne Story of Painting.* Tulsa, OK: Usborne Pub., Ltd., 1980.

Richardson, E. P. *American Art—A Narrative and Critical Catalogue.* The Fine Arts Museum of San Francisco, 1976.

Shorewood Art Reference Guide. 3rd Enlarged Ed. Shorewood Reproductions, 1970.

Ventura, Piero. *Great Painters.* New York: G. P. Putnam's Sons, 1984.

Understanding Art and the Elements of Design

Adkin, Jan. *Symbols: A Silent Language.* New York: Walker & Co., 1984.

Arthur, John. *Realists at Work.* New York: Watson-Guptill, 1983.

Batterberry, Ariane Ruskin. *The Pantheon Story of Art for Young People.* New York: Pantheon Books, 1975.

Batterberry, Michael, and Batterberry, Ariane Ruskin. *Primitive Art.* New York: McGraw-Hill, 1972.

Gerald F. Brommer, ed. *Design Reference Series (Line, Color and Value, Shape and Form, Space, Texture, Balance and Unity, Contrast, Emphasis, Movement and Rhythm, Pattern).* Worcester, MA: Davis.

Cady, Arthur. *The Art Buff's Book.* Washington: Robert B. Luce, 1965.

Cumming, Robert. *Just Imagine, Ideas in Painting.* New York: Charles Scribner's Sons, 1982.

———————. *Just Look . . . A Book About Paintings.* New York: Charles Scribner's Sons, 1979.

Feldman, Edmund B. *The Artist.* Englewood Cliffs, NJ: Prentice-Hall, 1982.

———————. *Thinking About Art.* Englewood Cliffs, NJ: Prentice-Hall, 1985.

Franc, Helen M. *An Invitation to See, 125 Paintings from the Museum of Modern Art.* New York: The Museum of Modern Art, 1973.

Gatto, Joseph A.; Porter, Albert W.; and Selleck, J. *Exploring Visual Design.* Worcester, MA: Davis, 1978.

Hanhisals, Judith Evans. *Enjoying Art.* Englewood Cliffs, NJ: Prentice-Hall, 1983.

Herberholz, Barbara, and Herberholz, Donald. *The Real Color Book.* Carmichael, CA: Art Media, Etc., 1985.

Hochman, Shirley. *Identifying Art.* New York: Sterling, 1974.

———————. *Invitation to Art.* New York: Sterling, 1974.

Kainz, Luise C., and Riley, Olive L. *Understanding Art, Portraits, Personalities, and Ideas.* New York: Harry N. Abrams, 1966.

Kennett, Frances, and Measham, Terry. *Looking at Paintings.* New York: Van Nostrand Reinhold, 1979.

King, Marian. *Adventures in Art, National Gallery of Art, Washington, DC.* New York: Harry N. Abrams, 1976.

Landa, Robin. *Introduction to Design.* Englewood Cliffs, NJ: Prentice-Hall, 1984.

Lanier, Vincent. *The Arts We See: A Simplified Introduction to the Visual Arts.* New York: Teachers College Press, 1982.

Liberman, Alexander. *The Artist in His Studio.* New York: A Studio Book, The Viking Press, 1974.

Line: Fine Arts Reader. San Jose, CA: Santa Clara County Superintendent of Schools.

Maurello, Ralph S., ed. *Introduction to the Visual Arts.* New York: Tudor, 1968.

McCarter, William, and Gilbert, Rita. *Living with Art.* Westminster, MD: Alfred A. Knopf, 1985.

Ocvirk, Otto G.; Bone, Robert O.; Stinson, Robert E.; and Wigg, Philip R. *Art Fundamentals, Theory and Practice.* 3rd Ed. Dubuque, IA: William C. Brown, 1968.

Paine, Roberta M. *Looking at Sculpture.* New York: Lothrop, Lee & Shepard, 1968.

Poore, Henry R. *Composition in Art.* New York: Avenel Books, 1967.

Preble, Duane. *Man Creates Art Creates Man.* San Francisco: Canfield Press, Div. of Harper & Row, NY, 1973.

Preble, Duane, and Preble, Sarah. *Artforms.* New York: Harper & Row, 1984.

Reynolds, Alice N. *All About Art.* New Haven, CT: Fine Arts Publications, 1971.

Sneum, Gunnar. *Teaching Design and Form.* New York: Reinhold, 1965.

Sporre, Dennis J. *The Arts.* Englewood Cliffs, NJ: Prentice-Hall, 1983.

Wolf, Aline D. *Mommy, It's a Renoir!* Altoona, PA: Parent Child Press, 1984.

Multi-Cultural Art

Alkema, Chester Jay. *Monster Masks.* New York: Sterling, 1973.

Araki, Chiyo. *Origami for Christmas.* New York: Kodansha International, Ltd., 1983.

Ashton, Robert, and Stuart, Jozefa. *Images of American Indian Art.* New York: A Walker Gallery Book, Walker & Co., 1977.

Behrens, June. *Gung Hay Fat Choy.* Chicago: Childrens Press, 1982.

Bernstein, Bonnie, and Blair, Leigh. *Native American Crafts.* Belmont, CA: Pitman Learning, 1983.

Bleakley, Robert. *African Masks.* New York: Gallery Books, 1983.

Cole, Ann, et. al. *Children are Children are Children.* Boston: Little, Brown, 1978.

Covarrubias, Luis. *Mexican Native Arts and Crafts.* Mexico: Alicia H. de Fischgrund, [196-?]

Fernandez, Justino. *Mexican Art.* New York, Hamlyn, 1971.

Girard, Alexander. *The Magic of a People.* New York: Viking, 1968.

Griswold, Vera J., and Starke, Judith. *Multi-Cultural Art Projects.* Denver, CO: Love Publishing Co., 1980.

Halpin, Marjorie M. *Totem Poles: An Illustrated Guide.* Seattle, WA: University of Washington Press, 1983.

Harvey, Marian. *Crafts of Mexico.* New York: Macmillan, 1973.

Johnson, Jay, and Ketchum, William C. *American Folk Art of the 20th Century.* New York: Rizzoli International, 1983.

Jue, David F. *Chinese Kites: How to Make and Fly Them.* Rutland, VT: Charles E. Tuttle, 1968.

Kenneway, Eric. *Origami, Paperfolding for Fun.* London: Octopus Books, Ltd., 1980.

Kinney, Jean. *21 Kinds of American Folk Art and How to Make Each One.* New York: Atheneum, 1972.

Kisahara, Kunihiko. *Origami Made Easy.* San Francisco: Japan Publications, 1973.

La Farge, Oliver. *The American Indian.* New York: Golden Press, 1973.

Linse, Barbara. *Art of the Folk: Mexican Heritage Through Arts and Crafts.* Larkspur, CA: Publishers-Arts' Books, 1980.

McKendry, Blake. *Folk Art: Primitive and Native Art in Canada.* New York: Facts on File, 1984.

Menten, Theodore. *Chinese Cut-Paper Designs.* New York: Dover, 1975.

Nestor, Sarah, ed. *Multiple Visions: A Common Bond.* Santa Fe: Museum of International Folk Art, n.d.

Newman, Thelma R. *Contemporary African Arts and Crafts.* New York: Crown, 1974.

Perl, Lila. *Piñatas and Paper Flowers.* New York: Clarion Books, Houghton Mifflin, 1983.

Rush, Beverly, and Whittman, Lassie. *The Complete Book of Seminole Patchwork.* Seattle, WA: Madrona Publishers, 1982.

Saito, Katsuo. *Quick and Easy Japanese Gardens.* San Francisco: Shufunotomo Co., Ltd., Chong Imports, 1971.

Sayer, Chloe. *Crafts of Mexico.* Garden City, NY: Doubleday, 1977.

Schuman, Jo Miles. *Art From Many Hands.* Worcester, MA: Davis, 1981.

Smith, Bradley. *Mexico, a History in Art.* Garden City, NY: Doubleday, 1968.

Smith, Bradley, and Weng, Wan-Go. *China, a History in Art.* New York: Harper & Row, [1973?]

Soliellant, Claude. *India in Color: Activities and Projects.* New York: Sterling, 1976.

Temko, Florence. *Folk Crafts for World Friendship.* Garden City, NY: Doubleday, 1976.

Watson, Jane Werner. *India Celebrates!* Champaigne, IL: Garrard, 1974.

Williams, Geoffrey. *African Designs from Traditional Sources.* New York: Dover, 1971.

Art Books in a Series for Children

Coen, Rena Newmann. *American History in Art.* Minneapolis: Lerner Publications, 1966.

_____ . *Black Man in Art.* Minneapolis: Lerner Publications, 1970.

_____ . *Kings and Queens in Art.* Minneapolis: Lerner Publications, 1965.

_____ . *The Red Man in Art.* Minneapolis: Lerner Publications, 1972.

Forte, Nancy. *The Warrior in Art.* Minneapolis: Lerner Publications, 1966.

Glubok, Shirley. *Art and Archaeology.* New York: Harper & Row, 1966.

_____ . *Art of Africa.* New York: Harper & Row, 1965.

_____ . *Art of America from Jackson to Lincoln.* New York: Macmillan, 1973.

_____ . *Art of America in the Early Twentieth Century.* New York: Macmillan, 1974.

_____ . *Art of America in the Gilded Age.* New York: Macmillan, 1974.

_____ . *Art of America Since World War II.* New York: Macmillan, 1976.

_____ . *Art of Ancient Mexico.* New York: Harper & Row, 1968.

_____ . *Art of Ancient Peru.* New York: Harper & Row, 1966.

_____ . *Art of Ancient Rome.* New York: Harper & Row, 1965.

_____ . *Art of China.* New York: Macmillan, 1973.

_____ . *Art of Colonial America.* New York: Macmillan, 1970.

_____ . *Art of India.* New York: Macmillan, 1969.

_____ . *Art of Japan.* New York: Macmillan, 1970.

_____ . *Art of Photography.* New York: Macmillan, 1977.

_____ . *Art of the Eskimo.* New York: Harper & Row, 1964.

_____ . *Art of the Etruscans.* New York: Harper & Row, 1967.

_____ . *Art of the New American Nation.* New York: Macmillan, 1972.

_____ . *Art of the North American Indian.* New York: Harper & Row, 1964.

_____ . *Art of the Northwest Coast Indians.* New York: Macmillan, 1975.

_____ . *Art of the Old West.* New York: Macmillan, 1971.

_____ . *Art of the Plains Indians.* New York: Macmillan, 1975.

_____ . *Art of the Southwest Indians.* New York: Macmillan, 1971.

_____ . *Art of the Spanish in the United States and Puerto Rico.* New York: Macmillan, 1972.

_____ . *Art of the Woodland Indians.* New York: Macmillan, 1976.

Harkonen, Helen. *Circuses and Fairs in Art.* Minneapolis: Lerner Publications, 1965.

_____ . *Farms and Farmers in Art.* Minneapolis: Lerner Publications, 1965.

Looking at Art (Series: *Faces, People at Home, People at Work*). Atheneum Books.

Let's Get Lost in A Painting (Series: *Winslow Homer, The Gulf Stream; Edward Hicks, The Peaceable Kingdom; Emanual Leutze, Washington Crossing the Delaware; Joseph Stella, The Bridge*). Champaigne, IL: Garrard Publishing Co.

Mondale, Joan Adams. *Politics in Art.* Minneapolis, Lerner Publications, 1972.

Price, Christine. *Made in the Renaissance.* E. P. Dutton & Co., 1963.

_____ . *Made in West Africa.* E. P. Dutton & Co., 1975.

Raboff, Ernest. *Da Vinci.* Garden City, NY: Doubleday, n.d.

_____ . *Dürer.* Garden City, NY: Doubleday, 1970.

Art Books in a Series for Children *continued*

_____ . *Frederic Remington.* Garden City, NY: Doubleday, 1976.

_____ . *Henri de Toulouse-Lautrec.* Garden City, NY: Doubleday, 1970.

_____ . *Henri Rousseau.* Garden City, NY: Doubleday, 1970.

_____ . *Marc Chagall.* Garden City, NY: Doubleday, 1968.

_____ . *Michelangelo.* Garden City, NY: Doubleday, n.d.

_____ . *Pablo Picasso.* Garden City, NY: Doubleday, 1968.

_____ . *Paul Gauguin.* Garden City, NY: Doubleday, 1975.

_____ . *Paul Klee.* Garden City, NY: Doubleday, 1968.

_____ . *Pierre-Auguste Renoir.* Garden City, NY: Doubleday, 1970.

_____ . *Raphael.* Garden City, NY: Doubleday, 1971.

_____ . *Rembrandt.* Garden City, NY: Doubleday, n.d.

_____ . *Velázquez. Garden City, NY: Doubleday, n.d.*

_____ . *Vincent van Gogh.* Garden City, NY: Doubleday, 1975.

Zuelke, Ruth. *Horse in Art.* Minneapolis: Lerner Publications, 1965.

Credits

Judy Sakaguchi – Cover Illustration

Book Production Systems, Inc. – Design, Art, and Production

Guy Hubbard
Head of Art Education, Indiana University

Guy Hubbard has taught art at elementary and secondary levels in England and in secondary school in British Columbia. He has contributed numerous articles in professional journals and has written several texts on art education, including *Art: Meaning, Method and Media* (co-authored with Mary Rouse), *Art in the High School, Art for Elementary Classrooms,* and *Artstrands.* Dr. Hubbard has developed Indiana University's graduate art programs. He is presently developing a computerized data base to serve art teachers, as well as teaching courses on computer-based instruction. His work is presently focused on the retrieval of images from videodiscs.

D. Sydney Brown
Writer and Consultant

D. Sydney Brown was Consultant in Art, and Consultant for the Gifted and Talented for Ontario-Montclair (California) School District from 1974-1985. He has taught classes, given presentations, and participated in conferences for the gifted and talented in art. He is currently developing books on art and critical thinking skills.

Lee C. Hanson
Art Consultant, Palo Alto School District

Lee C. Hanson has taught art at various levels and recently developed Project WEST, an elementary art education program. She has written books and articles on art education, including the 3rd edition of *Early Childhood Art,* co-authored with Barbara Herberholz. She is active in major California and national art education associations, and has received a California Art Education Association award.

Barbara Herberholz
Independent art consultant

Barbara Herberholz has taught art at all levels and has developed an art appreciation program now implemented in many California elementary schools. The 3rd edition of her book, *Early Childhood Art,* was co-authored with Lee Hanson. She is active in the California Art Education Association and has received several CAEA awards.

Talli Richardson Larrick
Fine Arts Curriculum Coordinator, San Diego Unified School District

Talli Richardson Larrick has taught, written, and coordinated arts programs for students of all ages. She co-authored the School/Community Comprehensive Arts Program for the California State Department of Education and the California Arts Council. The program is being implemented in California schools. Ms. Larrick has been involved in Gifted and Talented programs. She is active in local and international art organizations.